"It is not the critic who counts; not the man who points out how the strong man stumbles or where the doer of deeds could have done them better. The credit belongs to the man who is actually in the arena, whose face is marred by dust and sweat and blood; who strives valiantly; who errs, who comes short again and again, because there is no effort without error or shortcoming; but who does actually strive to do the deeds; who knows great enthusiasms, the great devotions; who spends himself in a worthy cause; who at the best knows in the end the triumph of high achievement, and who at the worst, if he fails, at least fails while daring greatly, so that his place shall never be with those cold and timid souls who neither know victory nor defeat."

Citizenship in a Republic speech at the Sorbonne, Paris, April 23, 1910 — Theodore Roosevelt

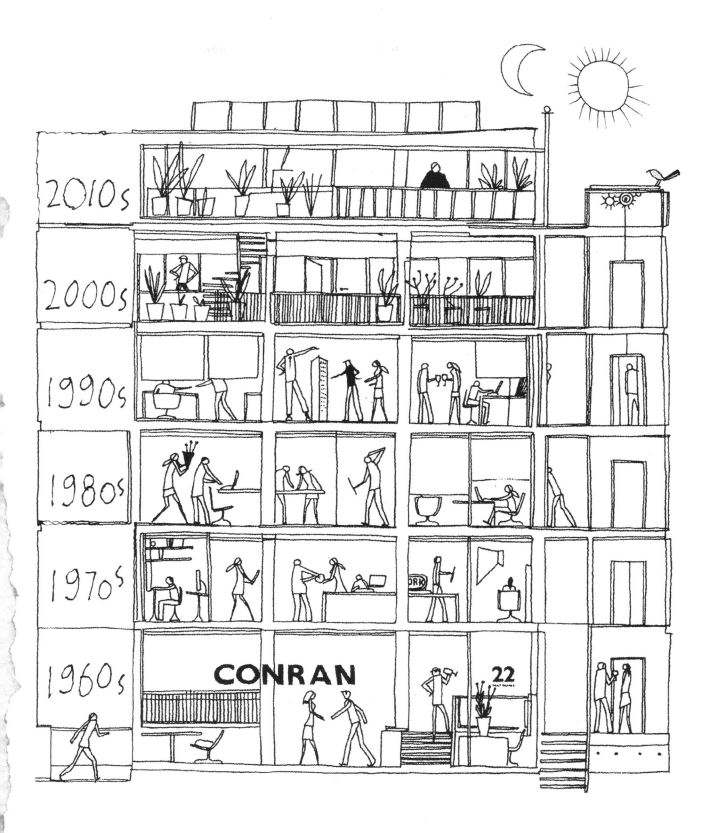

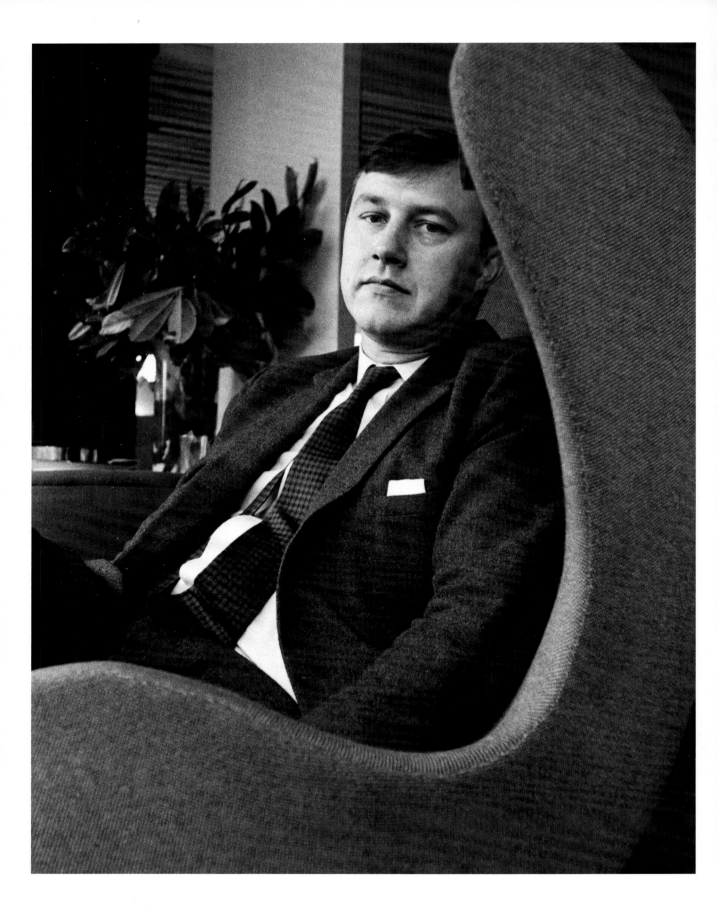

MY LIFE IN DESIGN

TERENCE CONRAN

CREATIVE CONSULTANT
STAFFORD CLIFF

CONTRIBUTING EDITOR
MATTHEW RICHES

conran
OCTOPUS

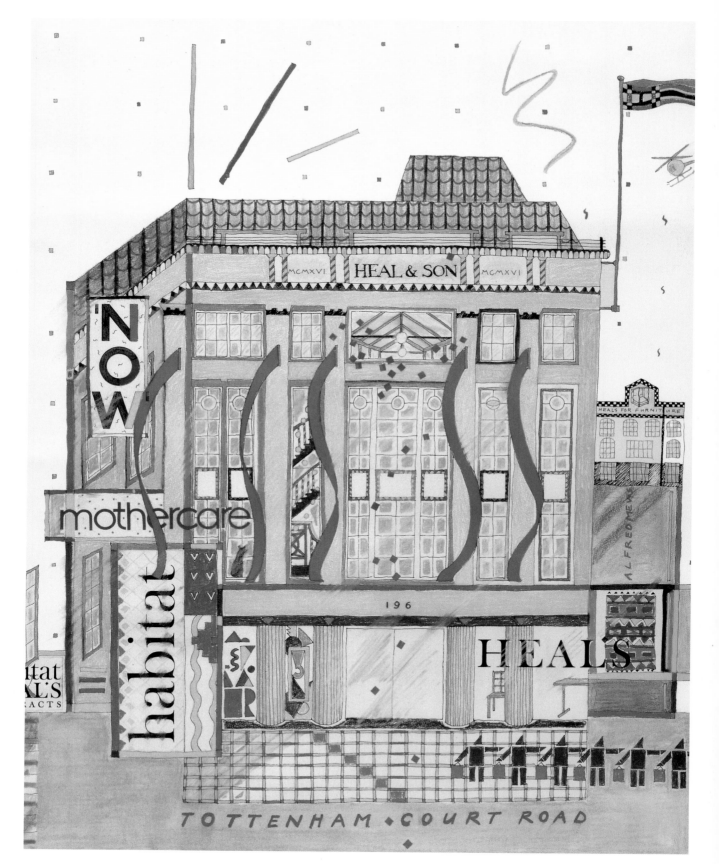

PAGE 1
"Shad All Over" is a sketch of our Shad Thames offices by the illustrator David Bray. It was commissioned to celebrate the Conran Spring Party held in 2009.

OPPOSITE
This poster was created to announce the launch in 1985 of the new Heal's Building, which amalgamated many of the retail concepts of the new Storehouse operation. It was such a beautiful building, with many delightful and original architectural features, all of which are perfectly captured in the poster's design and illustration by Helen Senior.

Contents

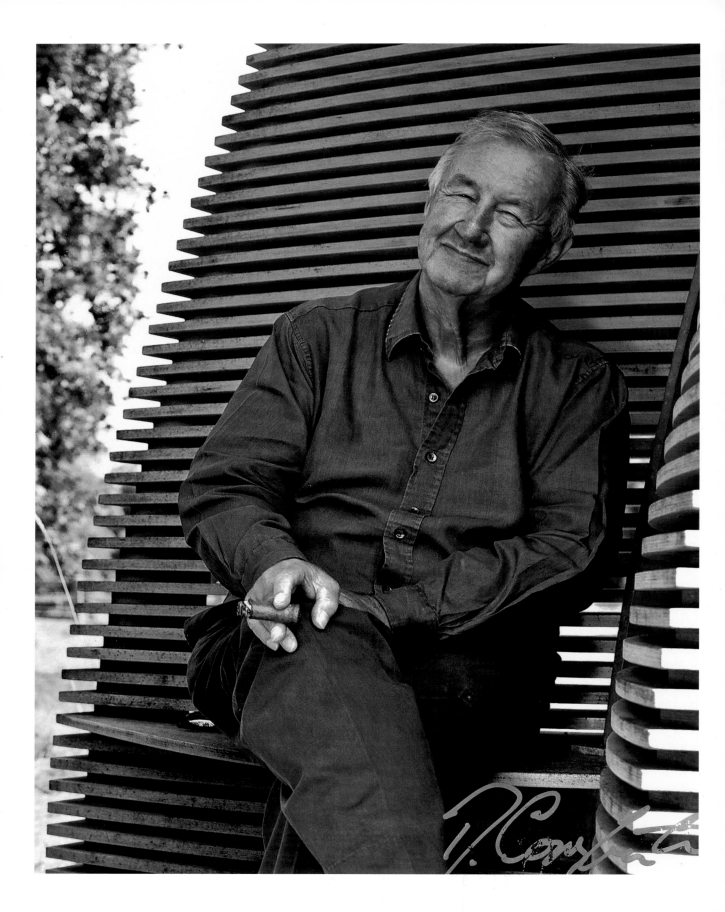

Sir Terence Conran

Specimen N° 535

Certificate of Authenticity

Venerated Patron and Mentor

Heatherwick Studio's Exhibition of Works, 7ᵗʰ June 2012

Foreword

by Thomas Heatherwick

THIS PAGE
My beautiful, personal invite to Thomas Heatherwick's brilliant 2012 exhibition. I was very moved that such a talented young man with the world at his feet would think of me in that way.

OPPOSITE
Sitting in one of my happiest places, Thomas Heatherwick's plywood gazebo in my garden at Barton Court that he made for his degree show at the Royal College of Art. I remember him showing me his plans for a twisting gazebo milled from one piece of birch and being utterly fascinated by his idea and ingenious thinking, so I invited him to build it in our workshops at Benchmark. It is the perfect place to sit and smoke a cigar, drink a glass of wine and enjoy a rare peaceful moment. I also love the photograph, taken by David Constantine.

Running two steps at a time down the fire staircase of London's Royal College of Art isn't an ideal way in which to meet someone, but 20 or so years ago I was convinced that Sir Terence Conran's perspective would be more valuable than the perspectives of any of my professors, and that seemed to be the only way to speak to him.

Terence stood out in my mind as the only designer who really understood why people wanted or needed special things. With Habitat, he busted through old-fashioned Britain and found a way not only to make beautiful objects, but to bring them to the high streets and into people's homes. To me he towered above other designers because he had the courage to manufacture and market what he and his team had created.

Since I have subsequently had the privilege to get to know him, it is clear that Terence is someone who is passionate about excellence in everything around us – from his restaurants, which brought Britain out of the culinary dark ages, to the revival of London's soulful Docklands buildings. His creation of the Design Museum was a natural extension of his belief in sharing and evangelizing thoughtful, imaginative and practical design.

Looking back, the striking thing was Terence's generosity to a random student stopping him on a staircase, bursting with questions. He was at the peak of his career, but he paused and reached out to support someone at the beginning of theirs.

Terence is a modernist who, together with a tiny handful of others, gave us a new vision of Britain and ourselves. From a country with questionable furnishings, dysfunctional appliances and fixed ideas of what a home is, it has become a place famous for its design and some of the best food in the world. Without Terence this transformation would not have taken place.

Sir Terence Conran has given this country – and me personally – many opportunities, but more than anything, he has been an inspiring mentor and friend.

Terence Conran's Design Universe

Terence Conran has been at the heart of many worlds throughout his career. Design is the one constant theme and the great connector, this being his own harmony of the spheres.

MICHELIN HOUSE

RESTAURANTS

RICHARD SHOPS

BHS

POINT OF SALE

GRAPHIC DESIGN

CONRAN STUDIOS

CONRAN SHOP

RYMAN

EXHIBITIONS

BRANDING

INDUSTRIAL DESIGN

AUTOMOTIVE DESIGN

WAY FINDING

BROCHURES

CORPORATE IDENTITIES

CATALOGUES

BUTLER'S WHARF

MILTON KEYNES

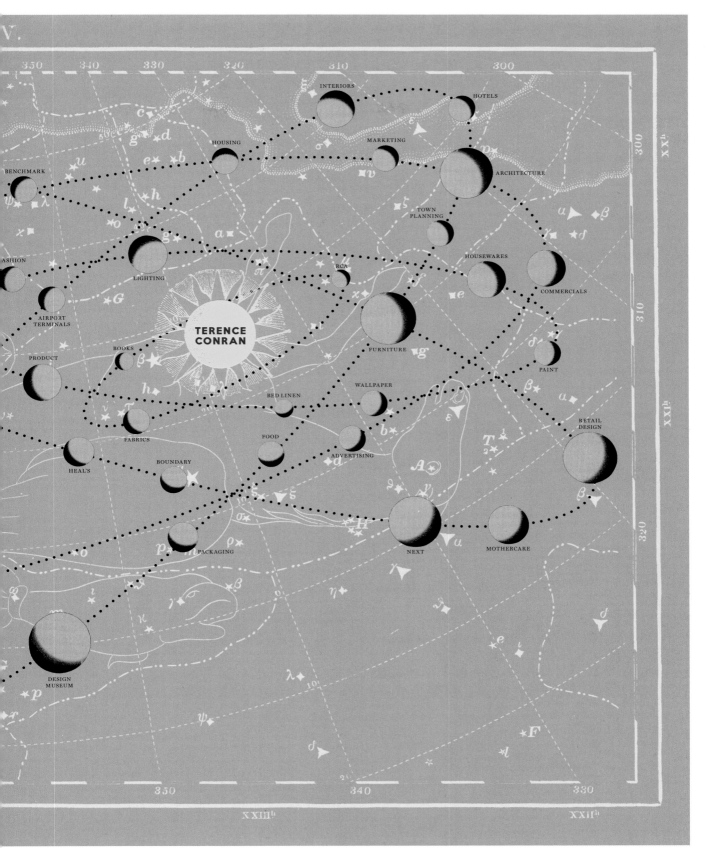

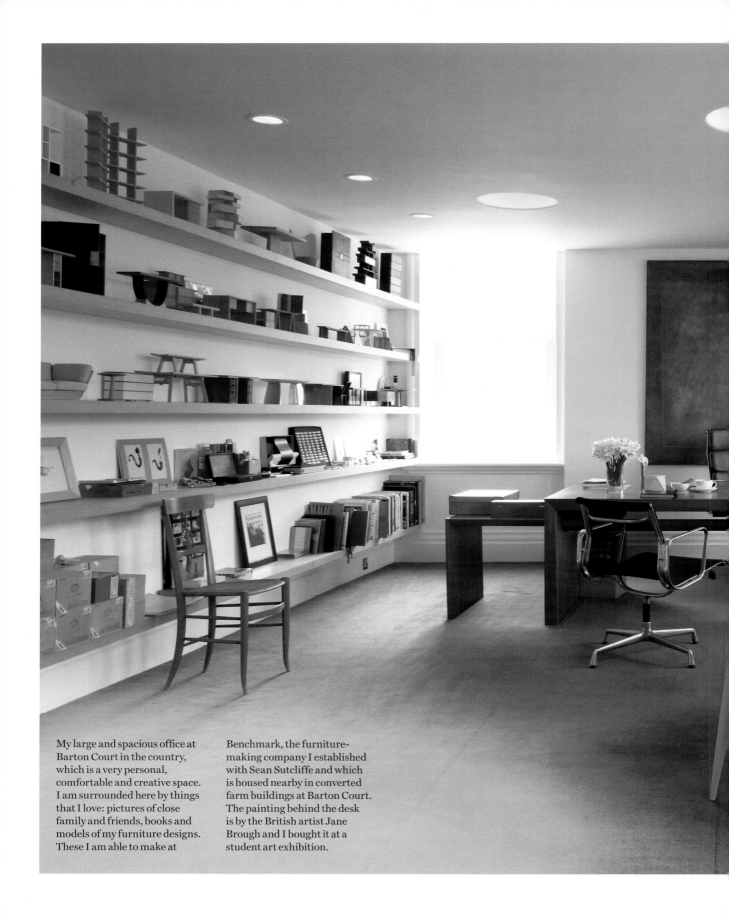

My large and spacious office at Barton Court in the country, which is a very personal, comfortable and creative space. I am surrounded here by things that I love: pictures of close family and friends, books and models of my furniture designs. These I am able to make at Benchmark, the furniture-making company I established with Sean Sutcliffe and which is housed nearby in converted farm buildings at Barton Court. The painting behind the desk is by the British artist Jane Brough and I bought it at a student art exhibition.

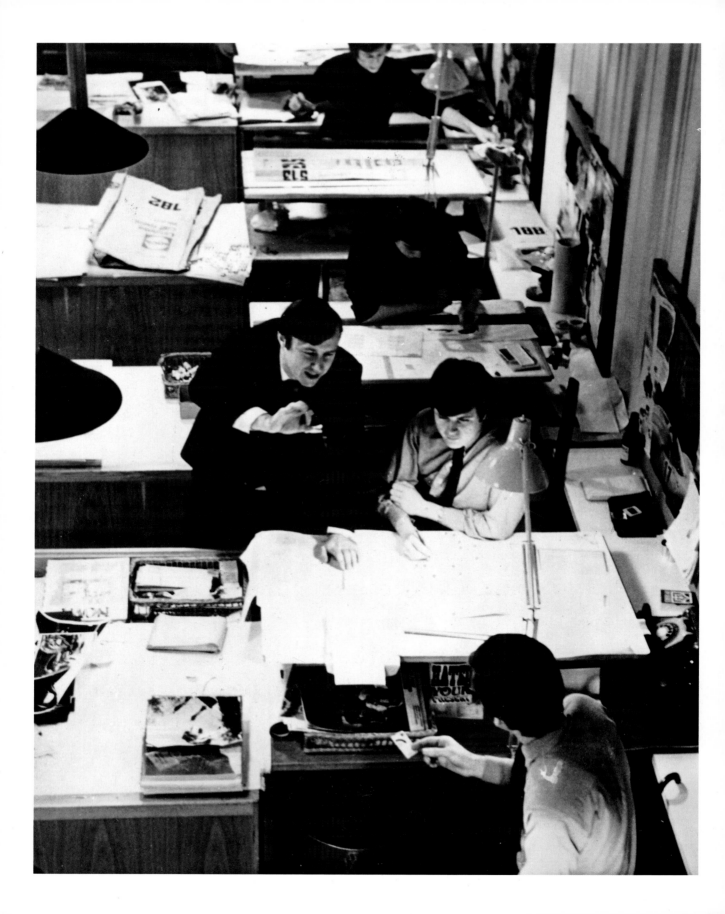

Introduction

I am fortunate to have enjoyed a long and colourful design life, which has been going on now for more than 65 years. I have formed and led four different design companies, working across practically every part of the design process. Together, we have made furniture and products for the home, printed textiles, retailed home furnishings, clothes, products for babies and children, as well as designing, opening and running restaurants, cafés, bars and hotels all over the world. We have also created skyscrapers, worked on large-scale urban regeneration projects and designed interiors for anything from airport terminals and museums to department stores, aeroplanes and cars.

OPPOSITE
The ground-floor graphic design studio of the Conran Design Group in Hanway Place really was a very creative environment. I always enjoyed discussing the details of the projects going through the office with the designers. This photograph, taken in 1967, shows me talking through a project with Peter Cockburn and Stafford Cliff.

I can't remember a time when design wasn't a major part of my life. I have always enjoyed making things and, from an early age, had the curious mind of a designer. A great deal of credit for that goes to my mother, Christina, who devoted herself to seeing that my sister, Priscilla, and I received the best creative education possible. She had simple tastes, which I inherited, and I'm quite sure that if the world had been different, she would have been a designer herself because she was so interested in the things around her.

At 13, I went to Bryanston School in Dorset, and that was where my interest in craft and making things really took off. The school has always had a strong creative ethic at its heart and I couldn't have been there at a better time. It was during the Second World War, and many artists, who were pacifists, were teachers there. My tutor, Don Potter, a former pupil of typeface designer and sculptor Eric Gill and a potter, was truly inspirational. I became something of a demented potter during my time at the school, but I also did as much as I could in the metalwork shop, where I learned to weld, a skill that I would put to great use during my early career as a furniture maker.

My first design group started in Fulham's North End Road in 1956. We were simply called the Conran Design Group and worked mainly on exhibition design, shop fitting and, of course, furniture design. Our early clients included the Ford Motor Company, the Atomic Energy Authority, the pharmaceutical company Smith-Kline and Mary Quant – we did the interiors for her second Bazaar fashion store in Knightsbridge.

In 1959, we moved to Hanway Place in the West End and expanded into graphic design. This was one of the most exhilarating and creative periods of my life. With John Stephenson running the Group, Rodney Fitch and Oliver Gregory responsible for interiors, and Ron Baker and Don Goodwin overseeing graphics, we became one of the largest design groups in the UK. We adopted the multidisciplinary approach to design championed in America by Raymond Loewy. I very much encouraged interaction in the team, which allowed us to work across the design process. We were involved in product and furniture design, interior design, graphic design, exhibition stands, packaging and corporate identities. There was no other design group around that had such a breadth of skills.

The first Habitat store opened in 1964 and its rapid expansion provided a continuous flow of work, but we also found that as more companies began to understand the importance of design, we attracted plenty of external work, too. We undertook a major project designing three office canteens for Gillette, created an exhibition stand in Moscow showcasing the best of British industrial design and, perhaps most exciting of all, designed the interiors and furniture for Heathrow's Terminal 1.

In 1968 I merged my company with Ryman, the office furniture and stationery firm. For a time, things worked very well for Ryman Conran, but it soon became clear that there were irreconcilable differences between my ambitions and those of the Ryman brothers – it seemed to me that they wanted to use all the available funds for the expansion of the office side of the business, where they saw great opportunities, but I saw exactly the same for Habitat's own expansion. Actually, we were both right but we couldn't afford to do both, so with some sadness I sold my shares and took Habitat out of Ryman Conran.

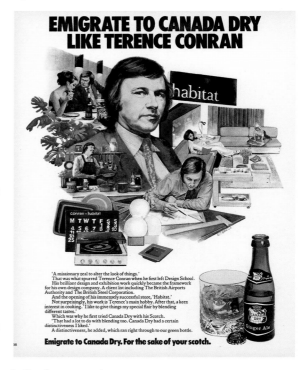

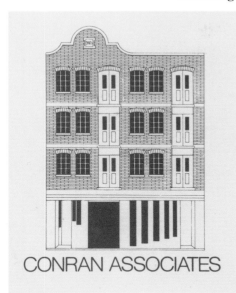

CONRAN ASSOCIATES

I left the Conran Design Group behind, with Rodney Fitch running it, in 1970, and moved to a building in Neal Street in Covent Garden, where I started a new design company called Conran Associates. This move made me very aware that, although my name might head the group, it was the team working on the design and in contact with the client that really made the difference between success and failure.

Habitat expanded so rapidly in the 1970s that the pressure on us to create and develop more products increased accordingly. We established a furniture and product design studio in an old stable building in the grounds of my house in the country, Barton Court, to focus entirely on Habitat. This was also a practical move because the Habitat warehouses, offices and showroom were in nearby Wallingford.

Oliver Gregory moved down to run the studio, which was full of bright young designers, and my dear friend Michael Wickham joined the team, making prototypes and introducing a bit of outside culture. We tended to be slightly inward-looking and entirely focused on design, so Michael educated us all – not least by introducing me to Shaker furniture.

In 1983 the Heal family asked if we wanted to buy their family furniture company, Heal's. Although Heal's had lost direction and was languishing in the past, I thought it was an incredible opportunity. I adored the huge, rambling building on Tottenham Court Road, with its beautiful architectural details, and felt that there was incredible potential to restore the company's reputation for making and selling good, modern furniture.

With the purchase of Heal's, we converted the Heal's building, which became the new headquarters for Habitat-Mothercare (the two companies had merged in 1982). Inside, there were also branches of both stores, while Heal's retained a sizeable portion of the space for itself. We created a state-of-the-art design function, with our group offices occupying the upper floors, together with photographic studios, a catalogue and advertising production department and space for prototype workshops.

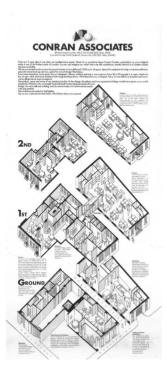

In the early 1980s we were offered a job at Milton Keynes, to inject some life into its very beautiful but austere shopping centre. It was here that I met Fred Roche, an architect and chief executive of the enormous Milton Keynes development. We got on very well and he had an excellent team working for him. A few weeks later he came to see me in Covent Garden and asked if I would form an architectural practice with him and several of his colleagues in Milton Keynes. I agreed immediately, and Conran Roche was formed in 1980. This was my third design group. Stuart Moscrop led the business with two excellent young architects, Richard Doone and Paul Zara. Two of its biggest projects were the development of just over 5 hectares (13 acres) of derelict land called Butler's Wharf in London Docklands and breathing new life into the Michelin building in Chelsea.

In 1990, I decided to leave Conran Associates and create an entirely new design group that would focus on architecture and interior design. Called Conran and Partners, the business was headed up by Richard Doone. By this time I had resigned from Storehouse, created out of the merger of Habitat-Mothercare in 1986, thereby losing control of my baby, Habitat, and the right to trade under any name that bracketed the words "Conran" and "Design". Although I was exhausted, bruised and disappointed by these events, I refused to go into meltdown. I was determined to bounce back and make sure this was the start of a new and much more rewarding story for me, rather than a long and unsatisfying path to retirement.

We took one of the apartments in the newly finished Butler's Wharf buildings as our offices and also my London home. There were several architects and designers working in one of the bedrooms of the apartment, and the finance team were in another back bedroom. It was a cosy arrangement but not exactly practical. At this time we were just beginning a rapid expansion of our restaurants across London as well as taking on architecture work, so urgently needed more space.

David Mellor had bought a totally derelict warehouse in Shad Thames and built a very handsome modern building on the site, where he hoped to open a shop and install his design group while living on the top floor. However, the recession hit him badly and he returned to his base in Sheffield. He offered the building to me and, as it seemed to be the perfect place for our designers and architects, I bought it. We converted the top two floors of 22 Shad Thames into my apartment, and the architects, designers, Conran Shop buyers and office team settled happily into their spacious new home below.

Conran and Partners soon developed into a multidisciplinary group when my son Sebastian came on board and put together an excellent product design team that worked alongside a very good graphics department. Sebastian has since moved on to run his own successful industrial design company but his influence on the company remains.

I am no longer involved day to day with Conran and Partners, which is led by Tim Bowder-Ridger, but I look on happily as they continue to create beautiful restaurants, bars, hotels, apartments and interiors around the world. They are also involved in social housing projects, bringing their design skills to an often neglected sector.

I may have sold my interests in Conran restaurants, but my passion for food and restaurants remains strong and the fire burns brightly in the work I do with my business partner, Peter Prescott. In our first major project together, we bought a wonderful Victorian former printworks in Shoreditch, the heart of London's creative hub, where I designed Boundary, which includes a small hotel, a large restaurant in the basement, a rooftop bar and grill, and a café on the ground floor called Albion.

So here I am, 84 years young at the time of writing, with much to keep me happy and busy. I am looking forward to building our small, personal restaurant business and growing our furniture-making company, Benchmark, with Sean Sutcliffe. The gigantic new Design Museum in Kensington is perhaps the culmination of all my design ambitions and dreams.

It really has been the most thrilling time so far. Starting out in those dreary, austere post-war years, we felt we had an opportunity to reshape the world in a new, more enjoyable image and add a little colour to life. We had looked at the Bauhaus in Germany and what they had achieved and hoped that we could extend those ideals in Britain.

I think we have done some great work over the years and used clever design to make a big difference to people's lives. To the hundreds of people I have been inspired by, worked alongside, collaborated with, worked for and even locked horns with in my design life, thank you. This book belongs to all of you. Enjoy the distant memories. I do.

Terence Conran

BELOW
The Marlowe Armchair is one of my favourite pieces in the collection we designed for M&S in 2011. When the first samples arrived, the legs hadn't been fitted to the main body; we were rather taken with it just sitting on the floor, so we made it available with removable legs.

OPPOSITE
This computer image shows the new Design Museum in its new home. The museum has always been pioneering, the first to show the work and inspirations of many of the most important designers and architects on the planet. This move, in 2016, to the former Commonwealth Institute in Kensington makes my rather long life in design worthwhile.

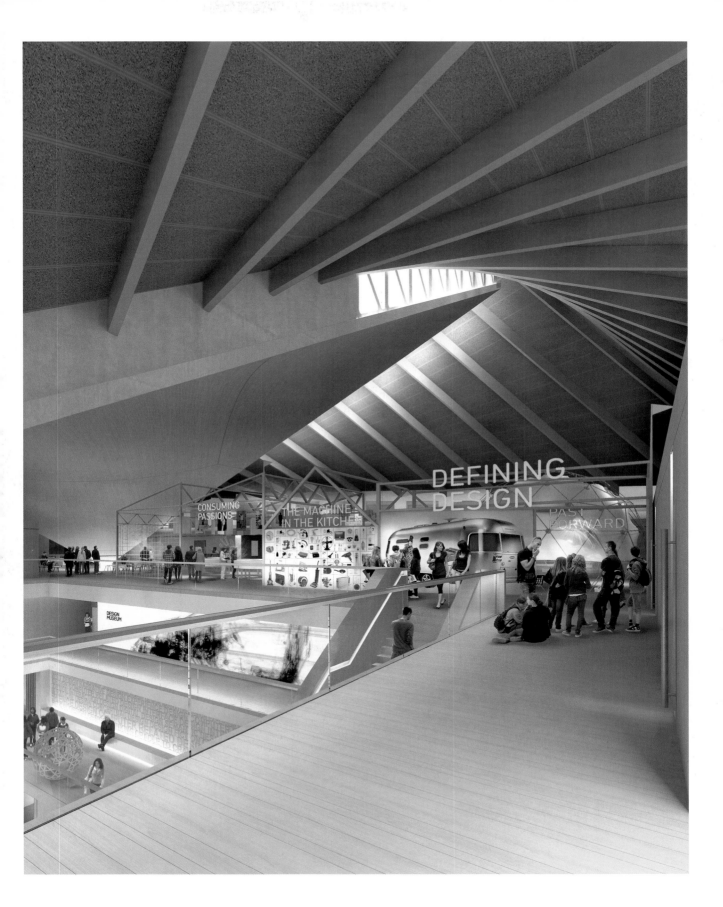

When the Conran Design Group
first moved into its building in
Hanway Place, London W1,
in 1959, we used the huge ground
floor as a funiture and fabrics
showroom for Conran Contracts.
As the graphic design part of
the business grew, we moved its
designers into this space and the
Conran Contracts showroom to
a shop in Tottenham Court Road,
managed by Michael Nicholson.
In this group portrait of the
design staff, most of the faces are
still familiar to me, although,
alas, some of the names are gone,
but I can still pick out the following:

1. Terence Conran
2. Rodney Fitch
3. David Wrenn
4. John Stephenson
5. George Montague
6. Colin Fulcher
7. Steven Goy
8. John Shuttleworth
9. Peter Cockburn
10. Michael Howerd
11. Ron Baker
12. Peter Crutch
13. Michael Nicholson
14. Stafford Cliff
15. John Bampton
16. Don Goodwin

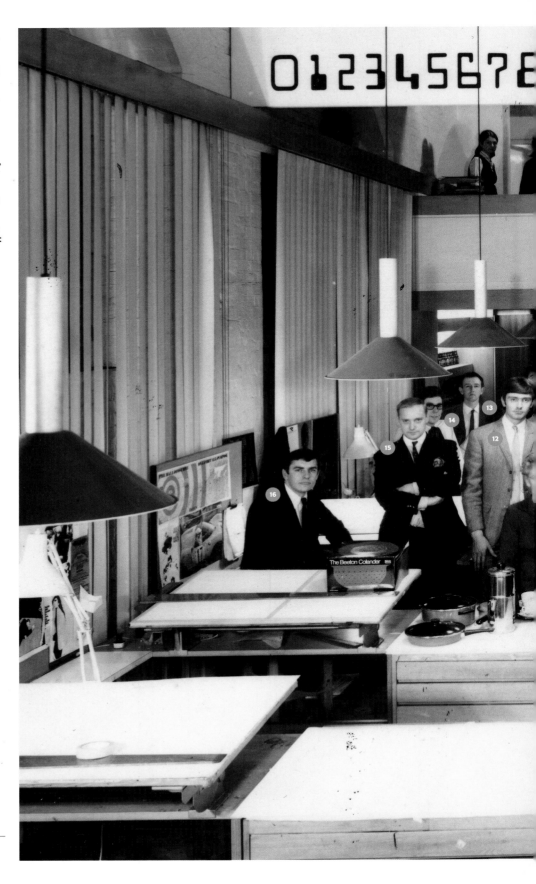

A Lifetime in Design

1950s

1956
Creates the Conran Design Group

1959
Moves Conran Design Group to Hanway Place, off Oxford Street

1955
Starts Conran Fabrics ↑

1953
Opens Soup Kitchen in Chandos Place →

1949–51
Works for architect Dennis Lennon on various projects, including the Festival of Britain

1960s

1964
Starts Habitat in Fulham Road

1961
Undertakes major design project for Harveys of Bristol

1962
Moves furniture business to 3.7sq m (40,000sq ft) factory in Thetford, Norfolk, and launches Summa, his first purely domestic range of flat-pack furniture →

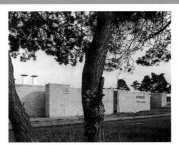

1968
Merges Conran and Habitat with Ryman to create Ryman Conran

1990s

1999
The Conran Shop and Guastavino's restaurant open in New York

1995
Opens Mezzo restaurant in Soho

1994
Opens first Conran Shop in Japan ↓

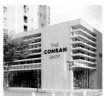

1993
Opens Quaglino's restaurant in St James's

1990
Resigns from Storehouse, sets up Conran Holdings from apartment in Shad Thames and founds Conran and Partners

2000s

2003
Named Provost of the Royal College of Art

2004
Conran and Partners complete work on Roppongi Hills, a new urban quarter in the heart of Tokyo, created by the Mori Building Company

2008
Opens Boundary Restaurant, Rooms and Rooftop in Shoreditch

2009
Opens Luytens on Fleet Street

1930s

**BORN
OCTOBER 4, 1931**

Terence and
his younger
sister Priscilla
←

1949
Starts furniture-
making workshop
in London's East
End with Eduardo
Paolozzi

1947–9
Studies textile design
at Central School of
Arts and Crafts

1940s

1943–7
Attends Bryanston
School, Dorset

1970s

1970
Buys Habitat out
of Ryman Conran
to create Conran
Associates

1971
Opens Neal Street
Restaurant in Covent
Garden ↑

1973
First branch of The
Conran Shop opens
on the site of the first
Habitat

1974
Publication of
The House Book by
Mitchell Beazley ↑

1986
Sets up Benchmark
Furniture in old farm
buildings at Barton
Court to produce
high-quality wood
and metal products.
Merges Habitat-
Mothercare with
BHS to create
Storehouse

1984
Buys Heals and
opens a Habitat,
Mothercare and Now
in the Tottenham
Court Road building,
along with Conran
Associates and a
huge new in-house
design team

1982
Becomes chairman
of Hepworths and
starts NEXT, based
on designs produced
by Conran Associates

1980s

1988
Sets up design group
to revamp image and
products of BHS

1989
Opens the Design
Museum and
Blueprint Café at
Butler's Wharf

1987
The Conran Shop,
Octopus Publishing
and Bibendum move
into Michelin House

1985
Sets up publishers
Conran Octopus
with Paul Hamlyn.
Habitat–Mothercare
buys Richard Shops,
Blazer and Heal's.
Rebuilds Heal's
image and building.
Buys Michelin House

1983
Buys Butler's Wharf,
near Tower Bridge,
for redevelopment.
Opens the
Boilerhouse Project
in the V&A, the
initial incarnation of
the Design Museum.
Knighted for services
to design

1981
Establishes the
Conran Foundation
to educate the public
and British
industry on the
value of design

1980
Collaborates with
Fred Roche to
create architectural
practice Conran
Roche

2010s

2011
Celebrates 80th
birthday with
exhibition at the
Design Museum
honouring his career
→

2014
Conran and Partners
completes a
20-hectare (49-acre)
regeneration project,
Futako Tamagawa,
on the outskirts
of Tokyo

2015
Redevelops the
classic Les Deux
Salons restaurant in
Covent garden, three
doors down from the
original Soup Kitchen

2016
New Design Museum
opens in the former
Commonwealth
Institute in
Kensington

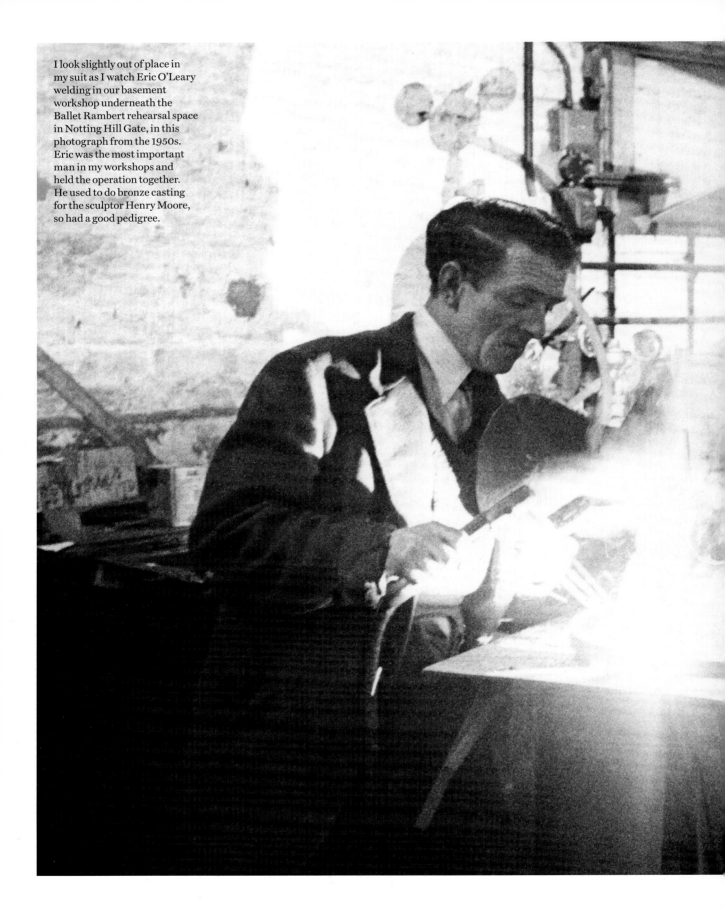

I look slightly out of place in my suit as I watch Eric O'Leary welding in our basement workshop underneath the Ballet Rambert rehearsal space in Notting Hill Gate, in this photograph from the 1950s. Eric was the most important man in my workshops and held the operation together. He used to do bronze casting for the sculptor Henry Moore, so had a good pedigree.

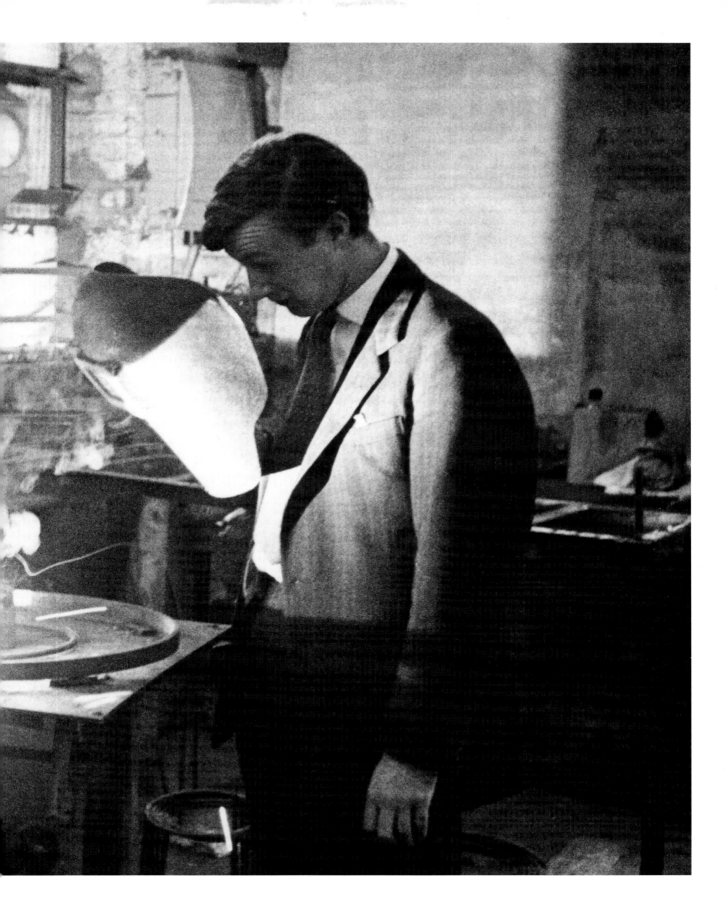

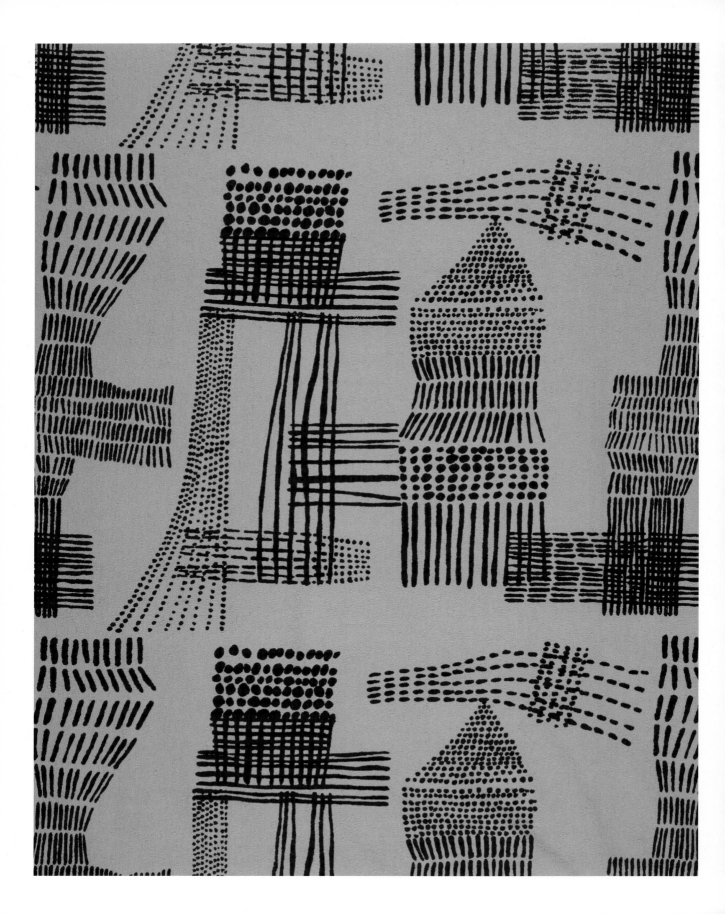

Textiles & pattern

Colour, pattern and texture have always been important to my enjoyment of life. It is perhaps no surprise that when I left Bryanston School in 1946, just after the Second World War, I found myself studying textile design at the Central School of Arts and Crafts in London. I was slightly alarmed to find that I was the only man – or boy, I suppose – in a class of 33 young women.

OPPOSITE
This very early screen-printed fabric, quite possibly from 1953, was for David Whitehead, an innovative textile company based in the Rossendale Valley in Lancashire. The influence of Eduardo Paolozzi is so strong in the design that it is practically a love letter to him.

It could have been so different, though. When I first thought about what I was going to do when I left Bryanston, I fancied having a crack at becoming a gunsmith – not making military weapons, of course, but I was fascinated by metal sporting guns. I admired the precision and the quality of craftsmanship involved in their design, the woodworking on the butt, but I discovered that the apprenticeship was poorly paid and lasted 20 years. I really couldn't commit to that.

At school, we had an art master called Charles Handley-Read, a very distinguished man, and I talked through my career options with him. He could see I was good at drawing and had an eye for pattern and colour, as well as an interest in organic chemistry, and he thought I might like to become a textile designer. He suggested I put a portfolio together and go for an interview at the Central School of Arts and Crafts in London. So off I went with a rather diverse collection of everything I had done: some repeat-pattern drawings, nature drawings, a book of pressed flowers, paintings, a few fuzzy photographs, ceramics, and bits and bobs of metalwork and woodwork.

I was a shy young man in those days but I enjoyed my interview with a wonderful lady called Dora Batty, who was the head of textiles, and a bunch of rather stern middle-aged ladies. They made largely approving murmurings and seemed quite interested in the diversity of my portfolio, despite the rather glaring absence of any sign of knowledge about textiles. A few weeks later, much to my surprise, I received a letter inviting me to start the course in September, just a few weeks before my 17th birthday. It was a very exciting moment to think that I had a career in front of me, and the more I thought about textiles, the more interested in them I became.

Dora Batty was very strict but she ran the course superbly. She saw that her students really had something to do at every moment they were there, which very much appealed to my nature. One of the most fascinating things she arranged was a twice-a-week, behind-the-scenes visit to the historic textiles collection at the Victoria & Albert Museum in South

Kensington, where there are vast halls with hundreds of thousands of prints and textiles from all over the world, the majority in remarkably good condition. As a result, I became terribly interested in Byzantine textiles, which looked very contemporary, and in the process of screen printing.

Dora brought in a whole raft of young designers and artists to broaden our horizons and inspire us. One of the great moments for me came after about six months, when Eduardo Paolozzi walked through the door. Just back from Paris, he was making a name

LEFT
My pressed-flower book, which I made when I was ten. I was passionate about collecting wild flowers, and their colours definitely influenced my textile designs. During the Second World War, I lived in Hampshire and absolutely exhausted the wild flowers in the local countryside.

OPPOSITE
Photographed for the 1973 Habitat catalogue, "Hadji" was a single-colour pattern applied to bed linen and aprons.

BELOW
A collection of mid-1950s designs from Conran Fabrics that have so much energy, they are almost electrical. The factory was headed up by a lovely man called Jeremy Smith, who became an expert in Indian textiles, and later imported many for Habitat.

for himself as a sculptor. He was a huge, rugged fellow with a gruff voice, and the young virgins from Surbiton had their heads in their desks, absolutely petrified of this ruffian. First impressions couldn't have been more wrong. Eduardo realized it was important to make friends with us, so he spent all his sweet (candy) ration coupons on a big lump of toffee, which he smashed with a hammer in front of us and shared with the whole class.

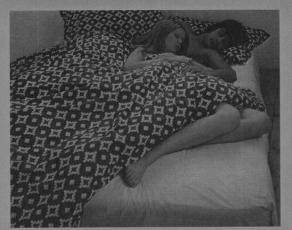

Soon the girls were all smiling at him and flirting, completely convinced that he was the best thing they had ever seen.

Dora had brought Eduardo in to teach us pattern making – his style was tough, organic and heavily influenced by his interest in primitive African art. He oozed creativity and taught brilliantly well through his enthusiasm. Everything he touched with those large, podgy hands turned into a wonderful organic object, and every textile he produced was beautiful to my eyes. After about a year, the whole class was making Paolozzi-style prints, rather than the prim and prissy patterns more evident at the start of the course.

Halfway through the course, in 1949, we put on an end-of-term textiles show of our work. A man called Dennis Lennon came along. He was an architect and worked for Fry, Drew & Partners, which was really the most modern and successful architect practices in London at that time. He had also just become the director of an organization called the Rayon Centre, which promoted the rayon industry. Dennis liked my work and offered me a job at the Centre. Although I hadn't finished my three-year course, Dora encouraged me to take it, as work for textile designers was scarce.

It was a good job, too; very interesting and with a roving brief. I suppose I was a "general design dogsbody" but I was designing textiles and I also helped put on exhibitions, arranged the flowers and made the coffee, of course – all for £4.10s a week. The Rayon Centre had a magazine, *Rayon and Design*, and I was given the job of art director, which I greatly enjoyed. I did a huge amount of drawing for it, too, interviewed a lot of fashion designers and included pictures of my textiles. I think it was the fashion designer Hardy Amies who called a piece of my work "hideous and repellent" in an article he wrote for the magazine. I had a terrific time, though, and got to see a great deal of the world. I was always grateful to Dennis for giving me the opportunity to develop my own ideas. When he set up his own practice in Manchester Square, I joined him and worked for him on the Festival of Britain in 1951, where, among other projects, my textiles were displayed.

In the 1950s, I also did a lot of freelance work for a Lancashire textiles company called David Whitehead. The managing director was an incredibly enterprising man called John Murray, whom I admired very much. The textile industry at that time was in decline but there were many talented textile designers around, and Murray was enthusiastic about the idea of using artists and designers to create distinctive designs for his fabrics. We shared a belief that design could provide industry with a competitive edge. I earned £25 per design and £2 for each colourway, which was a lot of money at the time. It allowed me to buy the lease on a small house in Regent's Park Terrace. Looking back, I can see my designs for David Whitehead were incredibly influenced by Eduardo but I was also beginning to develop a look that was becoming distinctly "Conran".

One of my most commercially successful designs ever was a fabric for David Whitehead. It was a simple, abstract design with good colours and little dotty lines but it became hugely successful and was sold on to the bedding company Myers, who used it for ticking.

I suppose that just after the Second World War, beds were desperately needed, but I was very proud of my success here: one million yards of Terence Conran ticking! David Whitehead told me that, as far as they knew, no factory in Manchester had recorded selling one million yards of fabric before. Sadly, I didn't get a royalty for my work.

Interestingly, two entrepreneurs have just bought David Whitehead & Sons. The company is currently reprinting the designs that I did at that time, which is very exciting because they are able to use modern techniques and materials to produce work of far higher quality.

Another fascinating aspect of the David Whitehead story is that the company was the biggest manufacturers of denim cloth in Europe. Until that point denim had been used in the UK extensively for working people's clothes, but after the War, production had dropped. John Murray had the idea that denim could be used as a fashion fabric and he commissioned me and a friend of mine, Raymond Elston, a trained fashion designer, to produce a clothing collection made of denim.

The idea was to show the collection at the newly completed Royal Festival Hall on London's South Bank, but first we had to give a catwalk display to the directors of David Whitehead. Over the space of six weeks, Raymond and I produced more than 70 garments, with him cutting the cloth and me producing the prints and organizing a photoshoot to show how the designs would all look when worn. When we showed them to the directors, their verdict was unanimous: "Oh, this is absolutely ridiculous. Denim is workwear. It's not leisurewear." The idea of denim as fashion disappeared almost without a trace, but now I just think of what might have been every time I see a pair of blue jeans.

At any rate, by the mid-1950s I had got this whole textile world going and established a company, Conran Fabrics, with my wife Shirley. It initially supplied my furniture business but we expanded and broadened our horizons quite rapidly. I remember Shirley's big design was called "Zuleika", which she made using torn tissue paper to create a motif of falling leaves. We employed an eccentric old lady, who lived in a basement in Powys Square in Notting Hill, to do the printing by hand in uneconomical short runs. The quality was variable, to say the least.

Conran Fabrics went on to become a very successful company, supplying designers and architects for projects such as British Airways Viscount Airliners and for the Orient Line cruise ships *Canberra* and *Oriana*.

As my career has progressed, textiles, pattern, texture and colour have continued to be important to my work. They have added interest to my home furnishings stores – Habitat and The Conran Shop – while in my various design businesses we have used print, pattern and textiles across the process.

It was in those early days studying and making textiles at the Central School of Arts and Crafts that I first began to absorb the Bauhausian ideal that good design should be available to the whole community, not just to the few. My story may have been a very different one had I felt able to take on a 20-year apprenticeship to become a gunsmith.

I owe an awful lot to my early tutors, Charles Handley-Read and Dora Batty, but I owe so much more to Eduardo Paolozzi, who influenced my whole approach to art, design and, even more importantly, to life.

ABOVE
These tiles were part of a collection of structured tiles called "Trace", a collaboration between our designers at Studio Conran and British Ceramic Tile in 2013. We used three-dimensional pattern to manipulate light and really bring rooms to life.

OPPOSITE
Another fabric design for David Whitehead, featuring roller-printed spun rayon. Looking closely at the fabric, I am absolutely fascinated at the level of detail that I used in my work. In the 1950s, rapid progress was made in printing techniques, and David Whitehead definitely led the way in using designers and artists to create contemporary, fashionable fabrics.

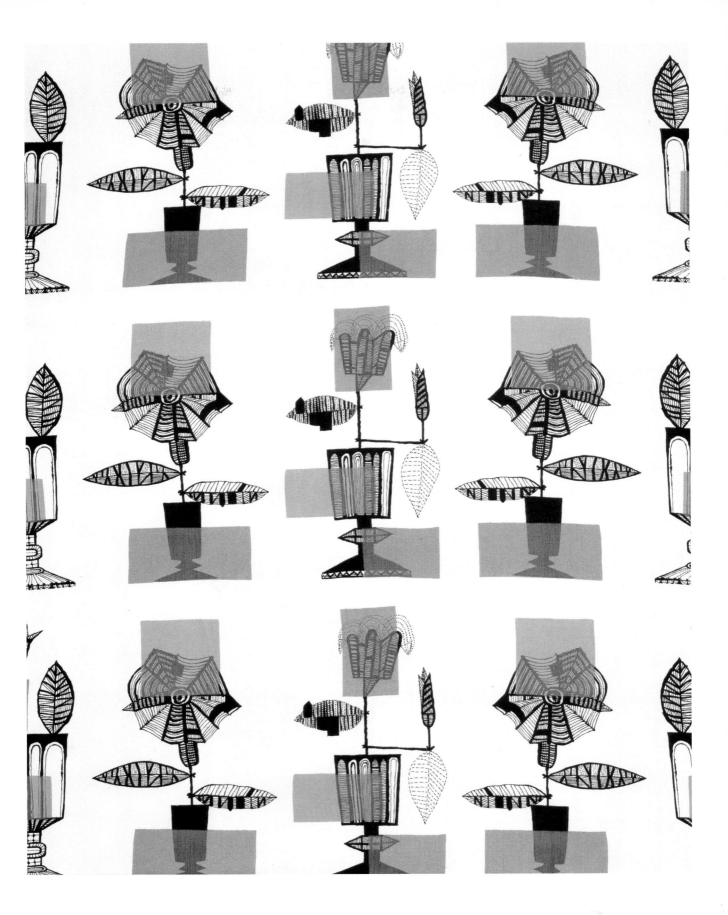

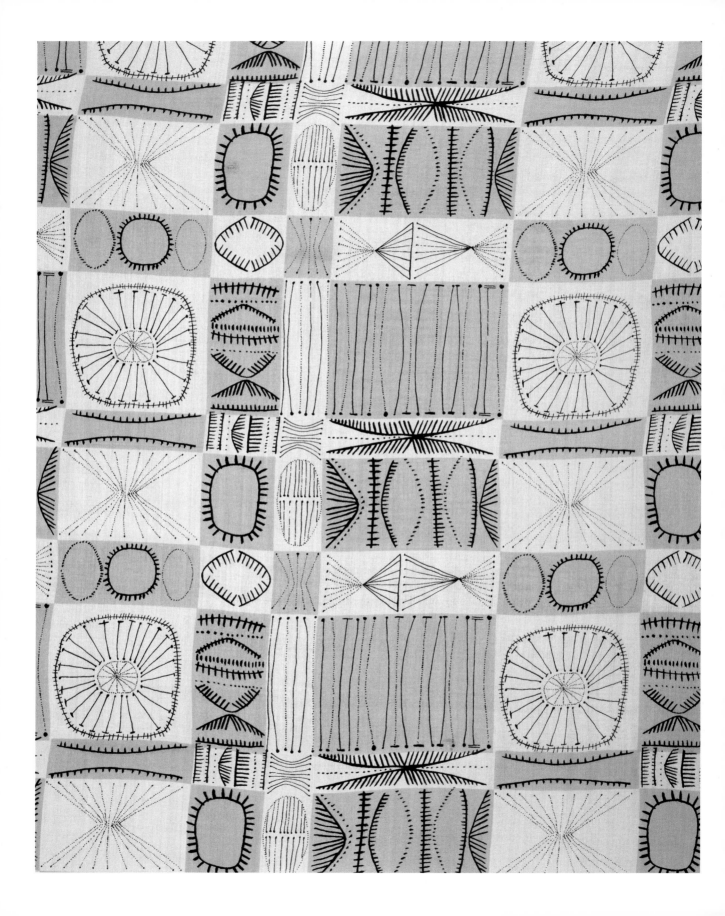

I designed and screen-printed this fabric called "Totem" in 1951. At the time, I had set up a small printing table in a workshop in the country and did a lot of quite experimental drawing. I was trying to capture a sense of energy and vitality in my work, and I think I succeeded.

THIS PAGE
In 2006 we collaborated with the traditional British textile manufacturer Dorma, to create a collection of textiles, including duvet covers, pillowcases, bed linen and towels. Jill Webb, who led the design team on the project, used 1930s art deco and traditional gentlemen's tailoring, sculptured fabrics and my own scrapbooks as the inspiration for the designs. Highlights from the collection included "Jermyn" (right), "Deco" (below left) and "Marbles" (below right).

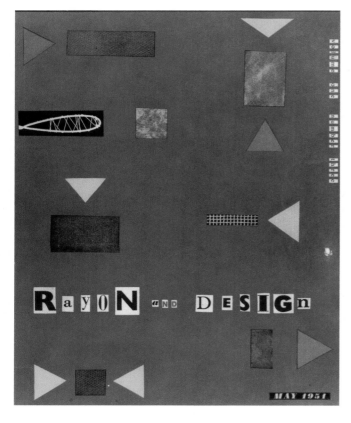

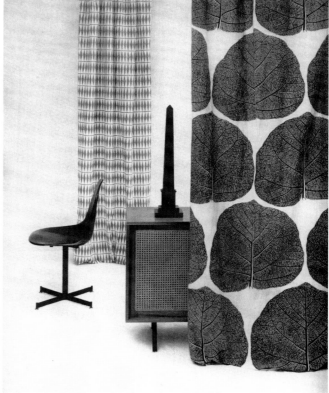

"My art master at Bryanston School, Charles Handley-Read, could see I was good at drawing and had an eye for pattern and colour, as well as an interest in organic chemistry. It was he who thought I might like to become a textile designer."

TERENCE CONRAN

PRINTED TEXTILE DESIGN

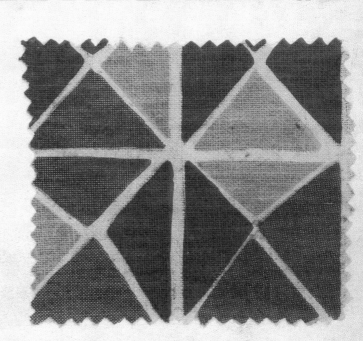

THE STUDIO HOW TO DO IT SERIES · 74

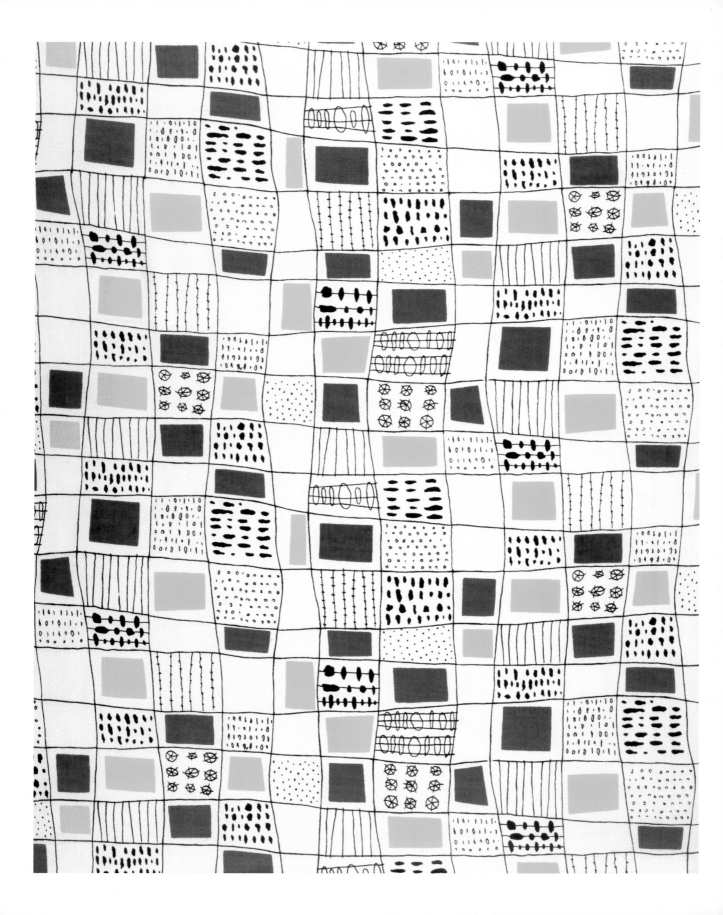

Made from rayon fabric, the "Chequers" design is perhaps the most iconic of all my textiles for David Whitehead. I was still a student at the Central School of Arts and Crafts when I designed it in 1949, and it was exhibited at the Festival of Britain in 1951. An entrepreneurial couple now own the Whitehead brand and have recently reintroduced this design to the market.

Roy Midwinter of Midwinter Pottery had seen the textile designs I had done for David Whitehead and asked me to work on designs for his ceramics. In 1957 we produced "Chequers", a very similar abstract design to my earlier textile work of the same name (opposite). I was particularly anxious to be successful for Midwinter, and my work, particularly "Salad Ware" (below left), was aimed perhaps a bit too much at the mass market, although I do think "Nature Study" (below right) is still very charming. I have it on the shelves in my office at home.

"The textile industry was in decline in the 1950s but John Murray and I believed that design could provide industry with a competitive edge, by using artists and designers to create distinctive designs for his fabrics."

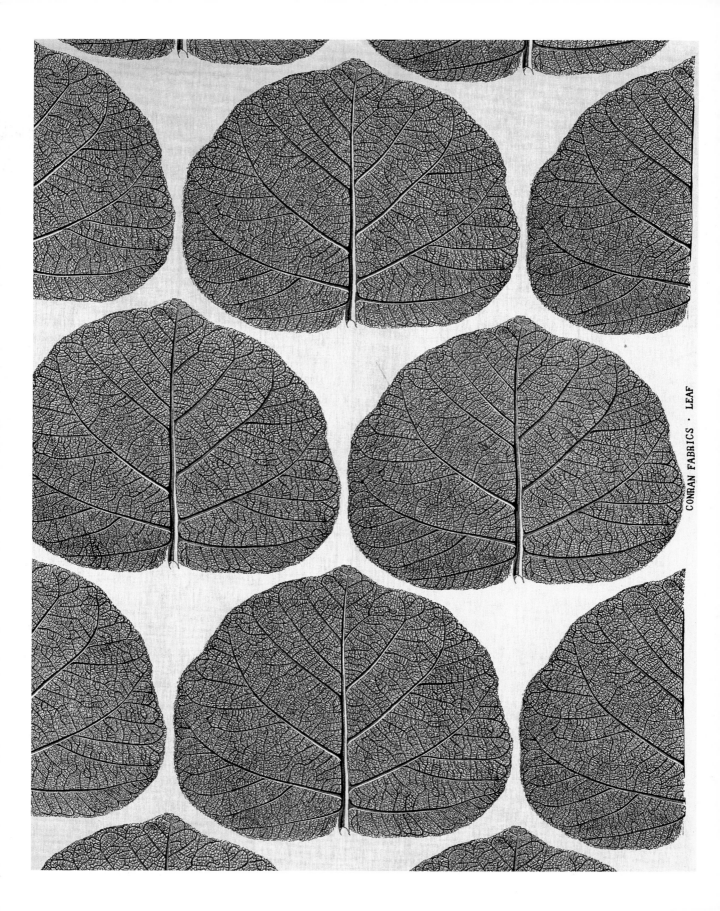

CONRAN FABRICS · LEAF

OPPOSITE

I created "Leaf" in 1957 for Conran Fabrics and it remains one of the favourite textile designs I have ever done. I used it in my own home and restaurants at the time. I found the leaf illustration in a book and drew over the top of it to get the detail. It was such a difficult process and took an enormous number of hours and a steady hand to capture the minuscule level of detail that makes the pattern so interesting.

BELOW

In 2013 Gordon's came to us and asked us to add a dash of design to their gin. The team at Studio Conran created ten fabric patterns, inspired and influenced by my early textiles, which were then printed onto 12km (7½ miles) of cotton and used to label one million bottles of gin.

OVERLEAF

Another textile for David Whitehead from 1952, which shows the extraordinary impact that Eduardo Paolozzi had on me. I think this design demonstrates just how brave and forward-thinking Whitehead's were as a company to put a product like this on the market at that time.

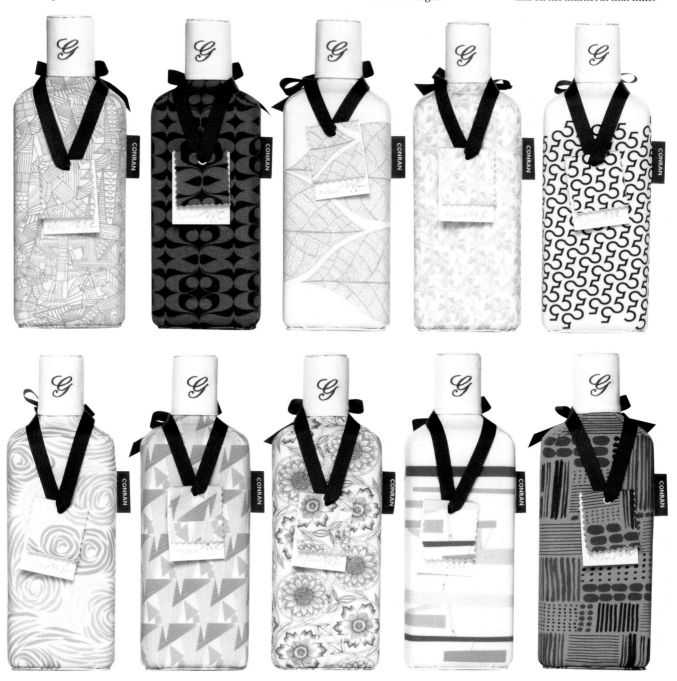

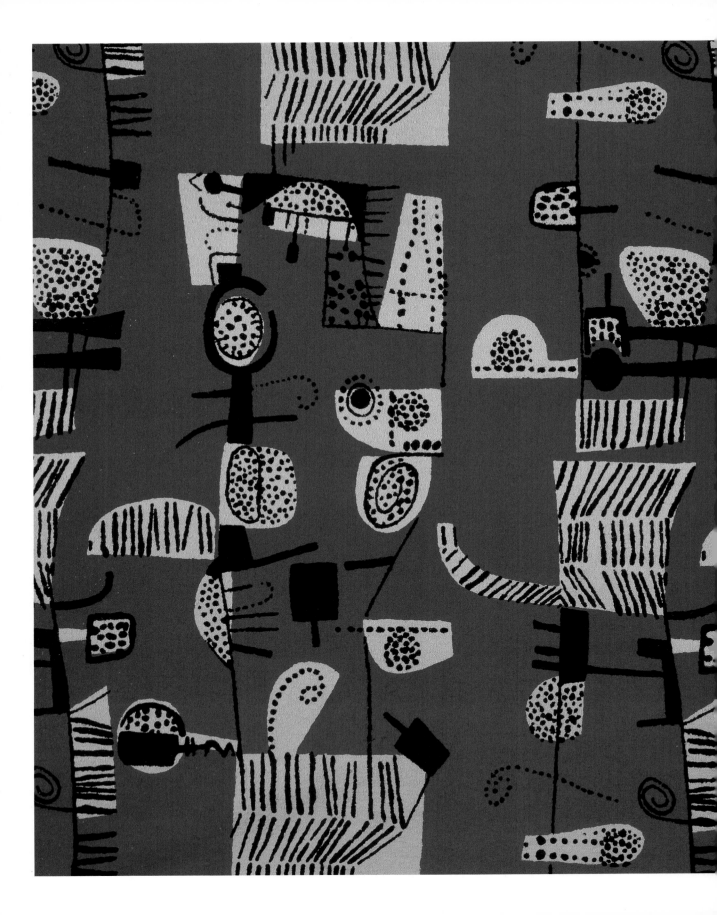

RIGHT

A book of fabric swatches, available from Conran Fabrics, from their 1965 domestic furniture brochure.

BELOW

A screen-printed, repeat-pattern, cotton furnishing fabric, initially designed for a store interior, by Conran Fabrics for Ryman Conran in 1970.

OPPOSITE

Conran and Partners collaborated with Danish manufacturer ege to create the "Visual Texture" range of carpets for use in large commercial spaces, such as hotels, restaurants and offices. My son Sebastian and Joanne Hargreaves led the design team, using innovative, digital dyeing techniques to create a series of designs with depth and texture, including "Cells", shown here.

In 2014 we produced my first-ever paint range, Paint by Conran. It was inspired by the wonderful, natural colours of the British countryside, and in particular the plants and landscapes that I have adored since I was a small boy exploring the wild meadows around Liphook.

It was a collaboration with Master Paintmakers, a company headed up by Arnie Kosky, which has been in the industry for more than 120 years, producing quality paints to a high technical specification. The design team created 96 individual colours across five overall collections: "Kitchen Garden", "Cottage Garden", "Highland", "Harvest" and "Orchard" and the original packaging featured charming illustrations by Holly-Anne Rolfe (right).

habitat

Zip along to Habitat's shiny new shop in Tottenham Court Road and kit up your home for the winter

Habitat

Although the first Habitat store opened in May 1964, its story began some years earlier and grew out of my frustration with British retailers in the early 1960s. I had just moved into a new factory in Thetford, Norfolk, and designed our first range of domestic furniture, which we called Summa. These days you would call it flat-pack furniture but then we referred to it as KD, or "knock down".

OPPOSITE
This large silkscreen poster, announcing the opening of the new Habitat shop in Tottenham Court Road, London, in 1966, was designed by Virginia Clive-Smith and beautifully illustrated by Juliet Glynn Smith.

I liked the flat-pack form of construction because it could be easily stocked, then taken away by customers in a car or cab, or even on the back of a Vespa. I believed that they would enjoy the simple assembly of their furniture. This was the Meccano generation, and the instant pleasure in buying furniture, taking it home, putting it together and using it all in the same day was as revolutionary as the miniskirt.

Summa was a good range of furniture with well-designed packaging. We exhibited it at the 1962 London Furniture Show, where we got a fairly positive response – about 80 retailers in the UK bought sample displays.

John Stephenson, who ran the Conran Design Group at the time, was a terrific car enthusiast. About six weeks after we had completed the delivery of our first orders, I suggested to him that we take a road trip to see what our Summa range looked like on the different shop floors.

What we found was deeply depressing. Most stores appeared not to have any philosophy of retailing. They simply stocked a mix of products – repro, retro, a bit of G Plan here and there – that they hoped would appeal to anybody who happened to walk through the door. The dusty salespeople were chiefly uninterested in the products. In many cases, they hadn't even unpacked, let alone assembled our furniture, and I even remember John having to show one salesman how to use an Allen (hex) key.

We returned from our long journey frustrated and depressed, realizing that our designs would not be successful in retail furniture stores on British high streets. I couldn't let go of the idea, though, thinking that it should be possible. My instincts were telling me that the world was changing, that young people were starting to have a bit of money in their pockets for the first time and might want to live in a less austere way than their parents. *The Sunday Times* had recently launched its first colour supplement, and Mary Quant's Bazaar fashion store was a booming success. I felt sure that people would want to express their personalities in their homes just as much as through their clothes.

I also remember reading cookery writer Elizabeth David's description of her ideal batterie de cuisine and thinking how lovely it would be to find a shop that could display and sell it. Through her wonderful books she had created a revolution in people's minds, awakening an appetite for good food and cooking, but you couldn't buy any of the equipment used in French kitchens that she talked about. So I thought, well, why not open this shop ourselves? It was also the ideal opportunity to sell our own modern furniture in a proper way alongside the things that related to it, which together made up an inexpensive, contemporary home.

I started the search for a suitable property that we could afford and eventually found a place on Fulham Road, between Draycott Avenue and Sloane Avenue. I think that previously the building had been a pub called the Admiral Keppel. The rent was

The initial components for the Summa storage range (left) and a room set displaying the Summa range of domestic furniture at Woollands department store in Knightsbridge (below). If other retailers had presented our products in such an imaginative way, I might not have felt quite so compelled to start my own store, Habitat.

30 shillings per square foot, with the huge basement thrown in for free, which I thought might make a rather lovely kitchen and lighting department. It was the answer – close enough to King's Road but not too fashionable.

I began putting together a team of those interested in my idea. Like-minded people from the Knightsbridge department store Woollands – David Phillips, Maurice Libby and Kate Currie – heard I was planning a new retail shop and came knocking on my

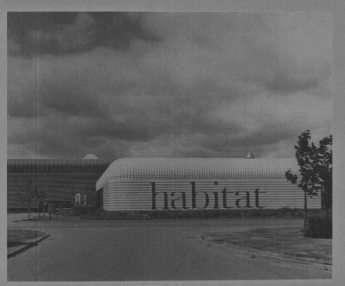

door. My wife, Caroline, shared the responsibility for the kitchen department and an ex-model, Pagan Taylor, became shop manager. Oliver Gregory who worked for my design group became a key figure. He had trained as a shopfitter and worked with me on the design and conversion of the shop.

Then we set about putting our collection together. We found products in the UK that had been largely forgotten about, especially ceramics and glass. We also contacted a French wholesaler, Les Halles, that sold to chefs and could supply everything in the Elizabeth David batterie de cuisine, and plenty more besides.

The shop design was very simple: painted bricks, terracotta-tiled floors, rough, slatted pine-strip ceilings and industrial light fittings. We put in a huge shop window so people could look in and be enticed by what was on offer. I think the whole fit-out came in at around £6,000.

So, with the shop designed we kept on trying to find the right name for it. We went through God knows how many ideas but, in the end, I think it was Pagan who suggested looking up "house" in *Roget's Thesaurus*. The entry went something like "house", "home", "habitat", and as one we said, "That's it!" "Habitat" was a name that everybody could relate to. It was absolutely right for the moment and it seemed to be a name that could be used across the world.

From the outset, we wanted Habitat to be more than just a furniture store, and it was never designed as a static business. It had to be constantly changing, with fresh ideas and new looks. Classic cookware and furniture were the mainstays of it all, but the store was also stocked with fabrics and dozens of household objects to seduce people in to making smaller, more casual purchases.

The thing that was really different from other retailers at the time was that all the stock was on the shelves, just like a rather stylish warehouse. These stacked displays were key to the Habitat look. I remember some of our staff being mystified by my insistence that the china, cookware and other items had to be piled so high, and some of them even tried to arrange them "artistically", but I was firm in my belief that creating that irresistible feeling of plenty I had experienced in French markets was the right thing to do. I think this emphasized the inexpensive price of most of the products, and people loved taking a supermarket-style wire basket and filling it up themselves. Generosity was the theme.

Very early on, Elizabeth Good wrote a fantastic article about us in *The Sunday Times*. She said something about "Heaven and Habitat", which was the most complimentary bit of praise I'd ever received. Customers responded enthusiastically to the modern furniture that they could take away and assemble themselves, as well as to the fabrics, china, glass and even toys.

As we became more professional as retailers, Habitat became financially successful and the idea of expansion was attractive. We soon realized that we would have to use our design talents to create more of our own exclusive products, and that in doing this, the volume of products ordered would become an essential factor. Luckily, we had formed a relationship with an entrepreneurial Indian company that had established contracts with many small manufacturers throughout India. Many of their existing products, sometimes with a little tweaking, were just right for Habitat, but usually we designed products to suit their skills. What we did so successfully was work with manufacturers and makers to improve the colours and designs so they would sell well in a Western market.

By this time we were expanding the number of our shops, so we built a new warehouse and offices and an out-of-town showroom in Wallingford, Oxfordshire, called the Jolly Green Giant. One day we were discussing if we should open in Glasgow, but I thought we might be more successful in Paris, which was actually closer. In the end, we opened in Glasgow and Paris. France had been such an inspiration to me that it was inevitable that one day we would take our ideas there and open our baby on "home soil", as it were. The French people I spoke to were convinced that Habitat was a French company with about four shops in the UK, such was the strength of our brand.

Most Habitat products sold in France were the same as those sold in the UK, but we also developed items specifically for the French market – where Habitat in the UK had introduced French items, such as the garlic press, to the mainstream, in France we had great success with the humble pie funnel. The duvet was another example. This had been a triumph in the British market and I was keen to include them in our French ranges. People were sceptical, though, saying the French were accustomed to sheets and blankets and would never change, but I stuck to my guns. Our promotion *"20 secondes pour faire un lit"* captured French imaginations and the duvet became a great success.

Gradually, with the help of a brilliant French team, we opened in every major town or city throughout France. Although, sadly, I no longer have anything to do with the company, the early Habitat spirit remains strong in the French stores today.

Habitat grew into an international business, with stores across Europe and in USA and Japan. That's not bad, considering, that in the beginning I was an angry young man with a medium-sized design business who had only ever envisaged there being one shop to sell his domestic furniture.

I think we also showed that in retail you need to follow the same philosophy, right from the drawing board, through the manufacturing process and on to the shop floor. All the products needed to appear as if they had been selected by one pair of eyes, and all our staff were just as passionate about what we were doing as I was.

From that deeply depressing trip, where it was impossible to find a retailer with any retail philosophy, here we were setting our own fashions and style. That was thrilling. We were making and selling products that young people desired, rather than recycling ideas from the past, and had initiated our own small revolution in taste and retailing. If pushed, I would say Habitat's success is quite possibly my greatest achievement.

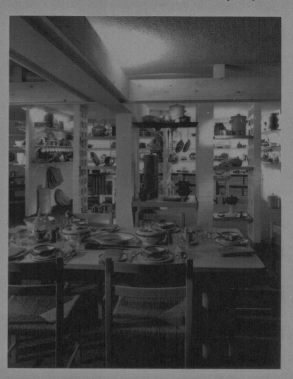

OPPOSITE
An early press shot featuring our store manager, the ex-model Pagan Taylor, in the kitchen department. She was a very stylish woman, who appealed to our target market of "young moderns with lively tastes", as we said at the time. We didn't want to be a static business – the whole concept needed to be always evolving with fresh looks and new designs. That said, furniture and classic cookware were always at the heart of our big idea.

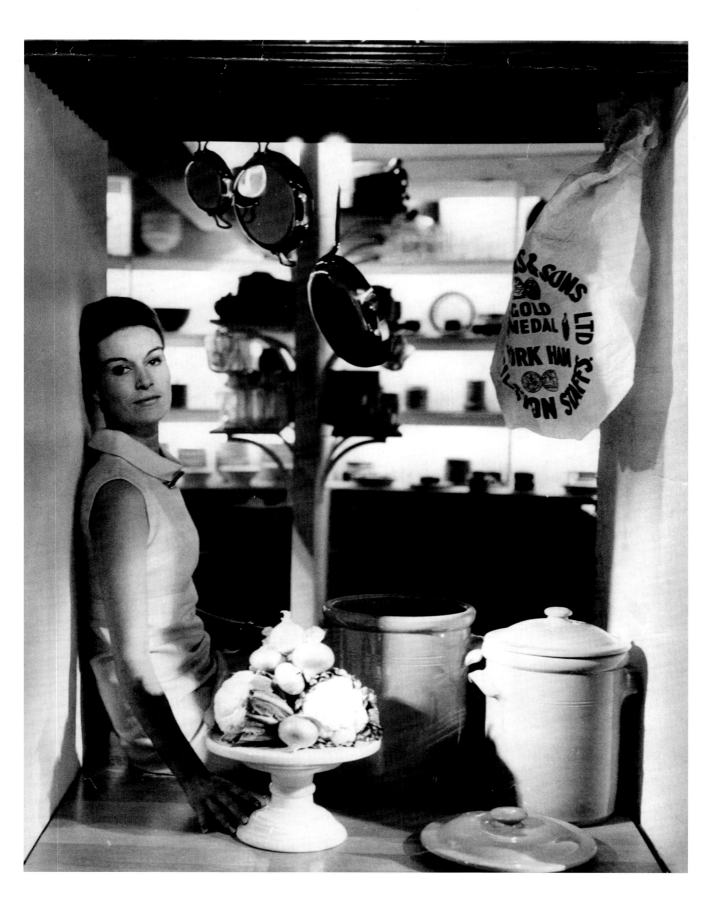

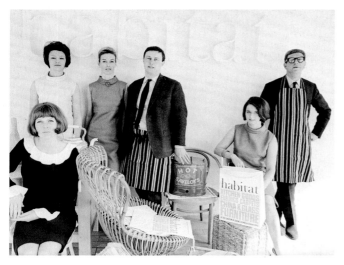

LEFT
The classic image of Habitat staff, photographed in May 1964 by Terence Donovan for *The Sunday Times*. From back left: Sonja Jarman, Pagan Taylor, Terence Conran, Kate Currie and Philip Pollock, with my wife, Caroline Conran, at the front. At the opening reception on the evening of Monday 11 May 1964, the staff were dressed by Mary Quant and had Vidal Sassoon haircuts.

BELOW
I wanted to re-create the feeling of abundance and plenty that I had experienced in French markets and make Habitat absolutely brim over with merchandise. All the packaging was removed so that the products could be not only seen but also touched – I always recognized the emotive value in customers handling our products.

OPPOSITE
Habitat on John Dalton Street, Manchester, photographed on its opening in 1967. One of the most innovative aspects of the design of this shop was the view from the street of the open stairwell, which allowed passers-by to see a large part of the basement shopping area and the merchandise on sale.

" 'The bright young chicks have got to have a red Magistretti chair, the way they have to have a Tuffin and Foale dress,' I told *The Sunday Times*."

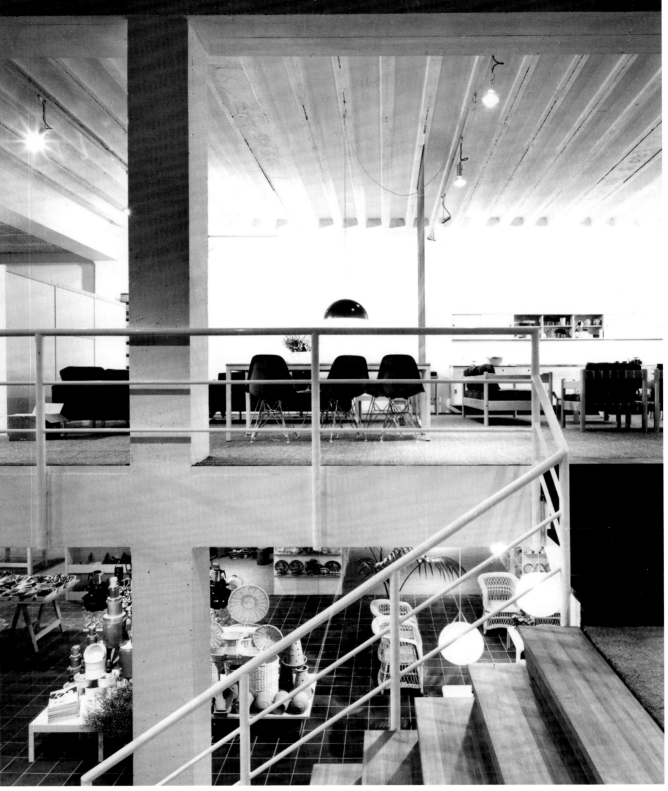

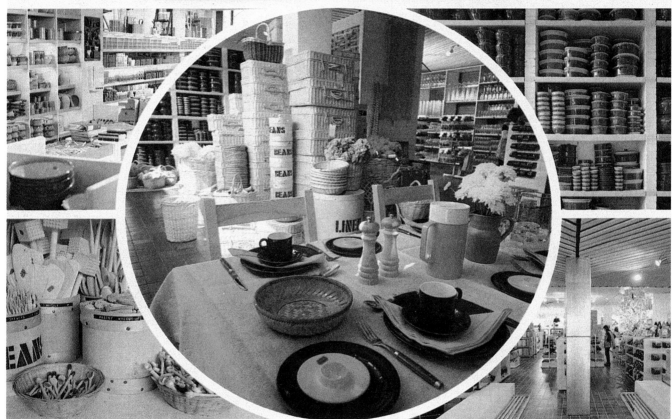

"We knew there was an opportunity for a revolution in the way things were sold, to create something that was more than just a shop selling furniture."

OPPOSITE
The essence of Habitat was captured in this composition from the 1973 catalogue. It was put together for the benefit of customers who might never have the opportunity to visit one of the Habitat stores and to excite them about our products.

ABOVE RIGHT
The second Habitat shop on Tottenham Court Road was larger and more modern than the first on Fulham Road. The building was indescribably depressing when we took it on, but we saw beyond the rotten wood and layers of brocade wallpaper and knew it would make an excellent store.

BELOW RIGHT
Habitat in Bristol, which opened in 1968, was a tiny space. All our stores followed the same design formula, deliberately enhancing the merchandise by being neither expensive nor alienating. Products were displayed in a "compelling warehouse atmosphere" and neatly stacked. In effect, the shop became the stockroom.

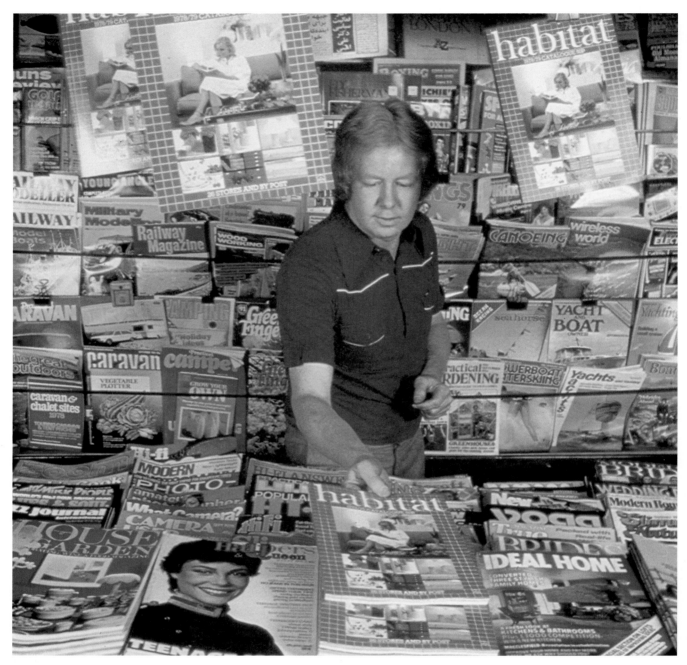

ABOVE
In 1977 Habitat catalogues began to be sold on UK newsstands and in branches of the high-street newsagent WH Smith, highlighting the extraordinary popularity of our idea.

OPPOSITE
Habitat catalogues from the 1970s and 1980s. Their story really began in 1969–70, when we bought the small furniture manufacturer Lupton Morton. The company had a mail-order business that employed a young graphic designer called Guy Fortescue. He and I produced an 88-page catalogue titled

Habitat: Creative Living By Post in the barn of my Suffolk cottage. Stafford Cliff then took the helm and, over the next ten years or so, pushed all the boundaries and broke all the rules. As well as selling an increasing range of products off the page, the catalogue ran editorial-style features, from decorating ideas to product

background stories. Most radically for the time, Cliff took our products into real homes in the UK, France and America, and photographed them with people's own vintage or antique pieces. We were keen to show that the Habitat lifestyle was not about buying everything new and from us, but also about mixing things and expressing one's own personality.

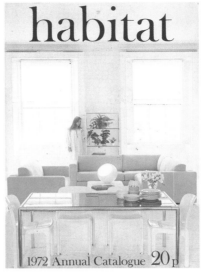

1972 Annual Catalogue 20p

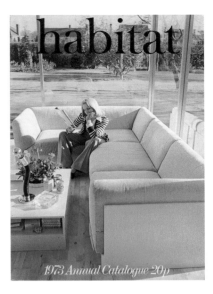

1973 Annual Catalogue 20p

1975 Catalogue 30p

1976 CATALOGUE 30p

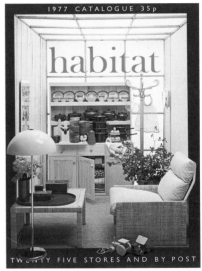

1977 CATALOGUE 35p

TWENTY FIVE STORES AND BY POST

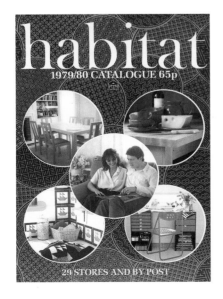

1979/80 CATALOGUE 65p

29 STORES AND BY POST

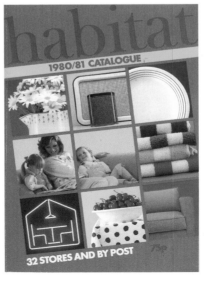

1980/81 CATALOGUE

32 STORES AND BY POST

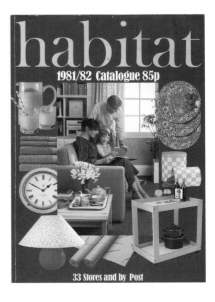

1981/82 Catalogue 85p

33 Stores and by Post

Lighting is an important part of the furnishing of your home and should be integrated into the whole scheme. It is the distribution of light that counts. A number of lights carefully planned are more effective and give greater flexibility than light from a single outlet. Here we tell you how best to plan your lighting.

Planning: decide on your furniture layout before planning your lighting and positioning the fittings. The living area needs the most creative planning – in other areas lighting functions are more related to specific tasks. The key to successful lighting is to flatter the area or object so make sure you have plenty of power outlets.

Key lighting functions: For ease of planning, home lighting can be divided into three different categories:
1. General lighting
2. Effect lighting
3. Task lighting
An understanding of these will help to create a satisfactory scheme.

LIGHTING – 3 TYPES

General lighting – is achieved by maintaining a level of light throughout a room usually from the ceiling. Such lighting is normally the first to be switched on in the room and high or low levels of illumination can be achieved by using a dimmer switch. **Effect lighting** – secondary lighting achieved by highlighting paintings, plants etc or from some special way of lighting shelves and curtains. **Task lighting** – this is the lighting function necessary to light the specific jobs around the home eg reading, writing, eating, cooking, making-up, shaving etc.

This room by room guide will give you some basic ideas.

LIVING AREA

For flexibility install a dimmer switch with the general lighting. Select from downlighters, wall lamps, ceiling fittings or pendants. For effect lighting use spotlights, uplighters, tablelamps and floor-lamps. Task lighting functions in this area include, dining, writing, reading and general low level lighting for watching television. Reception areas and hallways – general lighting from spotlights, ceiling fittings or centrally fixed downlighters.

KITCHEN

General lighting from fixed spotlights. For total flexibility from spotlights mounted on a track system or downlighters. Task lighting from low level baffled units under cabinets.

BEDROOMS

General lighting from a pendant or downlighters mounted in front of wardrobes. Background lighting from spotlights. Task lighting – reading from bedhead mini-spots or tablelamps. Make-up – mirror lighting.

BATHROOMS

General lighting from special surface fittings, spotlights and downlighters. Task lighting – over mirror. For shower units a vapour-proof fitting is necessary.

OUTDOORS

Plan outdoor lighting to extend the living area outside the home to the terrace and garden. Select lamp wattage carefully and position fittings to direct any glare away from motorists. Apart from wall lamps, outdoor lighting looks much more natural if light sources are hidden and the light is reflected from walls, shrubs or trees.

Our thanks to light fitting designer, Peter Rodd of MD Lighting.

READING

Light from the side or behind. Avoid front lighting. Supplement with some background lighting to reduce sharpness of contrast.

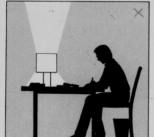

DINING

A pendant at the correct level is best – and avoids glare into the eyes. Use a rise and fall unit for complete flexibility.

TV WATCHING

Low level background lighting near the TV cuts down bright contrast from the screen for comfortable viewing.

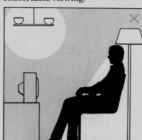
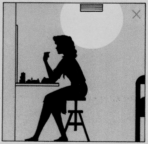

WRITING

Light from above to avoid strong shadows falling on to your work – the ideal type of fitting is the flexible jointed worklamp.

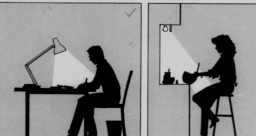

COOKING

Avoid working in your own shadow. Use a central fitting for general lighting only. Place task lighting over working surfaces.

MAKING UP

Mirror lighting should be shadow free – position lights not behind you but around the mirror to shine into your face.

Illustrations: John Geary

OPPOSITE

Almost from the outset, the Habitat catalogues devoted pages to giving customers helpful information about various aspects of the home. The 1981 catalogue included this guide to both good and bad lighting for domestic tasks, such as reading, watching television and applying make-up – things people still get wrong to this day. The illustrations were by John Geary.

ABOVE LEFT

A simple, modern, Conran-designed kitchen in a room set displaying furniture made in our Thetford factory. The kitchen units, in Swedish pine with white lacquered doors, were wall hung – a new concept in the mid-1960s in UK at the time – and proved incredibly popular.

ABOVE RIGHT

Our simple but very popular range of "Campus" furniture was offered in a choice of six upholstery colours. It was probably our best example of knock-down, or flat-pack, furniture because it really was so easy to assemble at home.

RIGHT

The contracts division at Habitat offered a tailor-made service for overseas customers: "If you're converting a Victorian villa into accommodation for students or fitting out a complete village in Saudi Arabia, we can supply everything from the beds and bed linen to the teaspoons and even the pictures on the walls. We pack your entire order into one huge 'igloo' specially designed to fit in the hold of a plane."

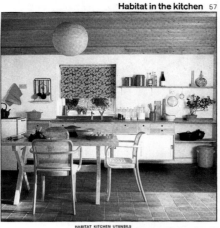

Habitat in the kitchen 57

HABITAT KITCHEN UTENSILS

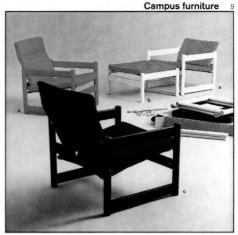

Campus furniture 9

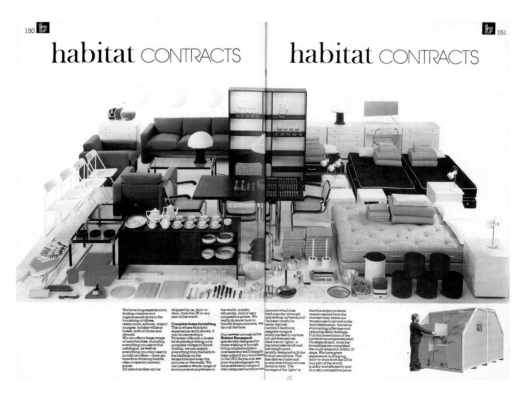

habitat CONTRACTS 150 habitat CONTRACTS 151

BELOW

A brilliant picture that demonstrates the instant availability of all our products direct from the store. We were inviting Habitat customers to buy whatever they liked, from sofas and chairs to saucepans and bed linen, and take it all away with them on that very same day.

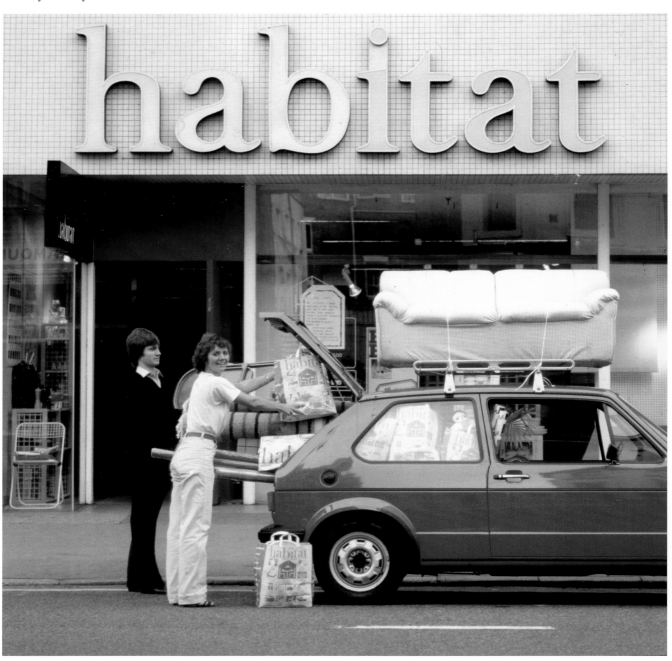

Unfortunately for us, somebody had already registered the name Habitat in USA when we came to open our first store there in 1977. Although they were not using the name at the time, they wanted a small fortune to allow us to. It was panic time – we were already installing the shop in the Citicorp Center, Manhattan, and had the products ready, but negotiations went on right to the last minute. In the end, we decided to obliterate the Habitat logo in USA – we were grinding the name off hundreds of products the night before we opened. This illustration was the back cover of the first US catalogue in August 1977, illustrated by Roy Ellsworth.

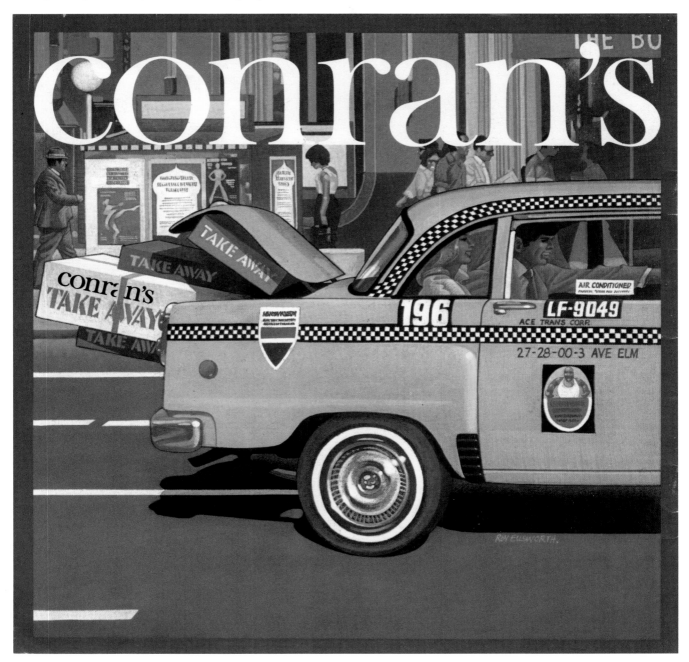

"I still feel nostalgic when I remember the early buying meetings at Habitat – they were some of the most creative and stimulating times of my life."

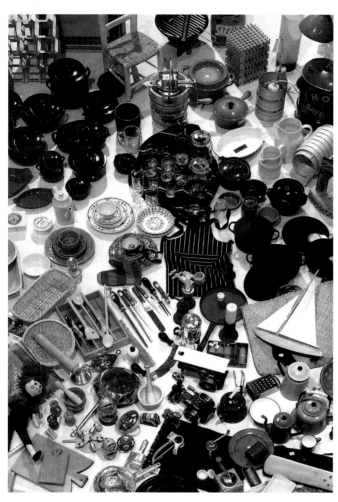

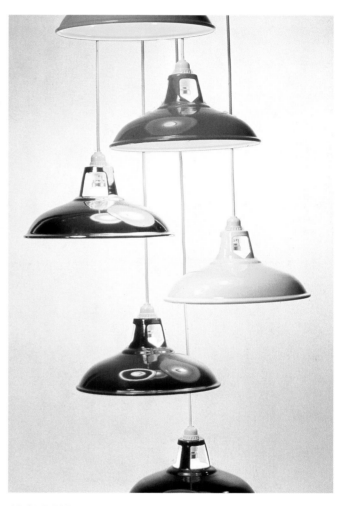

OPPOSITE

A room set featuring our "Theta" furniture for the 1973 catalogue, photographed by Roger Stowell and art directed and designed entirely by Stafford Cliff. We used the first-floor living room in my house in Regent's Park Terrace, London, for the set. My wife Caroline and our two young children, Sophie and Ned, obliged as the models.

ABOVE LEFT

This charming scattering of Habitat products from 1965 captures the spirit and joy of the merchandizing meetings that were held at the time. Some of the items here are absolute classics – the Anglepoise lamp, garlic press, cafetiere (French press), Sabatier knives and enamelware – and are as popular today as they were then.

ABOVE RIGHT

We picked up these enamelled steel, industrial light fittings extremely cheaply, simply because they were normally used only in factories and workshops. They were supplied in grey but we transformed them by spraying them in bright primary colours. Introduced into the Habitat range at £1.46 each, they gave us a great margin.

BELOW

In 1965 the Habitat design team was given the Spices Award for outstanding design work by D&AD, the global association that promotes excellence in design and advertising, and this iconic broadsheet poster received particular praise. The original logo had been designed by Dudley Bootes-Johns in the studio; Virginia Clive-Smith designed the shopping bag.

BELOW RIGHT

This is one of a series of advertisements from the late 1960s that appeared in the increasingly popular Sunday colour supplements. It was a lovely piece of advertising, designed and produced in the studio by Helen Senior.

OPPOSITE

In 1978, when we had stores in France, Belgium and USA, as well as across the UK, the Habitat shopping bag was redesigned by Stafford Cliff. In the style of a children's primer, it reflected the spread of the brand and the scope of its product range, and kept the one-colour line-printing technique we used when Habitat first opened. Interestingly, our early bags were the same heavy-duty sacks used

for bulk potatoes, which we stitched at the bottom with blue tape. Robust and functional, they reflected perfectly Habitat's inventive use of inexpensive materials and suppliers. In all my businesses, I have fought many battles with accountants looking to save money by using plastic bags, rather than good-quality paper ones. I have always believed that this would undermine the ethos and message of our stores.

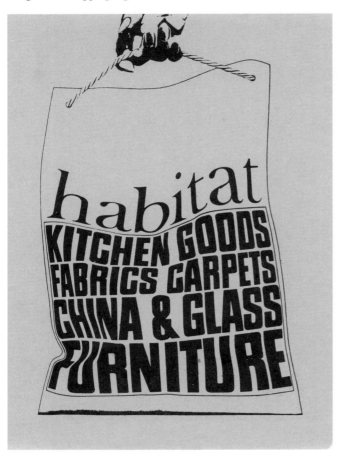

"I think I was perceived as very serious when I was a young designer in the 1950s, unlike Habitat, which became particularly well known for its good humour, wit and charm."

habitat

Great Britain	France	Belgique, België	America
china la vaisselle vaatwerk	kitchen la cuisine keuken	glass la verrerie glaswerk	lighting l'éclairage verlichting
bedrooms les chambres kamers	deliveries la livraison levering	shopping le libre-service vrij van dienst	comfort le confort komfort
windows les fenêtres vensters	tableware le couvert bestek	colour les couleurs kleuren	advice les conseils raadgevingen
casserole la cuisson het bakken	walls les murs muren	seating les sièges zetels	presents les cadeaux geschenken

STOREHOUSE PLC

REPORT AND ACCOUNTS

Fashion & Retail

I have always believed that shopping should be an enjoyable occasion, rather than a necessary one, and that it is always much more fun fulfilling your desires than your needs. Although I may be best known for the home furnishings stores Habitat and The Conran Shop, my design groups have been responsible for the creation, design and identity of hundreds of shops and retail chains in the UK and beyond.

OPPOSITE
In 1987 Peter Bentley illustrated the front and back covers of the Storehouse report and accounts, transforming an otherwise dreary piece of corporate literature into a lively evocation of a shopping centre.

I realized very early on that the most successful retailers always had vision and passion, but when I was a young designer there was an overriding lack of design awareness. Shops tended to be built to a uniform kit of parts with no element of individuality – a characteristic I have always tried to infuse into all my design businesses.

My first real shop design and build was Mary Quant's second Bazaar in Knightsbridge in 1957 (see page 70). It was a terrific job because, after the success of her first shop on King's Road, Mary was really in the limelight. She used Bazaar as a venue for fashion shows, so it was more than just a store and always buzzing with models, photographers, journalists and hedonists – and, I dare say, a few customers scattered about the place, too. We put in a mezzanine with a theatrical, open staircase for the models to walk down and then parade the length of the shop. We hung bales of fabric that Mary used in her work on the walls, which looked fantastic but actually cost very little. The place had tremendous energy and excitement. To entice people inside, we made the entire shopfront out of glass so you could see through the whole store, which really wasn't the way things were normally done then. Like much of my early design work, it was all created on a thrifty budget with a very much roll-your-sleeves-up, hands-on approach. I think I was even doing the vacuuming the night before the shop opened to a tremendous fanfare with lots of press coverage, which definitely raised my profile.

One of my earliest retailing inspirations was Woollands, a department store next door to Harvey Nichols in Knightsbridge. It was run by Martin Moss, a terrific man who understood the value of design and embraced modern retailing. I don't think he was given enough credit for his creative vision. Martin gave me a great job when he asked me to create a ground-floor boutique and a "shop within a shop" at Woollands. It was called the 21 Shop and was aimed at the youth market, selling the work of the young fashion designers of the moment: Sally Tuffin and Marion Foale, Ossie Clark, Mary Quant and Gerald McCann. This was the early Sixties and London was really starting to swing, so it was a fantastic project. The Temperance Seven played on the opening night and there were queues around the block until midnight. The 21 Shop really felt like a phenomenon and I went on to design the menswear shop there.

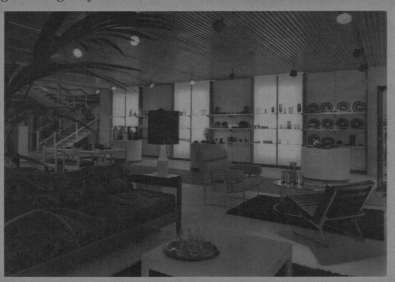

BELOW
An interior we designed for the department store Joshua Taylor, in Cambridge. The project, led by Rodney Fitch, involved converting a garage next to the main store into an interiors section. The light woods that we used and the white-painted walls and ceilings gave the space a clean, modern feel. Our simple design treatment allowed the store's merchandise to be the focus of attention.

I am particularly proud of my involvement in the creation of the retail chain NEXT – a new idea in womenswear and retailing. In 1982 I was chairman of Hepworths menswear in Leeds and we decided to buy a chain of 80 rainwear shops called Kendalls. At the time, I thought it was a dreary business but from a property perspective it was just what we were looking for. At Hepworths, we had long been wanting to get into womenswear and here was the opportunity to do it. Those stores would become NEXT.

The managing director was a very good retailer called Trevor Morgan. George Davies was the merchandizing director and his wife, Liz, the lead designer. Our design group did the interiors, which were simple, with natural wood finishes and plenty of space for walking around and looking at the clothes. It was very comfortable, unlike most clothing

stores at the time, which tended to have a high density of stock on the shop floor. The clothes were simple, elegant and looked very different from anything else on the market. The clever thing was that they also looked up-market but were very well priced, which was certainly down to George and Liz.

Coming up with a name for the chain was a challenge – Trevor wanted us to find an anagram of Kendalls so we could reuse the lettering already on the shopfronts. John Stephenson – in charge of the design side of the project – came up with NEXT, which we loved but the Hepworths directors in Leeds absolutely hated.

We then both commissioned market research, a practice I have always mistrusted and believe can only tell you what people already like and not what they might like. Their research said it was a terrible name that would be a hindrance to the business, while ours said it was modern and attractive. It was a bloody good name, as it turns out, and a bloody good business, too. NEXT was an immediate success and remains so to this day.

Not all my adventures in the world of retailing have been successful, and probably none was more frustrating to me than my experience with British Home Stores. In 1986 we merged Habitat, Mothercare, Richard Shops, Blazer and Heal's with BHS and formed Storehouse. This merger gave us a business with a turnover of £1 billion and outlets under our control in every high street. Here was our chance to introduce intelligently designed products to the mass market, but I don't think there was ever a bigger missed opportunity.

I had seen Gap in USA doing incredibly well and thought if we could get a clothing collection in a similar style and introduce some of their philosophy into our business, then this was THE opportunity to do something special. We were competing with M&S at the time, so I believed we needed clothes that were simple and cheap but also fresh, which I didn't think BHS was.

So I asked the BHS buyers to go to America and study Gap, but afterwards they still manufactured their usual clothing, which I thought was too dreary. This is what happens with a merger, I thought! I then set up a small fashion design group to work with the BHS buyers to try to get my message across but the head of this design group reported that she just could not make any headway with them. At this point, I felt so frustrated at the political logjam that I decided to leave Storehouse as Chairman and sold my shares.

I think the difference between a takeover and a merger is best demonstrated by looking at our earlier experiences with Mothercare. In the 1960s Selim Zilkha, who was a retailing genius, and Jimmy Goldsmith had identified their own gap in the market for clothes and products for pregnant women, babies and young children. By the late 1970s Selim and I had become great friends, but his merchandise had begun to attract much criticism. He came to me and suggested I buy Mothercare.

Selim felt that the company needed somebody who could redesign the merchandise as well as modernize the interiors of the stores. So we sat down to sort out a deal and talk through the changes that would be needed for Mothercare to become more appealing to young women.

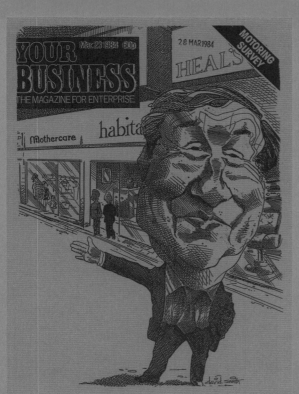

ABOVE
As our retail empire expanded, the Conran name became big business, and the press was always keen to employ a caricature artist to illustrate a story about me. Despite never having sat for a caricature, I imagine I may have been caricatured more than most living Englishmen. The artist on this occasion was David Smith.

The job was practically a blank slate and it involved an incredible amount of work because we changed everything. Mothercare felt quite clinical, so for our theme we took sweet-pea colours, which were gentle and charming, and used them to define the look of not only the stores and the merchandise, but also the graphics, packaging and catalogues. My son Sebastian played a major role in remaking all the hard goods, and I particularly remember a terrific baby buggy (stroller) he designed. He was absolutely in his element and did some amazing, innovative work.

A little more than a year after the takeover, we presented our design work for Mothercare and its new look to the press and city analysts. It was a great moment and worked dramatically well, with the share price and – more importantly – sales soaring. I think that we managed to demonstrate to the retail world how crucial design could be on the British high street.

I would very much like to finish this discussion with one of my absolutely favourite stores: The Conran Shop. While Habitat had done an almost perfect job making plain and simple furniture and accessories available to the wider public, it seemed to me that the Habitat generation was probably ready to move on and shop somewhere different. When I saw IKEA coming – Habitat, I suppose, had cleared the ground for them – I thought this might be a big problem for us. I also felt that Habitat had become so large that the time had come to create a more personal home furnishings store, where I could get back to being involved in all the details and decision making. In 1973 I opened the first branch of The Conran Shop on the site of the original Habitat store in Fulham Road, Chelsea.

I always thought that The Conran Shop should be filled with the very best and most interesting products and furniture from the four corners of the world, all chosen with the same pair of eyes. I wanted it to be a shop that sold more classic, modern furniture for a more informed generation, such as Eames, Bauhaus originals and Mies van der Rohe, alongside fine glassware and china, beautiful handmade rugs and the very best French cookware. It was my dream store – modern, exciting and sophisticated, taking me right back to when Habitat first opened in 1964.

Reflecting on my career in retailing, I believe I can be allowed to feel a little pride in what we achieved in the hundreds of shops with which we have been involved, as either the founders or the designers. I am proud of how our work at Mary Quant's Bazaar, the 21 Shop, NEXT and Mothercare, among others, and yes, even BHS, has influenced the fashion world. In homewares and furnishings, I think we made good-quality products available and more accessible to a very wide audience.

Perhaps we have always had the very useful ability to read the mood of the time and put new and surprising things in front of people in beautiful, well-considered environments. Most of all, I think we have demonstrated very clearly that intelligent, modern design has a place on every high street.

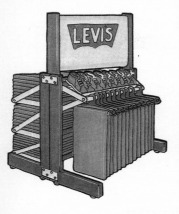

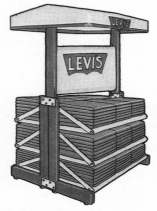

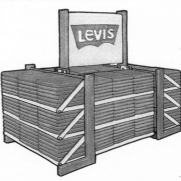

The visuals on this page show part of our work for Levi's on the Continent.

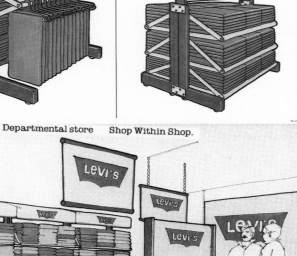

Departmental store Shop Within Shop.

The system is designed to be suitable for any outlet from the sophisticated department store, to a small jeans specialist shop.

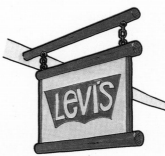

Hanging store-sign.

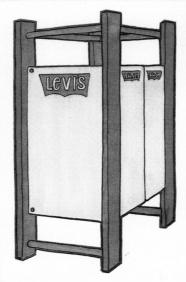

Free standing changing cubicle.

Distinctive 'A' Board, for pavement or in-store use, to take changing graphic messages.

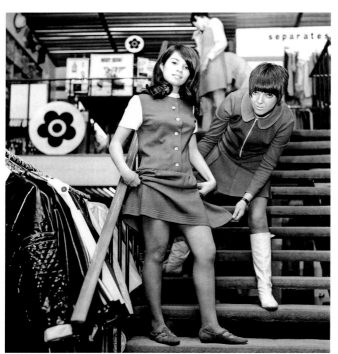

THIS PAGE
Mary Quant asked me to design her second Bazaar fashion store, in Knightsbridge, which opened in 1957. The open staircase leading to the mezzanine was a focal point and allowed the models to make a grand entrance wearing Mary's latest clothes. I think our design helped to give the store its special atmosphere and character. Although Habitat wasn't a fashion store, I think there were strong links between it and Bazaar. We were also saying to our customers: "Come to our store, here are our ideas and our products. Take them away with you today."

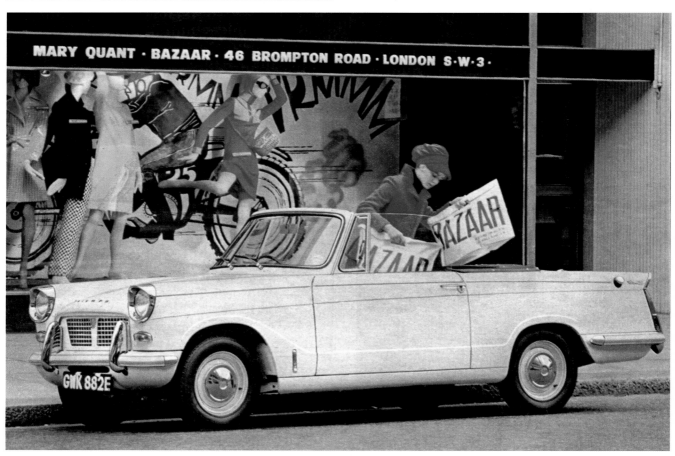

Uniqlo, Japan's big retail
success story of the 1990s, chose
Conran and Partners to design
its first flagship stores in the
UK and create a manual to
roll out the concept nationwide.
Our designs focused on Uniqlo's
functional and economic design
ethic, reflecting its core
principles of simplicity, quality
and value, and retaining the
trademark utilitarian nature of
its Japanese stores. The project
was led by Richard Doone and
Robert Malcolm.

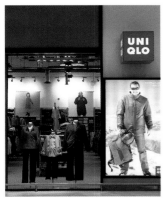

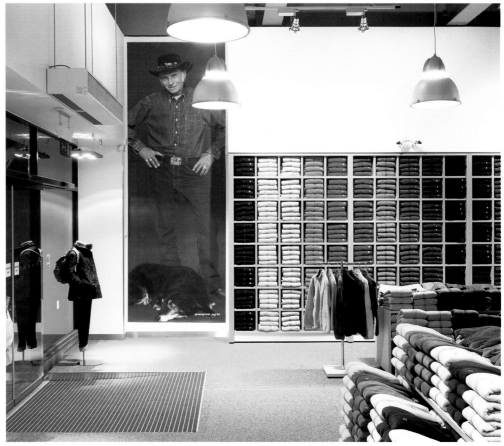

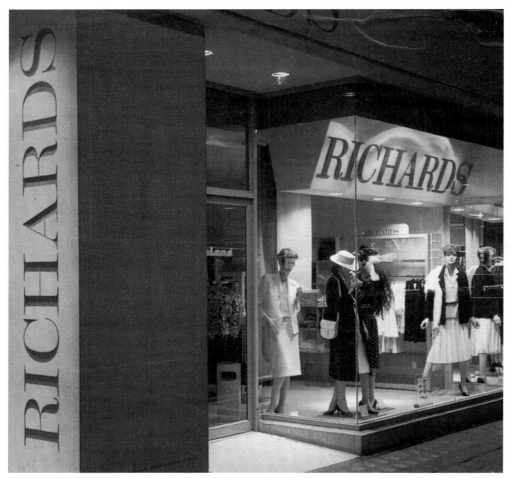

LEFT

Grasping the importance of good design to its survival on a fiercely competitive high street, Richard Shops asked us to completely refurbish its chain of 130 stores. We shortened the name to Richards, redesigned the shop windows to create a more aspirational image, and modernized the fixtures and fittings, thereby comprehensively creating the brand.

OPPOSITE

We were asked to design the logo and the broadsheet catalogue for Clothesline, which was launching a simple, primary-colour range of clothing for men, women and children, predating Gap by nearly a decade, to be sold through mail order. This early 1970s catalogue, with its cut-out hook at the top, was photographed by Roger Stowell, and Kaffe Fassett, who was a model at the time, appeared in many of the pictures. The products were selected and sourced by Ann Boyd, formerly creative director at Ralph Lauren. Clothesline was very successful but we didn't pursue the connection further, which I regret to this day – it is much easier to make a good margin on clothes!

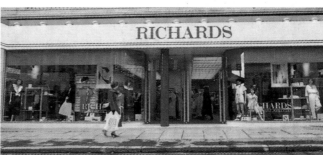

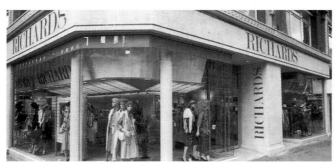

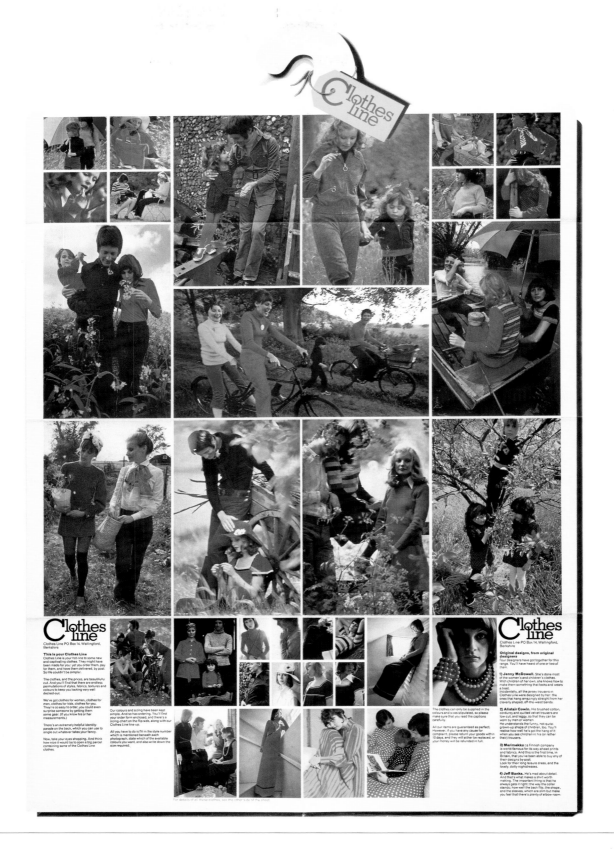

Clothes Line

Clothes Line PO Box 14, Wallingford, Berkshire

This is your Clothes Line

Clothes Line is your hot-line to some new and captivating clothes. They might have been made for you: yet you order them, pay for them, and have them delivered, by post. So life couldn't be simpler.

The clothes, and the prices, are beautifully cut. And you'll find that there are endless permutations of styles, fabrics, textures and colours to keep you looking very well decked-out.

We've got clothes for women, clothes for men, clothes for kids, clothes for you. They're so easy to order, you could even surprise someone by getting them some gear. (If you know his or her measurements.)

There's an extremely helpful identity-parade on the back, which you can use to single out whatever takes your fancy.

Now, take your eyes shopping. And think how nice it would be to open a big parcel containing some of the Clothes Line clothes.

Our colours and sizing have been kept simple. And so has ordering. You'll find your order form enclosed, and there's a sizing-chart on the flip side, along with our Clothes Line line-up.

All you have to do is fill in the style number which is mentioned beneath each photograph, state which of the available colours you want, and also write down the size required.

The clothes can only be supplied in the colours and sizes stipulated, so please make sure that you read the captions carefully.

All our items are guaranteed as perfect. However, if you have any cause for complaint, please return your goods within 10 days, and they will either be replaced, or your money will be refunded in full.

Clothes Line

Clothes Line PO Box 14, Wallingford, Berkshire

Original designs, from original designers

Your designers have got together for this range. You'll have heard of one or two of them.

1) Jenny McDowell. She's done most of the women's and children's clothes. With children of her own, she knows how to make them something that looks and wears a treat.
Incidentally, all the jersey trousers in Clothes Line were designed by her: the ones that hang amazingly straight from her cleverly shaped, off-the-waist bands.

2) Alistair Cowin. His brushed cotton, corduroy and quilted velvet trousers are low-cut, and leggy, so that they can be worn by men or women.
He understands the funny, not-quite-grown-up shape of children, too. You'll realise how well he's got the hang of it when you see children in his (or rather their) trousers.

3) Marimekko : a Finnish company is world-famous for its way-ahead prints and fabrics. And this is the first time, in Britain, that you've been able to buy any of their designs by post.
Look for their long leisure dress, and the lovely, dotty nightdresses.

4) Jeff Banks. He's mad about detail. And that's what makes a shirt worth making. The important thing is that he always gets it right: the way the collar stands; how well the back fits; the shape, and the sleeves, which are slim but make you feel that there's plenty of elbow-room.

For details of all these clothes, see the other side of the sheet.

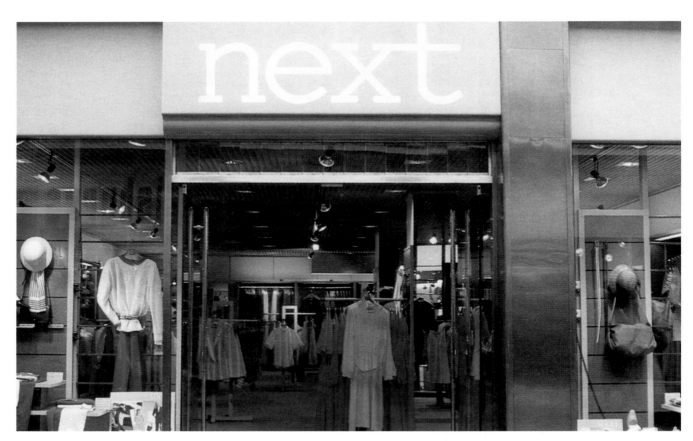

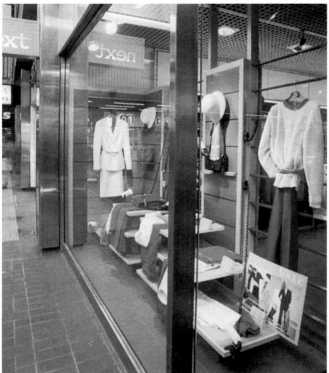

"At the time we opened NEXT, the concept of the shops, their design and the products were quite unlike anything else you could find on the market."

OPPOSITE

In 1982 the Conran Design Group created NEXT for Hepworths, pioneering a new approach to women's fashion retailing. Our work spanned the entire project as we positioned the brand above mass-market chains and below high-fashion specialists. Flo Bayley designed the logo and graphic identity, which remains highly recognizable to this day. The uncluttered, fresh interior of the store matched the simple but elegant clothes to make well-coordinated fashion and accessories available on the high street. The whole project took just six months.

THIS PAGE

The brief we were given in 1970 by the women's fashion chain Wallis was to "create a new concept for a major fashion retailer intended for implementation throughout the UK". It was to include the redesign and detailing of merchandise systems, displays, shopfront, finishes, service desk, signage, lighting and fitting rooms, for initial implementation at a store of 232sq m (2,500sq ft) in Kingston upon Thames, just outside London. Stafford Cliff designed the logo, which, apart from a slight redraw, is still the same today – surely quite an achievement in the retail world.

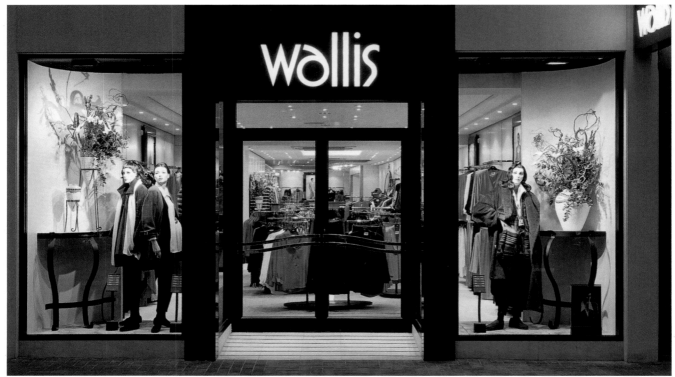

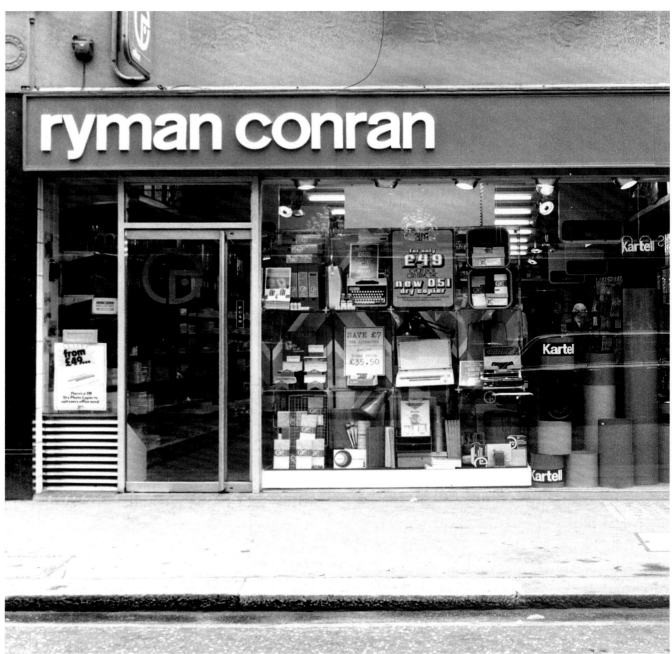

In 1976 Conran Associates were commissioned by Ryman to develop a complete retailing package, to include shop interiors, corporate identity and packaging. We introduced a basic concept of dual merchandizing – domestic and office – into a number of Ryman stores, in order to retain their success with commercial products and improve their domestic market. "Ryman at Home" featured green graphics, while "Ryman at Work" had red.

OVERLEAF

Marks and Spencer asked us to design a new retail environment for their Home department. With Jenny Jones leading our design team, we took the strengths of traditional high-street shopping and introduced the convenience and immediacy of technology and online retailing, to enhance the overall experience. The new designs, first revealed at the flagship M&S store in Cheshire Oaks (pictured), were rolled out nationwide throughout 2012 and 2013.

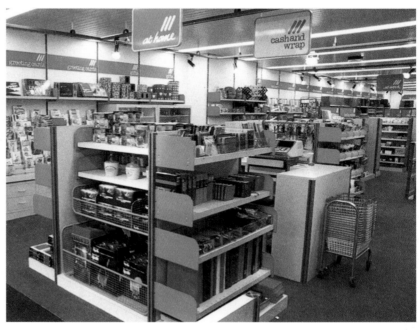

THIS PAGE & OPPOSITE
I suppose The Conran Shop was born out of frustration at having to reject products because they were perceived as too expensive or unusual for the typical Habitat customer. We expanded more modestly than with Habitat but have stores in London, Paris and Japan. My son Jasper recently did the most remarkable job refreshing and rejuvenating the whole company, from the branding to the shop floor. Jeff Hedding and Giuseppe di Stefano, who head up the Fulham Road and Marylebone stores respectively, are two of the most brilliant store managers I have come across. The wonderful Betsy Smith's window displays never fail to raise a smile and the spirits.

www.conranshop.co.uk

"With The Conran Shop, we were able to be more imaginative and bold in our decisions and could sell the work of established designers, while encouraging new design talent and young craftsmen."

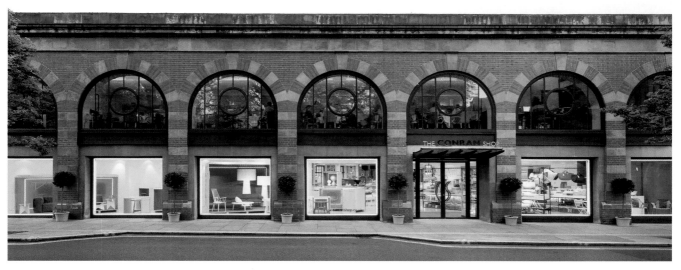

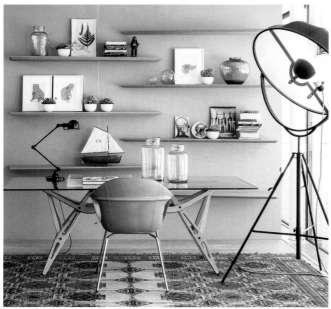

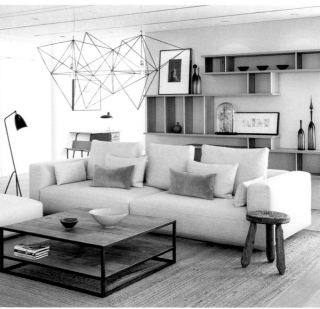

"The Conran Shop logo wasn't actually the brand. It was more to do with how the personality and ethos of the business was projected through other customer touch points. The Conran Shop bag, for this reason, became a classic, lasting some 25 years, and embodied the spirit of the shop: bold, progressive, innovative, surprising, unexpected." —James Pyott

RIGHT

This paper shopping bag for The Conran Shop was created by James Pyott in 1992 and became a classic. The design, based on James's love of the work of Sonia Delaunay and the Bauhaus, simply said that if you think this is stylish, then you are as well. As a young designer at Conran during the 1990s, Pyott recalls, "It was a place of innovation, larger than life personalities, style gurus and an atmosphere which was both intimidating and intoxicatingly exciting. As designers, we were all taught to believe in our ability and trust our intuition in whatever we designed – that vision would ultimately lead to the best marketing solution and create the best possible design. Our instinct was that the work we were doing had to be timeless and eventually become a design classic. Packaging was a great area where, as a designer, you can add aspiration to amazing products. It was all very democratic and discussions on colour could be challenging and last several hours, but we would all finally agree and when applied would look amazing."

OPPOSITE

Over the years, we have worked for practically every major brand on the UK high street.

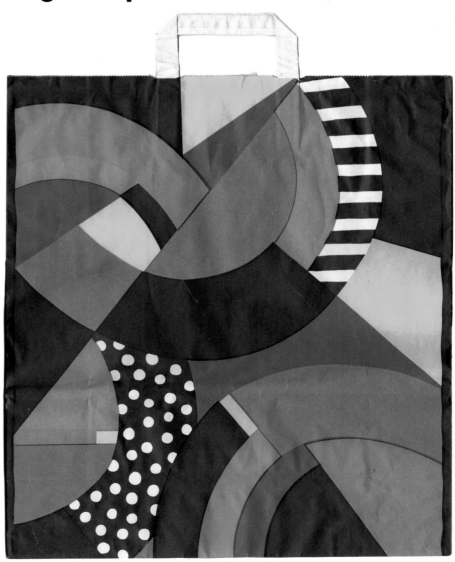

HABITAT	HEAL'S	MOTHERCARE	CONRAN	NEXT	WALLIS	BHS
VIRGIN	RYMAN	TOPSHOP	C&A	PRISUNIC	BURTON	LEVI'S
MARY QUANT	21 SHOP AT WOOLLANDS	BOOTS	DESIGN CENTRE, HAYMARKET	HEMA	WOOLWORTHS	HACHETTE
HEPWORTH	HOUSE OF FRASER	SIMPSON	LILLYWHITES	7-ELEVEN	ICELAND	SAINSBURY'S
UNIQLO	MARKS & SPENCER	MISS SELFRIDGE	RICHARDS	VISION EXPRESS	SWAROVSKI	BARCLAYS
LANVIN	LANCÔME	DIXONS	THE GAP	GRANADA	GEORGES	PATISSERIE VALERIE
MONOPRIX	TESCO	WH SMITH	BLAZER	BLACK + DECKER	SONY	PENGUIN BOOKS
DE BIJENKORF	SEPHORA	PETER DOMINIC	MACY'S	AUGUSTUS BARNETT	PETER ROBINSON	JC PENNEY

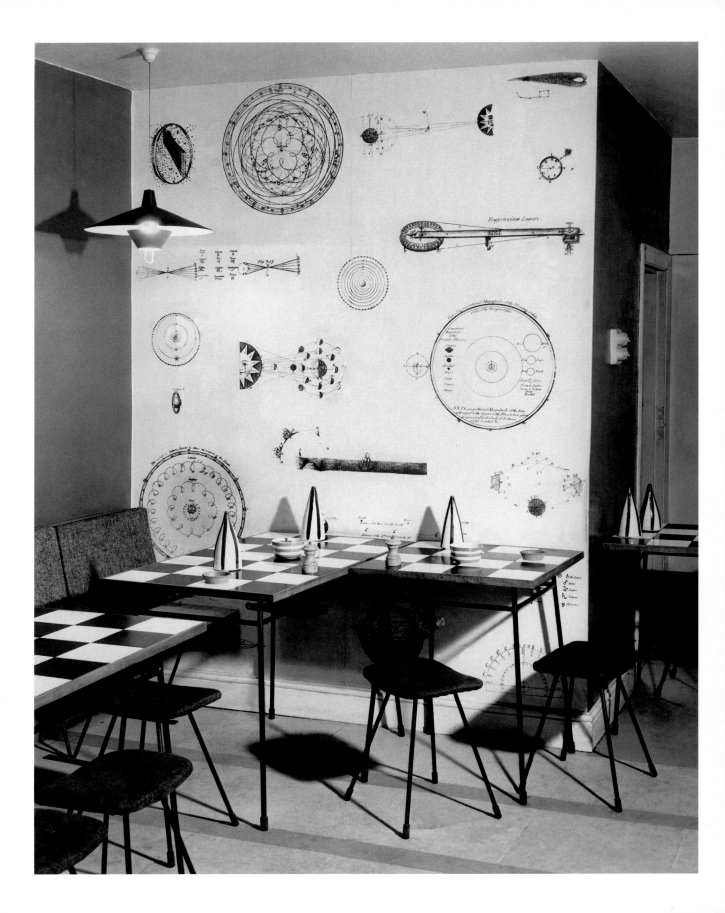

Food & Restaurants

It is incredibly satisfying to be able to offer people the complete experience that a restaurant can bring: good food and drink, comfort, friendly service, conviviality, entertainment and companionship, all under one well-designed roof.

OPPOSITE
The interior of The Orrery restaurant in 1954, which I still think looks rather charming. I designed and built the furniture myself: black-and-white tiled tables and wood-topped metal stools. On the walls and hanging from the ceiling were enlarged prints of orreries – clockwork models of the solar system. It is amazing how many people from the creative industries have said to me over the years: "I first met you when you owned your coffee bar on the King's Road."

The starting point for all the design schemes in my restaurants has always been to try to conjure up a particular mood or atmosphere from memories of past pleasures, as well as creating a character that reflects both the location and the architectural qualities of the space. From my first café in the 1950s to my latest restaurant more than 60 years later, this philosophy has always served me – and, I hope, our customers – exceptionally well.

My love affair with food and restaurants began with my first visit to France in 1953, when I took a road trip with my friend Michael Wickham, his wife Cynthia, and my girlfriend of the time. Throughout our journey south in his Lagonda, I was amazed by the quality of everyday French life. I shall never forget the abundance of sunshine and colour, the wonderful produce in the markets and the spirit of generosity. We ate cheap, delicious food in roadside cafés, or *routiers*, washed down with carafes of rough red wine. It was all in such stark contrast to the unrelenting drabness of Britain at the time, with its post-war rationing. I was entirely seduced by what seemed like paradise, and so began my unrelenting love affair with France and its food, wine and culture.

It seemed to me that here was an obvious business opportunity. Along with my friend Ivan Storey, I made the decision to open a café. Neither of us had the first clue about the business of running one but our conviction was strong, and it wasn't the last time in my life that I made a decision based entirely on instinct.

I took myself off to Paris to learn the trade, working initially as a washer-up in the rather squalid kitchen of La Méditerranée. This was my introduction to the business of running restaurants, and my subsequent promotion to vegetable boy augured well.

Our café, the Soup Kitchen, opened in 1953 in Covent Garden. It was a simple design: black-and-white-floor, furniture that I designed and made myself, a red wall for a bit of cheap drama and large black-and-white prints from *Le Livre de Cuisine* by Jules Gouffé. The atmosphere was young and contemporary, which was appropriate for the first Conran-designed restaurant.

Our food offering was equally simple: four different soups ladled into Cornishware bowls, baguettes (we had found a baker in London who could make them), served with cheddar cheese, and an apple flan, made by Mrs Truman from Bethnal Green. We also had the second Gaggia machine in London – we had driven all the way to Turin in a dilapidated Riley to collect it ourselves. We had a success on our hands, having made the connection that eating out was not just about sustenance but a pleasure based on ambience, food and good service.

My next step in the restaurant business was a café at the bottom of King's Road, called The Orrery. It was in a small Georgian building with a walled garden to the rear. This time, I employed a chef, an eccentric Polish man who slept on top of the ice-cream freezer at night – I think he rather liked the way it quivered. Again, the menu was simple, although we had moved on from soup to omelettes – two eggs don't cost much. The chef found it quite easy to prepare the ingredients in the morning, and around his stove he would have his various fillings and a nice bunch of herbs at the ready. He was able to make an omelette in 50 seconds.

BELOW
The exterior of The Orrery, with some rather odd-looking young lads hanging about outside. It was at "the other end of King's Road" in a little Georgian building, which, at first, I thought might make a good furniture showroom. The front was all glass but I put in an eye-level frieze featuring pictures by my sister Priscilla, who was a photography student at the time.

OPPOSITE
Before the smoking ban, each of our restaurants had its own signature ashtray. A great deal of time and effort went in to designing them, and they became highly covetable – and instantly stealable – design objects. In our first ten years, as many as 18,000 Quaglino's ashtrays found their way into people's handbags and pockets, but we always knew they would – it was a very expensive but effective marketing tool.

The design of The Orrery (see page 84) was pretty much a smartened-up version of the Soup Kitchen, decorated with large prints of oversized orreries – clockwork models of the solar system – on the walls and even the ceiling. The café was very popular with architects, designers and artists. We had got our timing just right and really connected with London's emerging creative scene.

The big attraction for me was the walled garden at the back of the café, for which the landlord assumed we would have no use. It was a particularly good summer the year we opened and we had built a barbecue. The garden was packed from April to October. You need a bit of luck in the restaurant business, and ours was being one of the few restaurants in London with an outdoor space during an unusually fine British summer. Our Polish chef was so thrilled to be out there running the barbecue – he was a performer and loved the theatre of it all, which also delighted the customers.

My furniture making was taking off, though, and I needed to devote more time and cash to that, so I sold The Orrery to the boyfriend of one of the waitresses. I wasn't to return to the restaurant business for another 15 years but my fascination with it didn't go away. I wrote books on food and articles for newspapers. I designed one or two restaurants for other people and ate out all the time at the best – and the worst – restaurants, creating a database of ideas in my head that I could draw on in later years.

By 1971, my design group had grown considerably and we moved into a building in Neal Street, Covent Garden. There was an empty space on the ground floor and basement that was just too tempting to ignore – the opportunity to get back into restaurants was calling.

I negotiated a lease and started what I would call my first proper restaurant – it had a wine list, waiters, several chefs and menus with artwork by a young chap called David Hockney, whose agent at the time was John Kasmin, a very good friend who was hugely involved in setting up the Neal Street Restaurant. A few years later, we opened the Garage Gallery together on nearby Earlham Street, along with fellow directors Anthony Caro, David Hockney and Richard Smith.

My sister Priscilla and brother-in-law Antonio Carluccio took over the Neal Street Restaurant in 1981 and ran it until 2012, when the landlord embarked on a redevelopment plan. In an often fickle industry, I was very proud that our original design lasted so well, demonstrating that good design doesn't need to be constantly restyled or follow fads and fashions.

My next big step up the gastronomic ladder came with the acquisition of Michelin House in Chelsea. It was perfectly obvious this building needed a restaurant and it absolutely had to be called Bibendum, after the original Michelin Man. Eventually we got permission to use the name and we designed the restaurant to reflect Monsieur Bibendum's curvy, ebullient form – he became our symbol on the china, glasses, tables and chairs, ashtrays and menus. We restored many of the mosaics and plaques that featured Monsieur Bibendum and, of course, he jovially presides over diners from all angles in those beautiful stained-glass windows.

We went through a big process of finding the right chef and, finally, thank God, came across Simon Hopkinson. I first remember Simon when he was the much-praised chef of a small restaurant called Hilaire in Old Brompton Road. His cooking was exceptional

BELOW
The jovial image of Monsieur Bibendum is the heart and soul of our restaurant because he oozes charm, humour and friendliness. I don't think there is an icon anywhere in the world that remains so recognizable and relevant. If we get another chance on earth, then please let me return as Monsieur Bibendum.

and we hit it off immediately, discovering that we shared many favourite dishes from around the world. We also agreed that the simplicity and quality of the ingredients were what really mattered – I think Simon called it "gutsy French bourgeois brasserie cooking". The success of Bibendum was a turning point in my restaurant career and gave me the confidence to open more and more restaurants.

Having just sold Habitat and extricated myself from Storehouse, I was feeling bruised from the aftermath of what had become an increasingly messy affair. But I had serious money to invest and a fierce desire to start a new and exciting chapter in my career. From the early 1990s onwards, my involvement in developing restaurants became increasingly intense and it was one of the most exciting and creatively stimulating times in my life. It leaves me breathless thinking about what we achieved – we certainly kept our designers busy.

There was the Butler's Wharf gastrodome, Quaglino's, Mezzo, Bluebird, which celebrated the wonderful achievements of racing driver Malcolm Campbell, Coq d'Argent, Sartoria (all in London), Alcazar (in Paris) and Guastavino's (in New York). My God, we were brave; not least because we weren't rolling out a chain but creating individual restaurants with their own personalities and character. There was no blueprint; some were small and intimate, others were inspired by the big brasseries I remembered from my early trips to Paris. Later, we opened Almeida in Islington, Plateau in Canary Wharf and Skylon in the Royal Festival Hall. By 2006 we owned around 50 restaurants, cafés and bars, which I felt was too many, as I wasn't getting the same personal pleasure out of the involvement.

Des Gunewardena, the chief executive of Conran Holdings, had been with me through that incredible time and was a very steady influence. He was vastly ambitious to build a really large company, so he secured financial backing to buy it from me. Now they run a highly successful global restaurant and hotel business by the name of D&D London, and very good luck to them.

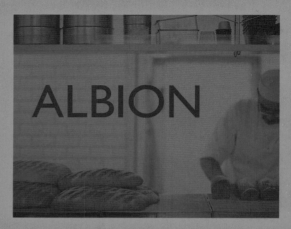

By contrast, I was eager to have a very small collection of restaurants that I loved and where I knew everybody who worked there. I could then get back to the simple pleasure I had experienced when setting up restaurants in the early days. So, here we are, up and running again, with a new company called Prescott & Conran. It is headed by Peter Prescott, one of the best professionals in the restaurant industry I have ever had the pleasure to work with.

We have a small collection of ventures, including a hotel in Shoreditch called Boundary, which incorporates a restaurant, a rooftop bar and grill, and the Albion café. There is Lutyens on Fleet Street, another Albion café on the South Bank, near Tate Modern, and we have just opened a bistro, restaurant, shop and café called Les Deux Salons. It is only three doors down from the site of the original Soup Kitchen, so in many ways you could say that I have come full circle.

So, that is my career in restaurants on a plate. The newspapers like a landmark and have recently claimed the opening of the German Gymnasium, between London's King's Cross and St Pancras stations, to be the 100th "Conran-designed" restaurant in the world – I suspect they have been slightly creative with their numbers. They are right, though, that my love affair with food and restaurants has given me immense pleasure and I very much hope this will continue for a little while yet.

BELOW
The Albion café in Shoreditch has been one of our most popular ventures, serving breakfast early in the morning right through to late suppers in the evening. Customers are an interesting mix of local residents, workers in the creative industries, tourists and even ravers heading home after a long night of partying.

OPPOSITE
We developed our branding on matchboxes, which diners could use in the restaurant or take away with them. They were more than just matchboxes, though. They also sold the restaurant's brand and identity, which was very important because we never saw Conran restaurants as a chain – they were a collection of individual businesses, each with its own personality and character.

SARTORIA
bar ristorante

20 SAVILE ROW LONDON W1X 1AE
TEL 0171 534 7000 FAX 0171 534 7070

AURORA

THE BUTLE
Chop

FISHMARKET
EST 2000

BLUE
PRINT
CAFE

CAN
DEL

GE
CLUB

GASTAVINO'S

301·129

BLUEBIRD

COQ d'ARGENT

ARCTIC CIRCLE
10
11
10

ORRERY

A
Z

TER

Z
BAR

miyabi

GEORGE

LE PONT DE LA TOUR

ON THE RIVER BY TOWER BRIDGE

BIBENDUM

NUNC EST BIBENDUM

Dried Peas and Beans

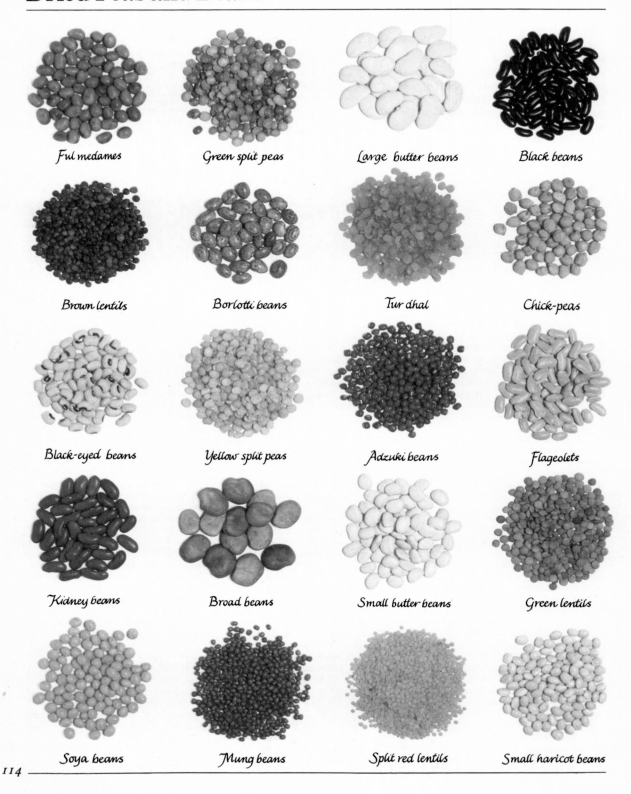

Ful medames

Green split peas

Large butter beans

Black beans

Brown lentils

Borlotti beans

Tur dhal

Chick-peas

Black-eyed beans

Yellow split peas

Adzuki beans

Flageolets

Kidney beans

Broad beans

Small butter beans

Green lentils

Soya beans

Mung beans

Split red lentils

Small haricot beans

OPPOSITE

A page from *The Conran Cookbook*, which was published in 1986 in collaboration with my then wife Caroline and chef Simon Hopkinson, with art direction by Helen Lewis. Far more than just a recipe book, it encompassed everything to take the home cook from the marketplace to the kitchen and, finally, to the plate. As well as detailed information about ingredients, raw materials and kitchen equipment, there were more than 400 recipes, the vast majority written by Caroline and Simon.

ABOVE

Classic Conran, the first book I did with Vicki in 2003, contains all the food and recipes we enjoy ourselves. It was pretty much an homage to the Barton Court kitchen and kitchen garden, both of which have given me so much pleasure over the years. The book was art directed by Leslie Harrington and beautifully photographed by Georgia Glynn Smith, while Bill Baker, the late, great wine merchant, brought wine, laughter and vitality. We miss him dearly.

COOKS DIARY

HOT & SPICY

WRITTEN BY
Cynthia Wickham

ILLUSTRATED
BY
CHLOE CHEESE

**52 PAGES OF RECIPES.
DAILY SPACE FOR NOTES
AND APPOINTMENTS**

OPPOSITE & ABOVE
Throughout the 1960s and 1970s, we produced a yearly *Habitat Cook's Diary*, which became very popular and covetable. It was a way of extending our ideas of food and cooking beyond the shop floor and into the homes, kitchens and everyday lives of our customers. We invited a variety of writers and illustrators to create them, ensuring that each one had its own individual style. They came with 52 pages of recipes and also space for notes and appointments on every day.

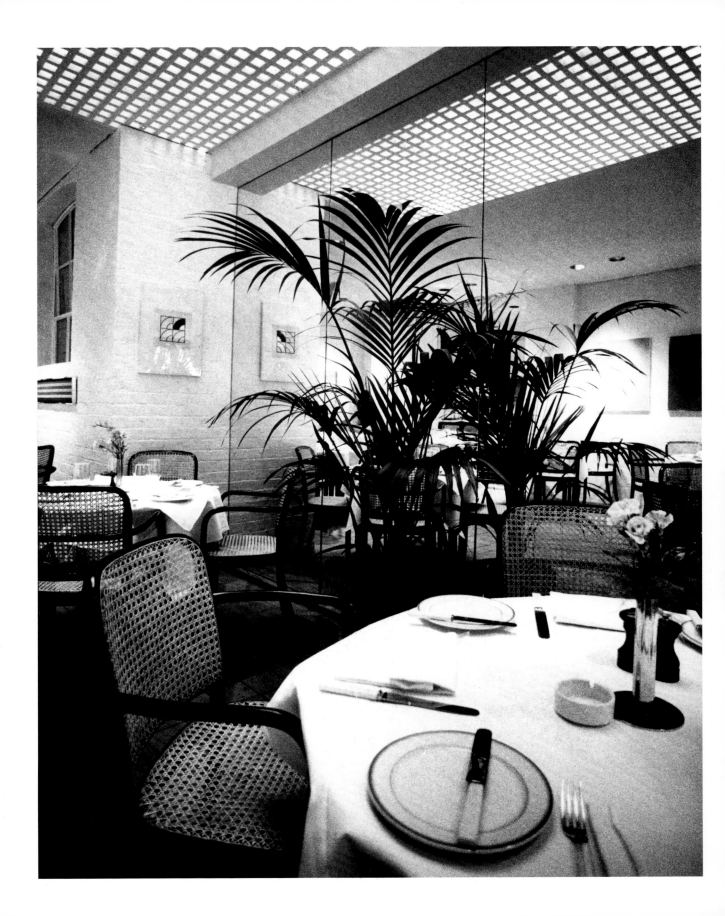

The Neal Street Restaurant in Covent Garden, which we converted in 1971 from the empty space on the ground floor of our offices. Two dear friends, Oliver Gregory and the art dealer John Kasmin, were my partners in the project. I worked closely with Oliver on the design of the interior which had white walls and ceilings throughout, while John provided the art from his gallery stock. Charles Campbell was the manager, a great bon viveur and a larger-than-life character.

BELOW

This charming menu card was designed by a young artist called David Hockney. The framed original hung on the wall behind the cash desk for the entire life of the restaurant. On it he had handwritten his favourite meal: beluga caviar, watercress soup, Chateaubriand with béarnaise sauce, cheese and crème brûlée.

"I am very proud that the original design for the Neal Street Restaurant lasted so well, demonstrating that good design doesn't need to be constantly restyled or follow fads and fashions."

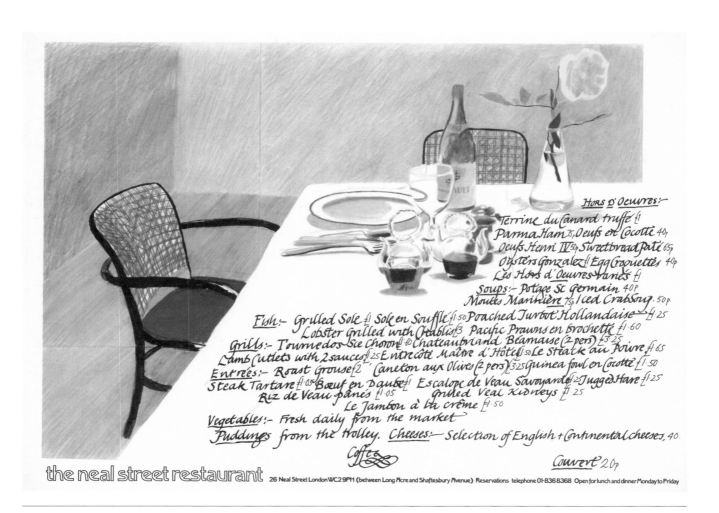

THIS PAGE

I wrote the first *Eat London* book in 2007 with Peter Prescott, who knows more about the restaurant scene in London than anybody else I know. The book, designed by David Hawkins at Untitled and specially photographed by Lisa Linder, included a clever book cover which unfolded into a map of London. The hardest part of the process is keeping up with the London restaurant scene itself. Such are the changes that we are currently working on a third edition to bring it up to date.

OPPOSITE

Sold in Habitat, *London à la carte* and *Paris à la carte* were a collection of reprinted facsimile menus from 30 of the top city restaurants. The wraparound cover on this edition was illustrated by Jane Bark.

OVERLEAF

In 1963 the Conran Design Group took on a huge project for Gillette, creating interiors for three canteens at its factory complex in London. We used partitions to break up the spaces, and introduced a continuous panel of graphic screen prints, based on sports, along the rather utilitarian walls, to brighten them up. We designed the tables and chairs, and I specified the design for all the plates, cutlery (flatware) and cups. The canteens were a great success and we were asked to create additional interiors – for a theatre and cinema complex and the company's main entrance hall.

London
à la carte

30 Facsimile menus, from leading
London restaurants with recipes
and details of how to find them and
what to expect when you do.

ABOVE

The Grade I-listed Royal Exchange building in London is arranged around a dramatic, covered courtyard. Led by Tim Bowder-Ridger, the team designed the Grand Café & Bar in 2003, inspired by elegant, early 20th-century Viennese coffee houses. Dominating the central courtyard is a gleaming pewter island bar, made by Benchmark, surrounded by café-style seating. The cocktail bar on the mezzanine floor has a relaxed, club-room atmosphere.

OPPOSITE

Opened in 2016, the German Gymnasium in London's King's Cross was referred to by the press as the 100th "Conran-designed" restaurant. Tina Norden led the design team from Conran and Partners for this D&D London restaurant, transforming the Grade II-listed building into a unique destination. It is a wonderful space, where the theatrical design really does lift the spirits – I see it as a Bauhaus version of a European grand café.

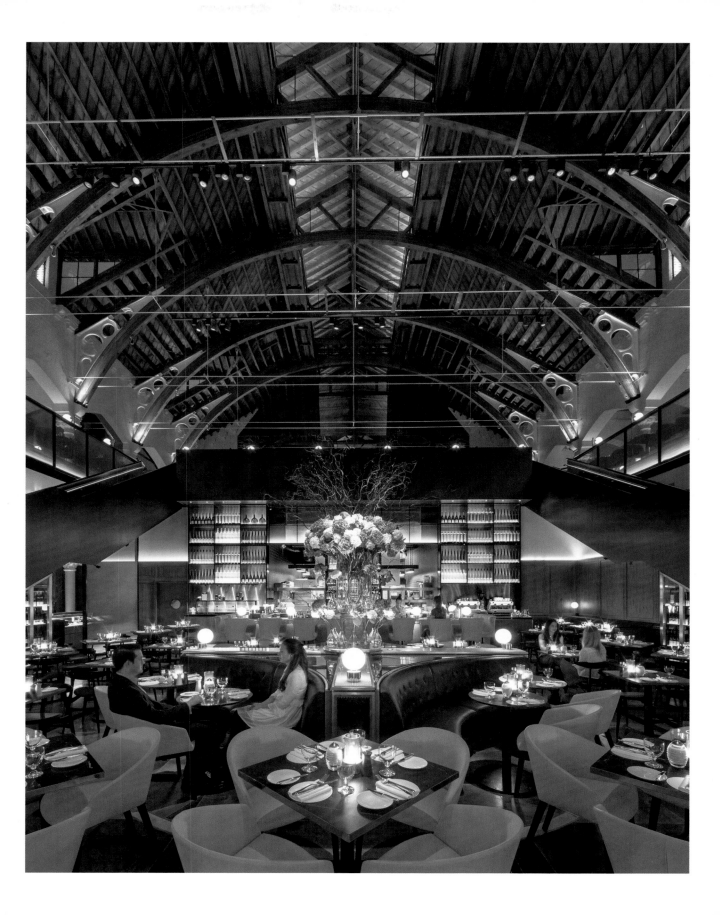

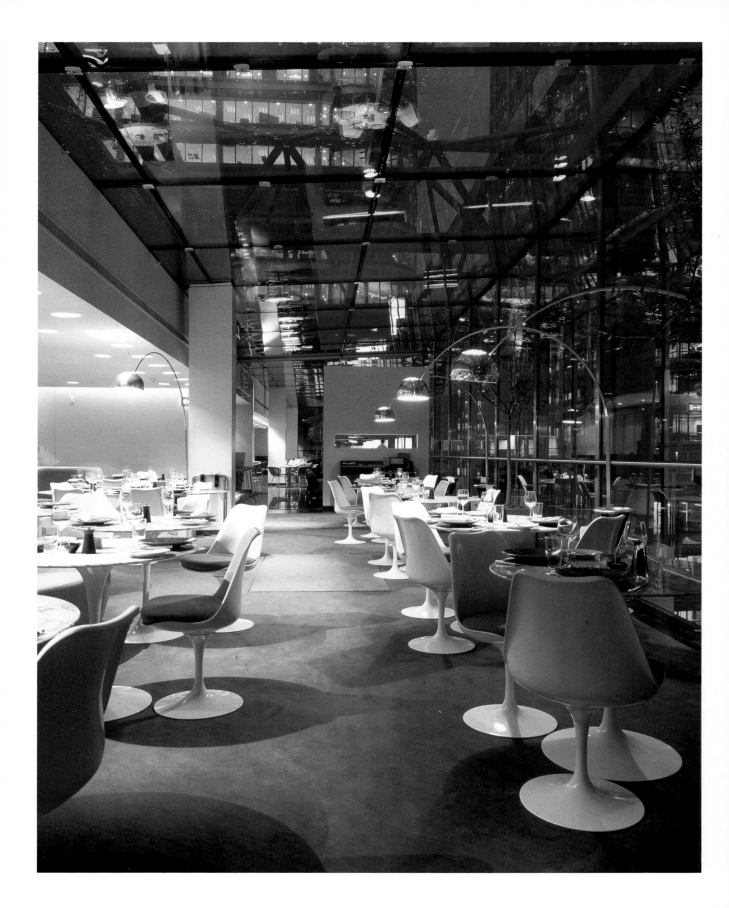

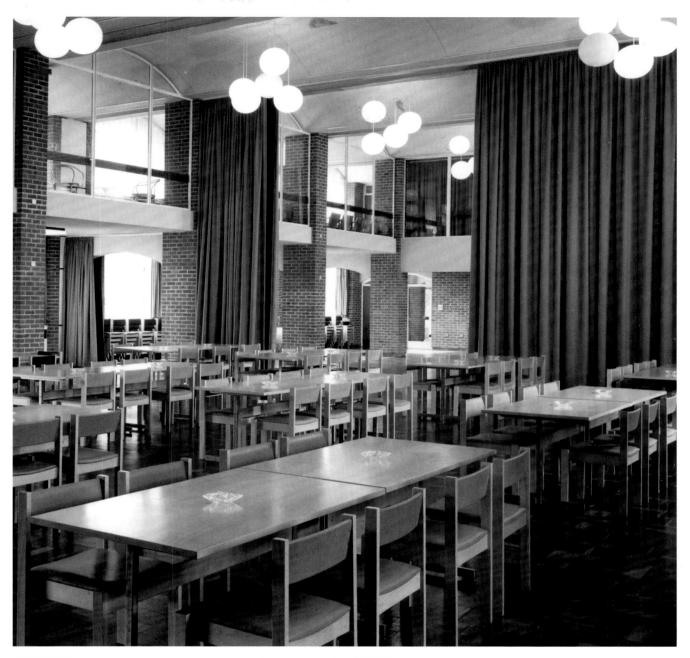

OPPOSITE

We opened Plateau on the fourth floor of Canada Place in London's Canary Wharf in 2003. The design team, led by Tina Ellis, created a breathtaking modern restaurant. The selection of design classics, such as the Saarinen Tulip table and chairs and Castiglioni Arco floor lamps, set the tone for our interpretation of mid-century design. By day, the restaurant is flooded with natural light. By night, the ambience acquires a mellow, metropolitan feel, with the dramatic backdrop of office towers glowing with lights.

ABOVE

The architecture practice Basil Spence & Partners were commissioned to build Falmer House for the University of Sussex in 1959. In 1962 Conran Furniture was invited to design the tables and chairs for the building's dining hall. This was one of a number of commissions we undertook at the time for universities, schools and libraries.

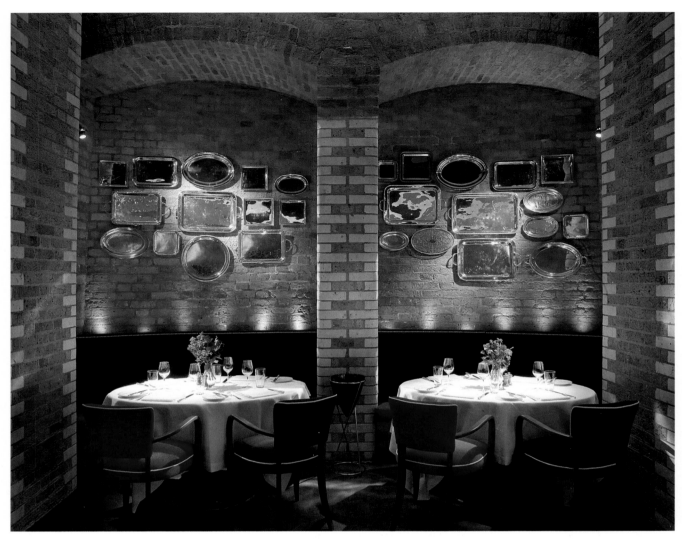

ABOVE

Opened in 2008, Boundary in Shoreditch was my first personal restaurant venture since Bibendum in 1987. Located in the basement of a Victorian former warehouse, the space is a dream, with high ceilings and six arched brick recesses, each of which is lined with silver trays that reflect a beautiful quality of light into the restaurant.

OPPOSITE

We worked for Harveys of Bristol in the early 1960s. They had a very entrepreneurial Chairman called George McWatters, and he asked for my ideas about how Harveys could benefit from design. At that time, selling alcohol was considered dangerous and not something that you should shout about, but we demonstrated to Harveys that they should be proud of their product. We created a design manual that was to be given to every member of staff, detailing how their labelling of wines, sherries and ports, as well as stationery, vehicles, shopping bags and shopfronts should look. The design of the labels for the "Bristol" range of sherries was a subtle adaptation of earlier labelling. We also designed a restaurant for Harveys in the wonderful wine cellars beneath their offices in Bristol. George was very enthusiastic about this extensive and costly project, as he fully understood how important the Harveys brand was to the future of his company. Even though some details of our design have altered slightly, I'm glad to say that the original elements remain exactly the same and are instantly recognizable; Harveys have remained successful and strong, because good design lasts.

"Boundary was a very personal venture, from finding the site to finalizing all the design details, which included choosing the art and designing the garden."

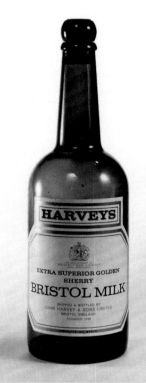

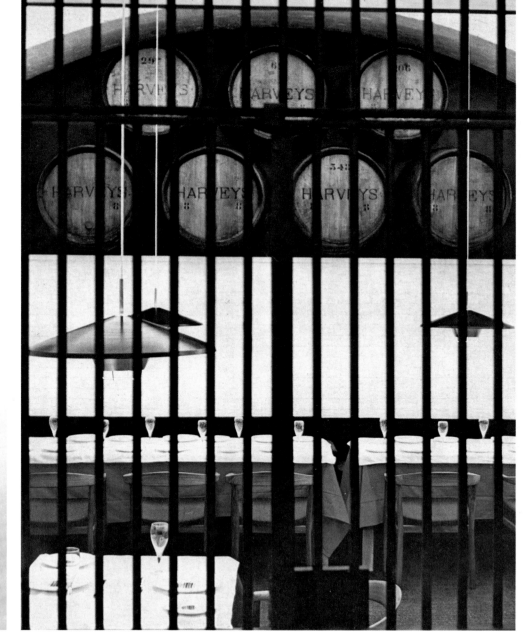

This magnificent mural painted by Timna Woollard dominates the interior of Cantina del Ponte in Butler's Wharf. It is a glorious kaleidoscope, capturing the hustle and bustle of a Mediterranean kitchen. It was a perfect backdrop for this restaurant and, I hope, a constant inspiration for the chefs.

RIGHT

New Yorkers' jaws dropped when they entered Guastavino's majestic space, with its ceramic columns and spectacular tiled ceiling. I am astounded at how brave we were to take on this vast and daunting project in a space that had defeated many a New York entrepreneur. Much credit must go to the team involved, including Joel Kissin, Richard Doone, James Soane and Tina Ellis. Thomas Heatherwick's golden, laminated wood sculpture dominates the back wall – incredibly, he built it while nursing a broken arm.

BELOW

For this vast project, we designed absolutely everything, down to the finest detail, including these zinc pinch pots for sea salt and black pepper.

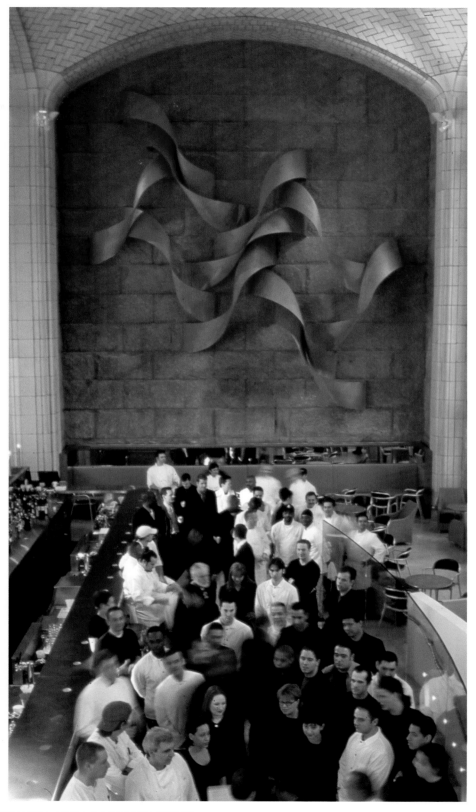

"... Quaglino's, Mezzo, Bluebird, Coq d'Argent, Sartoria, Alcazar, Guastavino's – my God, we were brave, not least because we were creating individual restaurants with their own personalities."

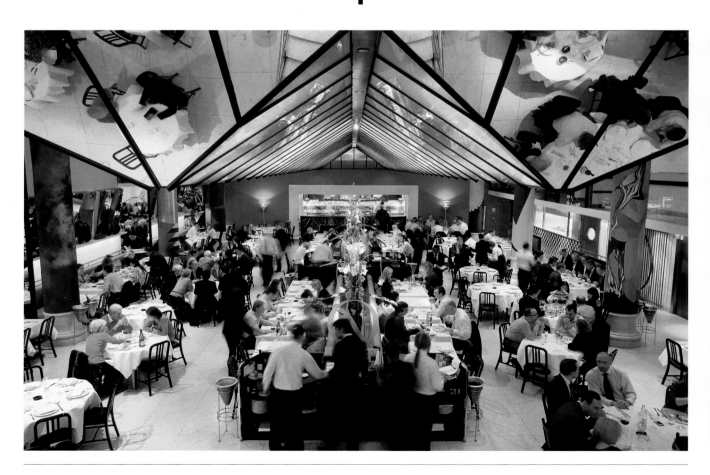

We opened Quaglino's on Valentine's Day in 1993. I always felt there was room in London for the equivalent of a great Parisian brasserie, and this was our opportunity. The sweeping staircase was perfect for making a spectacular entrance, and this view out over the restaurant from the top was breathtaking. The iconic "Q" provided a graphic that ran through the whole restaurant, including on the classic Quaglino's ashtray.

THIS PAGE

Ever since my stint of washing dishes and peeling vegetables in Paris in the mid-1950s, I longed to have a restaurant there. We opened Alcazar on rue Mazarine in 1998. This is a view of the restaurant from the main bar. The centrepiece of the double-height space was a flower vase by Michael Savage. Every two days it was lowered and filled with a fresh display. In the evenings, black and white silent films from the 1930s were projected on to the curved white balcony. The graphics and classic AZ symbol were inspired by the printing blocks used when the site still functioned as a printworks.

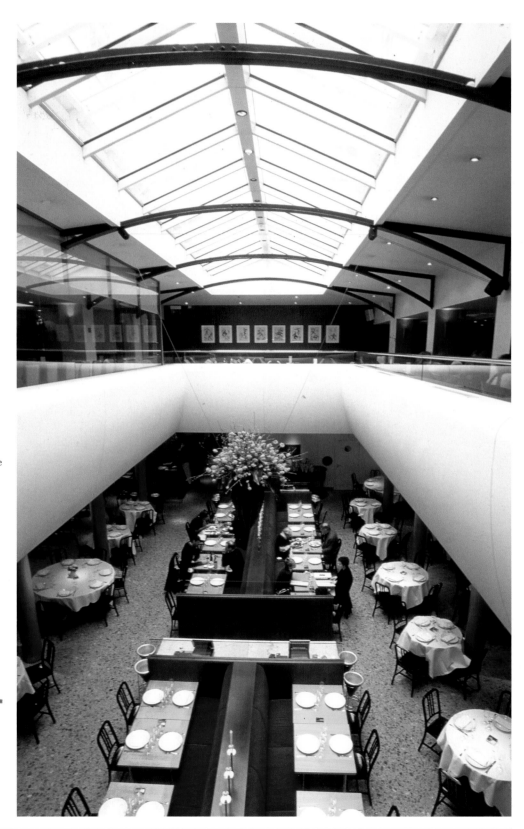

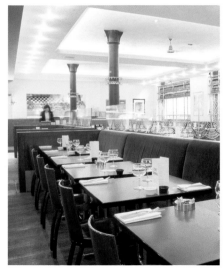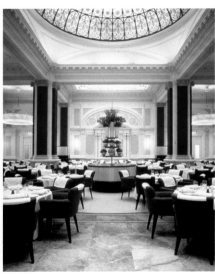
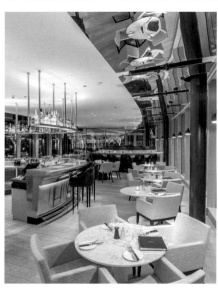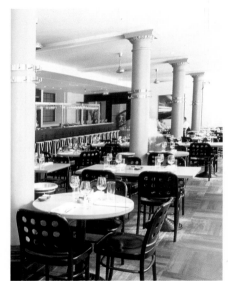
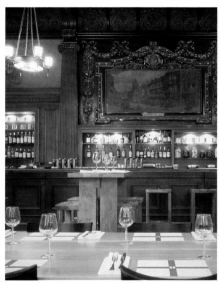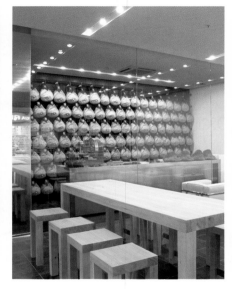

TOP ROW, FROM LEFT
The Zinc Bar & Grill in London's Heddon Street had an easy, democratic buzz; we modernized the popular Viennese institution Café Drechsler, which first opened in 1919; the very grand Aurora restaurant in the Great Eastern Hotel, London, with its magnificent stained-glass dome.

MIDDLE ROW, FROM LEFT
Crafthouse restaurant in Leeds, designed by Conran and Partners for D&D London; Terminus in the Great Eastern Hotel, based on old-fashioned bustling bars and brasseries that should be a part of every train station; the café at Bluebird, a bright, simple design for simple, classic food and drink.

BOTTOM ROW, FROM LEFT
George, a classic British restaurant in the Great Eastern Hotel in London's Liverpool Street; we designed the interiors and graphics for a pioneering prosciutto bar in Parma, Italy, called Rosa dell' Angelo; the great Lenbach bar and restaurant in Munich, Germany.

BELOW
Tina Norden from Conran and Partners was the lead designer of The Angler restaurant on the seventh floor of South Place Hotel, near Moorgate, London. It has a long, elegant dining room, with an excellent menu and floor-to-ceiling windows overlooking the City of London.

"The starting point for all my restaurant designs has been to try to conjure up a particular mood or atmosphere from memories of past pleasures."

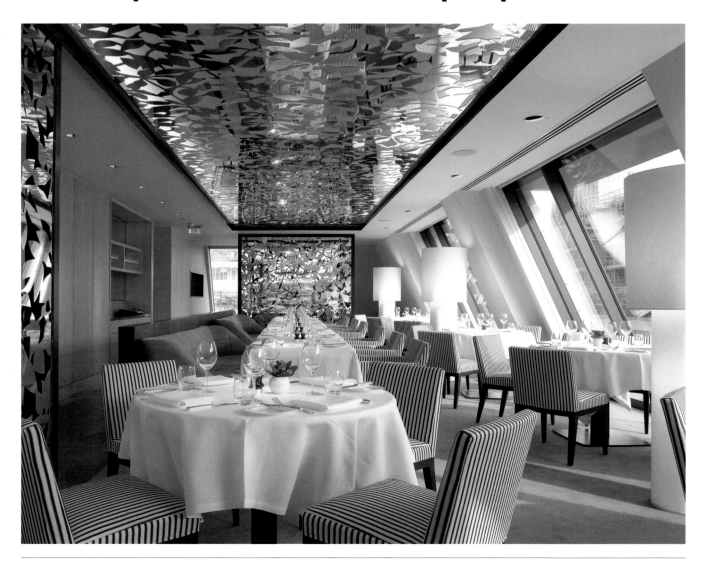

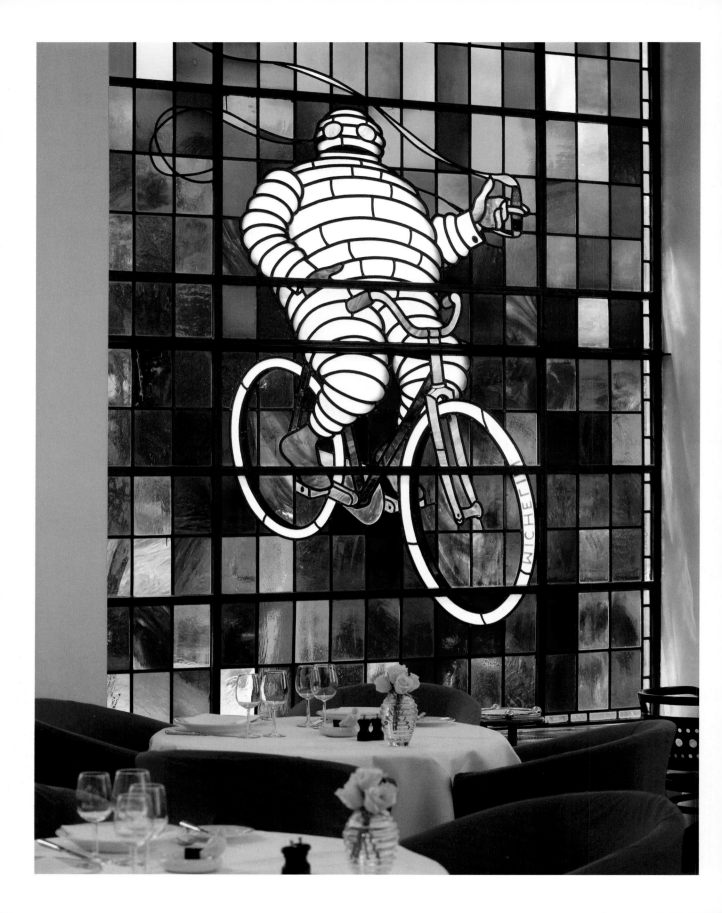

BIBENDUM

NUNC EST BIBENDUM

MENU

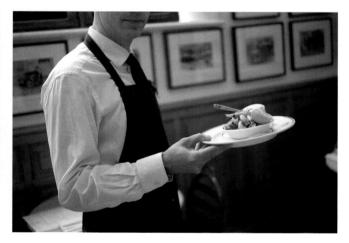

OPPOSITE

The success of Bibendum, which opened in 1987, gave me some much-needed cheer at a difficult time in my life. The jovial spirit of Monsieur Bibendum, with his trademark cigar, overlooks diners in one of a series of three stunning stained-glass windows.

THIS PAGE

Bottom left: The small Oyster Bar at Bibendum evokes the spirit of the cafés of Paris. The chairs, tables and bar all mirror Monsier Bibendum's curvaceous form.
Top left: Enjoying a coffee and an illicit cigar with Simon Hopkinson and Matthew Harris who were

both in the kitchen when Bibendum opened in 1987 – Simon as head chef and Matthew as chef de partie.
Top right: The cover of the large-format launch menu featured a design that was based on the mosaics in the forecourt of Michelin House. Inside the menu, Simon Hopkinson listed

many of his trademark dishes, which included 23 starters (appetizers). Among the main courses (entrées), there was poulet de Bresse rôti, sauté de veau aux morilles, and grilled rabbit with mustard sauce.
Bottom right: A bowl of fresh prawns from the Oyster Bar.

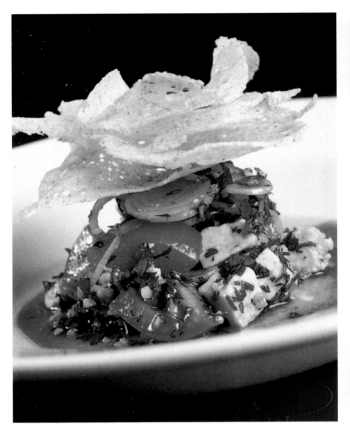
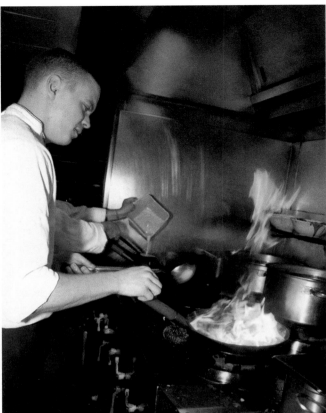
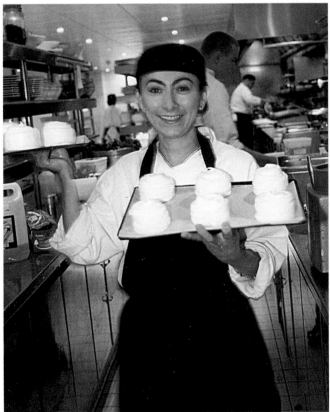
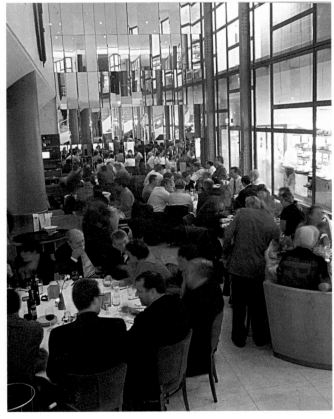

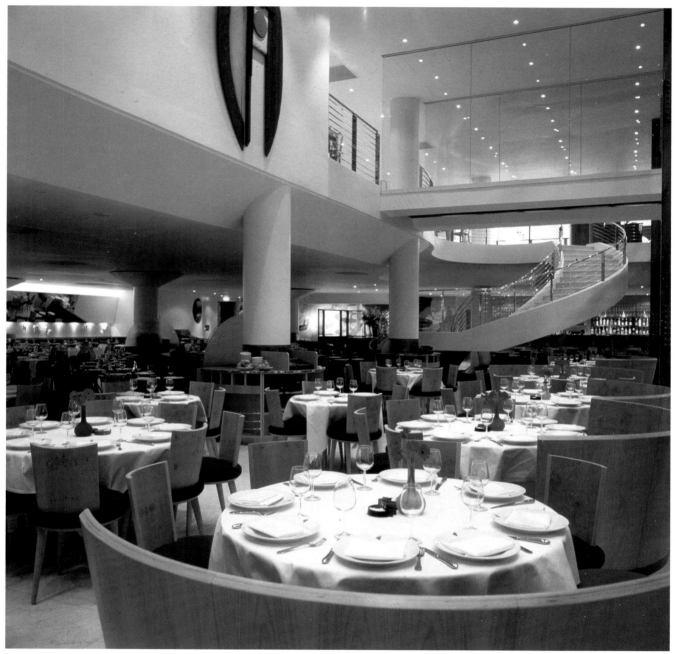

RIGHT

Lutyens opened in the summer of 2009 on Fleet Street, London, and was my second venture with Prescott & Conran. It is located in the former Reuters building, designed by the celebrated architect Sir Edwin Lutyens. Ticker tape, symbolic of the news agency, is referenced in the marble mosaic floor.

BELOW RIGHT

Lutyens is a classic Conran interior and a modern version of the much-loved Parisian brasserie in design. A light and airy space, with large windows at both ends of the room, it retains several architectural details, including the building's original structural steel columns. I love the bespoke porcelain lights by Jason Boatswain.

BELOW

The graphic identity for Lutyens was created by Jonathan Peek, who was inspired by the illustrations of William Nicholson. It features three, perfectly snooty French waiters.

OPPOSITE

The cocktail bar at Lutyens includes a large bar, sofas, armchairs, cosy corners and alcoves, as well as sublime drinks mixed by excellent bartenders.

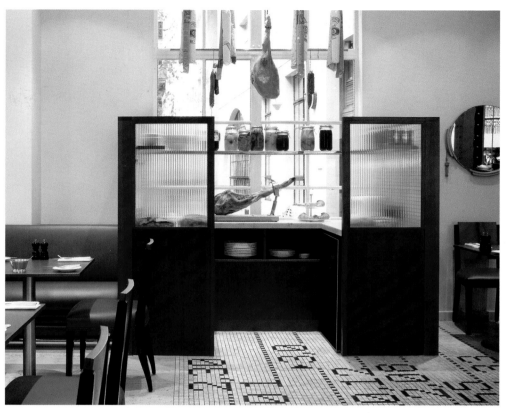

LUTYENS
RESTAURANT, BAR & CELLAR ROOMS

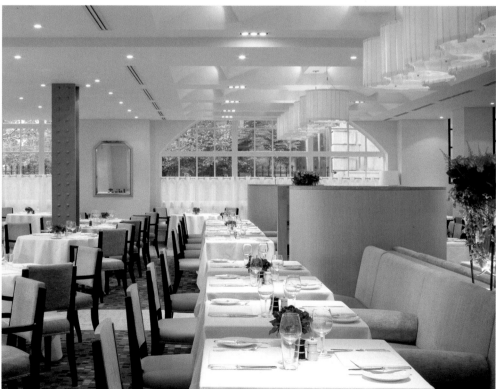

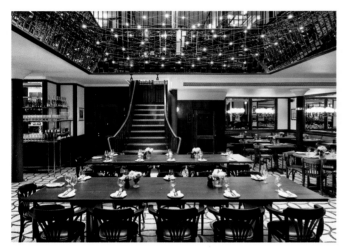

LES DEUX SALONS

BISTRO & RESTAURANT

THIS PAGE

In 2014 we bought Les Deux Salons on William IV Street in London, just three doors down from the original Soup Kitchen, where my restaurant career began. As part of the interior makeover, we covered the columns in the upstairs restaurant in a mirror mosaic which, when spotlit, adds an atmosphere of glamour. We reopened the space, using the same name, in 2015.

"A triumph ... Creating an authentic Parisian brasserie has been the holy grail for Conran – but he has done it, and gone one better." — Fay Maschler, restaurant critic

THIS PAGE
The centrepiece of the double-height atrium is a lightweight, ethereal chandelier by the Belgian lighting designer Jan Pauwels. It mirrors the recurrent pattern of the floor and glazed ceiling panels. I collaborated on the interiors with Isabelle Chatel de Brancion of SPIN Architecture. We changed very little in terms of layout but we did introduce a little *souffle de vie* – a freshness and a little gentle modernizing – to create a classic, Parisian, multipurpose restaurant.

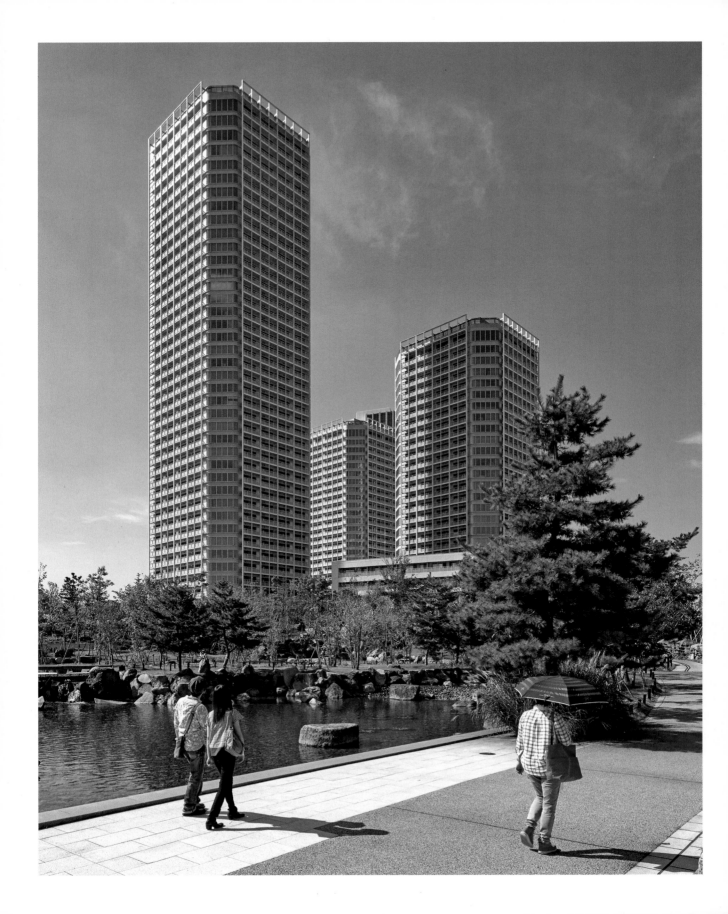

Architecture & Interiors

Throughout my career, architecture and design have come together to create some of the most satisfying projects I have worked on. These have tended to be large in size – airports, museums, houses, restaurants, bars, hotels, shopping centres, office spaces and gardens – and have challenged us to use the full scale of our abilities across the design process, to have a positive influence on the way people live.

OPPOSITE
The Conran name is highly regarded in Japan. Known for our calm and sensitive approach to design, we have been working there for more than 20 years on diverse projects, both big and small, urban and rural. This picture by Edmund Sumner is of the residential quarter of our extensive work on the Futako Tamagawa Rise project in Tokyo, which was brilliantly led by Richard Doone.

It always seems to me that the Scandinavian nations have a much more integrated understanding of the importance of good design in every aspect of their lives than anywhere else in the world. This is not just in their domestic architecture and home furnishings, but also in their public buildings, town planning, landscaping and transport systems – right down to their directional signage. They see nothing particularly special about good design, as it has simply become a part of their everyday lives.

The way that design can enhance our lives has always been of the highest importance to me. Having worked in design my entire life, creating interiors for homes, shops, restaurants and hotels all over the world, I feel that I am well qualified to comment on the positive – and negative – effects an interior can have on your personality and mood. A thoughtfully designed interior can lift your spirits and make you feel alive.

I always tried to ensure that a singular vision ran clearly through all our design groups – I suppose you could call it the Conran Design Ethic. I enjoyed assembling a team of experts with a wide range of experiences that could be applied to the different sectors, but who all had the same approach to design. This collective aesthetic is absolutely vital for large-scale jobs, and in 1966 the Conran Design Group got its biggest-ever commission: the interior design of Terminal 1 at Heathrow Airport.

Back then, the airport operator, BAA, was owned by the public and had very different aims from those it has today, where I think it takes a much more commercial approach. At the time, this was a dream of a project. The architects were Frederick Gibberd & Partners, whose proposals for the interior hadn't impressed the Heathrow design co-ordinator, so that aspect of the job was up for grabs. Somebody at Heathrow had seen the excitement we had generated with Habitat and asked us to put forward a proposal. One of our designers, David Wrenn, assisted by George Montague, developed some ideas that the design team at Heathrow loved, and we got the job. A young James Dyson, fresh from the Royal College of Art, was also part of the team.

Our airport interior was very different from anything we had done previously in our retail projects but it was well received by the public. There was a coherence to our work that I remain very proud of. The terminal seating, the phone boxes, the check-in desks and even the signage for the shops were all recognizably "Conran Designed".

In my early years, any architectural work meant collaborating with an architecture firm, as our own design group didn't have those particular skills. So it was a big moment for me, in the early 1980s, when Fred Roche, chief executive of the vast Milton Keynes development, where we were doing some work, suggested we form an architecture practice together. I liked Fred and his young team, which included Richard Doone, Paul Zara and Stuart Moscrop, and the idea was very appealing, so I agreed immediately and Conran Roche was formed. We did some great early work, including designing the most sustainable building in the UK, for Longman's headquarters in Harlow, and the huge Butler's Wharf project, as well as reviving my favourite building in London, Michelin House.

Eventually Conran Roche was absorbed into Conran and Partners, which to this day continues to work on architecture and interior design projects all over the world, from

ABOVE
The retail interiors that we designed for Heathrow Terminal 1 in 1966 were quite unlike any other design work we had done before, but they perfectly suited the airport setting. It was very modern and, almost like air travel itself at the time, seemed to give people an optimistic glimpse of the future.

warehouse conversions to more modest apartment blocks and the occasional private house. We have also designed shops, offices and, from time to time, large-scale regeneration projects that combine all of these elements to create long-term communities.

We have a 360-degree approach to master-planning, architecture and interior design. The way places are planned, how they are furnished, their use of light and the ease with which you can move around the space all have a huge impact on making people's lives better and more enjoyable, which is what I have been trying to achieve all my life.

Another great joy for me is that we have not been restricted to the luxury end of the market, but have enjoyed working across all sectors – from social housing, through shared ownership and private sale – at both mid-market and high-end. We bring an attitude of design to whatever we are asked to look at, always making the best use of a site, thinking about orientation, daylight, space planning, energy usage and the right density of development.

Working on Butler's Wharf in the 1980s and 1990s showed how high-density living, in a development containing a diverse mix of uses, can succeed if it is designed properly and managed well. Butler's Wharf has apartments, houses, shops, bars, restaurants, a museum, a children's nursery and a student residence for the London School of Economics. It would have been more profitable to make it all private housing, but that would have made it less of a place to live, with no sense of community.

In more recent large-scale regeneration projects, such as the Green Man Lane scheme in Ealing and Wornington Square on Portobello Road, we have reintroduced streets and squares, together with high-quality modern buildings – new homes that are fit for purpose and raise the spirits. Our work has drastically improved the living conditions for those already living on these estates and added homes for sale to subsidize the public housing. I think we have changed the nature of these places from "council estates" to real pieces of the city, with a mix of uses and a diverse community.

The greatest thrill for me is producing work that makes a valuable contribution to the regeneration of an area. No piece of architecture or interior design can be seen in isolation, because these buildings shape how we experience the world. Contemporary living means being part of a vibrant community, and great design has a vital role to play in creating spaces that have a positive impact on the way people live.

We have also worked extensively in the Far East, where our design reputation has always been highly regarded, particularly in Japan. Most of these projects have been superbly led by Richard Doone, in part because I think the clients are attracted to his calm approach, both to design and business.

Our work with the Mori Building Company, Tokyo's largest private developer, began with Roppongi Hills: a bold, mixed-use regeneration project in the heart of Tokyo. We were involved in the architecture, interior design, landscaping and graphic design of the

new 11-hectare (27-acre) urban quarter, providing some 800,000sq m (8,600,000sq ft) of office, residential and retail space, as well as a hotel, cinema and new broadcasting headquarters for TV Asahi. The development was world class and stunning in scale and ambition – it was similar to building a new development the size of Canary Wharf in the heart of Soho – and our work was noticed and admired by developers all over the world.

Other projects for Mori have included a low-rise housing project called Kamiyamacho, featuring 26 apartments and 11 luxury apartments for a residential development called Motoazabu. We also redesigned the Ark Hills Club and its spa, creating a contemporary interior for a health and fitness club. Amusingly, I remember the first time I met Mr Mori and he proudly showed me a huge map of central Tokyo on his wall. There were large areas of green across the map and I expressed surprise at the amount of parkland in the city. He replied that they weren't parks or green spaces but land owned by the Mori Corporation!

Our architects have recently completed the largest development in Tokyo on the southwest edge of the city, alongside the Tama River. We won the Futako Tamagawa project in an international design competition in 2003. I remember Richard Doone getting back to the London office with the news. It was a Friday afternoon, tools were downed and there was champagne all round.

The Futako Tamagawa project provides a total of some 400,000sq m (4,305,000sq ft) of retail, office, leisure and residential buildings, as well as a new city park. Our master-plan concept for the site, led by Richard, is based on a central promenade that connects the various buildings from the railway station to the west through to the residential towers to the east, and the buildings respond to the changing environment along the route. The feel is more solid and vibrant around the railway station, becoming lighter and finer in detail as it moves to the east, representing the journey from the city to nature. It really is a beautiful piece of architectural storytelling, and I'm very proud of Richard and his design team.

I have enjoyed working on hotels since the early 1950s when I was employed by Dennis Lennon to design the chairs, fabrics and interiors for The Ridgeway Hotel in Lusaka, Zambia. Such work gives a designer the opportunity to think about how people would like to live if the boundaries were extended, even if just for a night or a few days. We bought the Great Eastern Hotel by Liverpool Street station and designed its interiors, and it was completed in 2000. At the time, it was one of very few hotels in the City of London but in a very poor state, with rooms available by the hour and two hidden masonic temples. It was such a complicated project, a Victorian rabbit warren with rooms of all shapes and sizes, but we wanted to make it somewhere extraordinary, where businessmen and women could stay comfortably and enjoy a meal in a different type of restaurant every day of the week. Our design made reference to the history of the building but added a layer of modernity that created an exciting contrast. It also connected to the emerging East London arts scene, with installations, club nights and exhibitions.

Our work in architecture and interiors has been a larger extension of my simple belief that good design should be made accessible to as many people as possible. We have worked with thousands of wonderful clients and developers over the years, and I think we have really made a difference to people's lives. We have kept the needs and aspirations of those who live or use the spaces at the heart of all our ideas, because they are the people who take ownership of our designs.

OPPOSITE
Following the completion of work on the interiors for Terminal 1 at Heathrow, we produced this brochure. The cover shows one of the foreman's consoles that controlled incoming baggage, flight-arrival boards and public-address systems. It was a terrific indication of the very modern look that ran through the whole airport. This was the first time moulded fibreglass had been used for a public space, and the curved glass was also an innovation.

Terminal Design

Conran Design Group
Industrial design consultants
5 Hanway Place
London W1P 9DF
England
Telephone 01-580 3060

"The main priority of air terminals used to be the comfort of passengers, creating a space where they would feel relaxed while waiting for their flights."

OPPOSITE

In 1966 the Conran Design Group was commissioned to create this air terminal for Aer Lingus. Located on Brompton Road in London, it served the airline's operations from Heathrow, so passengers would check in at the bureau before being transported by bus to the airport.

RIGHT

One of a series of interior visuals, drawn by David Vickery, of the mini shopping centre situated landside at the new Gatwick North Terminal. Graham Lusted headed up the Conran interior and graphic design team, which produced schemes for both landside and airside areas, and worked with the architects YRM to produce a seamless building.

BELOW, RIGHT

In 1998 we were commissioned to create the most exclusive "flying club" in the world, transforming the Concorde Room at New York's JFK airport. We wanted the lounge to be a design classic like Concorde itself, and every piece of furniture in it was a celebration of 20th-century design, from the Le Corbusier chaise longue and Matthew Hilton armchair to the Eileen Gray Bibendum chair and Charles and Ray Eames lounger. The painting is by American artist Sol LeWitt.

ABOVE LEFT

One of the very first architectural projects we took on as Conran Roche architects was the Addison Wesley Longman headquarters in Harlow, Essex, where we created a building that pioneered environmentally friendly workplace design. The project director was Richard Doone, a brilliant young architect, who would go on to lead Conran and Partners as managing director for many years. The Longman headquarters provided 16,000 sq m (172,222 sq ft) of office space arranged around three atria. The Jura limestone floor and concrete structure assisted in keeping the building cool.

BELOW LEFT

We made full use of the parkland surroundings, and our work set new standards for environmentally friendly offices. At the time of completion, it was considered to be the UK's "greenest" building. As designers, we realized that if low-energy office design were to have a significant impact, our work needed to be affordable, accessible and adaptable enough to meet the changing needs of large organizations.

OPPOSITE

The view from the top of the main atrium, looking down to the staff café. The rug was custom-made by Helen Yardley.

THIS PAGE & OPPOSITE

Conran and Partners collaborated with Brooks Brothers in the RIBA Regent Street Windows Project 2015. The design concept was a flock of white, button-down collars captured mid-flight, with a single gold button-down leading the formation (right). The company was also commissioned to create both the store environment and brand identity for E-Mart, South Korea's number-one hypermarket retailer, for its first home furnishings store, unveiled in 2015 (below). Architects from Conran and Partners were at the heart of a major regeneration scheme for Edinburgh's redundant waterfront, helping to create a buzzing commercial complex on the quayside of Western Harbour. Work began in 1995 and was completed in 2001 (opposite).

Opened in 2009, Martinhal Beach is a resort village near Cape St Vincent in the Algarve, Portugal. It is set on a dramatic, beautiful and ecologically important stretch of coastal wilderness, and the client, Four Winds Resorts, wanted the development to grow naturally out of the landscape. The hotel, broken up into a number of elements, sits partway down a slope facing the sea; above it are duplex apartments set on a ridge looking out to the sea. Conran and Partners worked with a local landscape specialist to preserve as much of the existing flora as possible. The project was led by project director Matthew Wood and Jason Trisley.

THIS PAGE

Completed in 1998, Ark Hills Club is an international private members club located on the 37th floor of the Mori Ark Hills Tower in Tokyo. It displays a unique collection of paintings, models and tapestries by Le Corbusier (above). The club is entered through a gallery that opens onto an axial route linking a series of Western and Japanese restaurants and private dining rooms. The views are so breathtaking and beautiful that we wanted to make Tokyo itself part of the design. In this private dining room (right), the large single window offers a framed view of the city.

BELOW

I love the energy, buzz and sheer scale of Tokyo, but it takes only 90 minutes for the bullet train to whisk you away to the tranquillity of Nasu and the wonderful, relaxing Niki Club, nestled in a woodland setting. Here, the team, led by Richard Doone and James Soane, created 24 bedroom pavilions, a lobby, restaurant, spa and meeting rooms. From the concrete and stone main lodge, visitors follow timber walkways to reach the pavilions, which are clad in Asian hardwood to blend with their setting. I returned in 2013, ten years after we finished our design work, and it was wonderful to see that the whole place had aged so beautifully, with the planting maturing and the buildings gaining a pleasant patina of age. I consider the Niki Club one of the best pieces of work we have ever done – a beautiful patchwork of landscapes. The essence of the scheme is the harmonious relationship forged between buildings and nature.

RIGHT

We wanted to make the interiors of the pavilions a home away from home, furnishing them with design classics and original Conran-designed products. We used calm, soothing colours to enhance the tranquil atmosphere. Each pavilion has a private terrace opening out onto the surrounding forest.

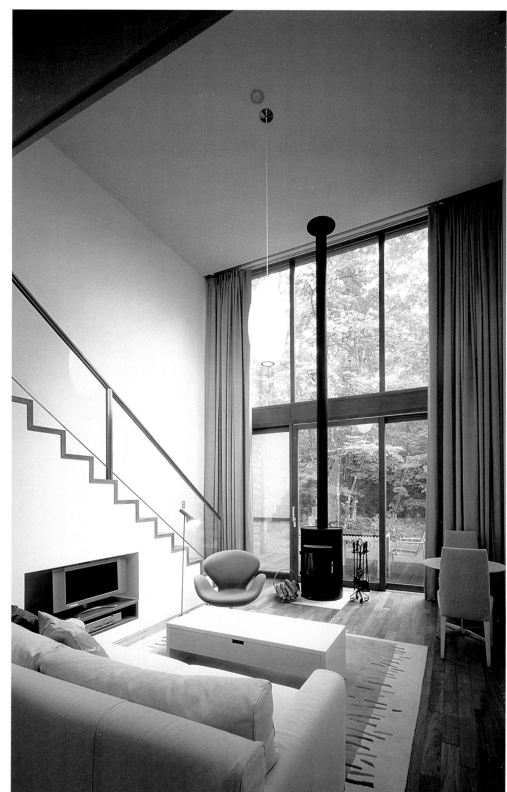

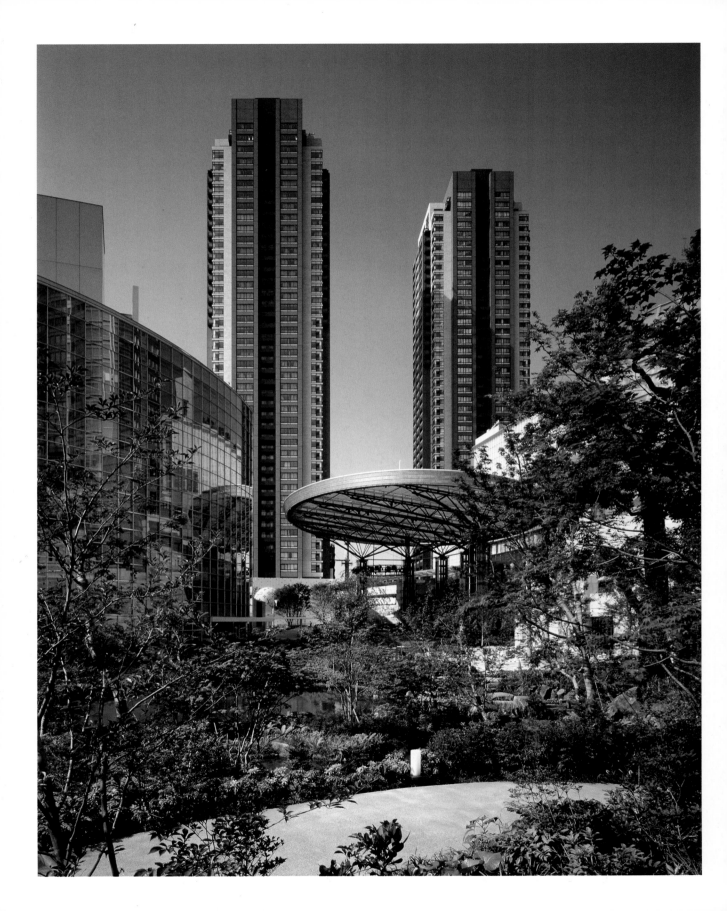

"The Japanese Prime Minister extolled the virtues of intelligent design at Roppongi Hills. More than two million people visited the shops, restaurants, hotel, apartments, art museum and clubs in the first week."

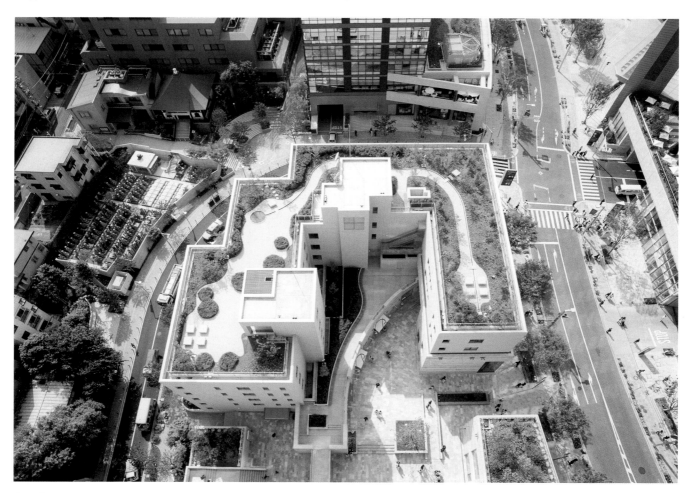

OPPOSITE

The bold regeneration plan for Roppongi Hills was instigated in 1986 by Minoru Mori, president and CEO of Mori Building Company. It was to be a huge, new, urban quarter in the heart of Tokyo, a world-class development that was stunning in both scale and ambition. In 1997 Conran and Partners were appointed as part of an international design team, led by Richard Doone. They were involved in the project's architecture, interior design, landscaping, product and graphics. After a fast-track construction period, Roppongi Hills opened in 2003.

ABOVE

In association with garden designer Dan Pearson, Conran and Partners landscaped the residential quarter, bringing the English countryside to the heart of Tokyo with a flowing series of private and public gardens, connected by informal copses, undulating hedges and even dry-stone walls. Mori wanted "lush planting" to inform the scheme.

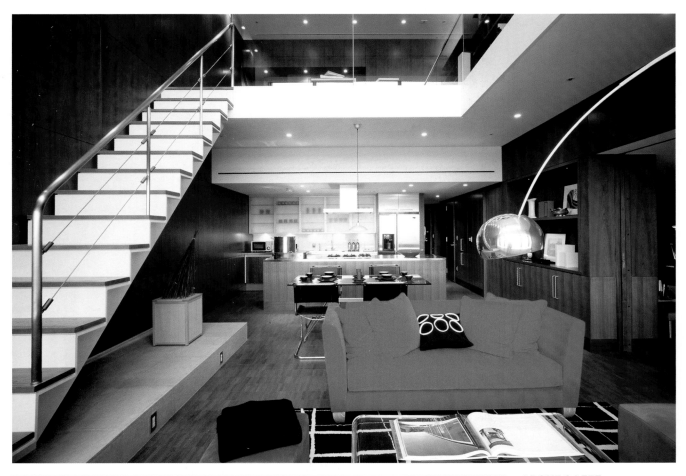

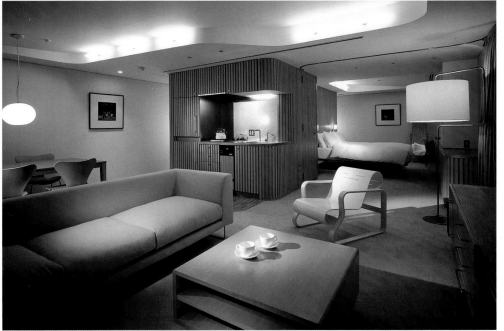

ABOVE & LEFT
Our interior design teams created
a significant number of
apartments at Roppongi Hills,
all with different themes and
combining the European notion
of open-plan living with a more
traditional Japanese outlook.
The "Forest" apartment is shown
above; the "Humanist" to the left.

OPPOSITE
The Roppongi Hills Club is a private
dining club occupying the entire
51st floor of the main commercial
tower at Roppongi Hills. It
features a series of 17 spaces,
including restaurants, bars,
private dining rooms, meeting
rooms and a banqueting room, all
designed by Conran and Partners.
The graphics in the entrance hall,
by Jonathan Barnbrook, were a
simple, beautiful concept that
captured the ambition and energy
of the development perfectly.

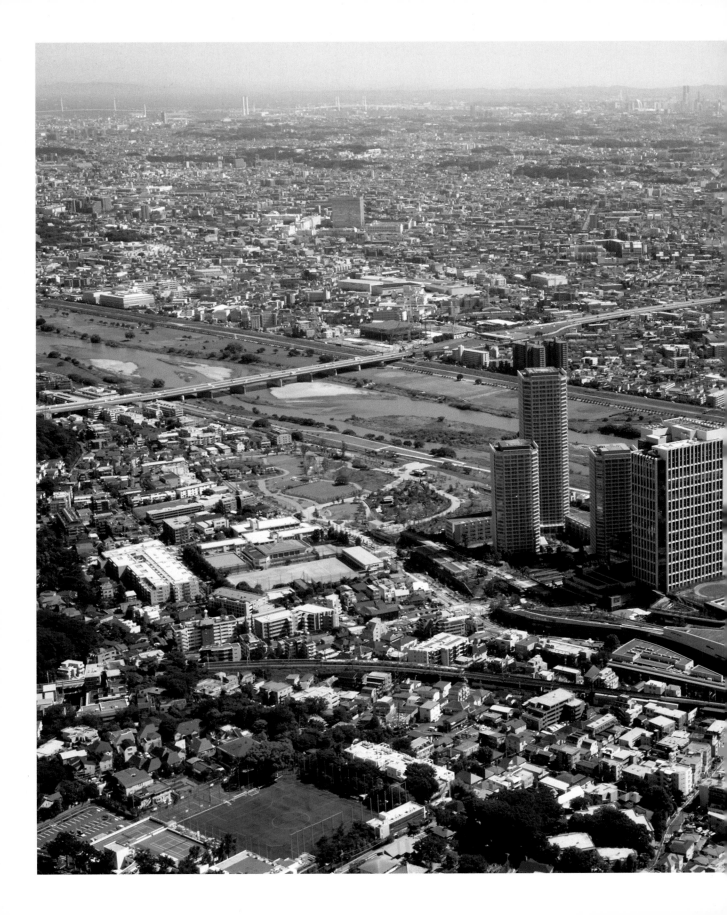

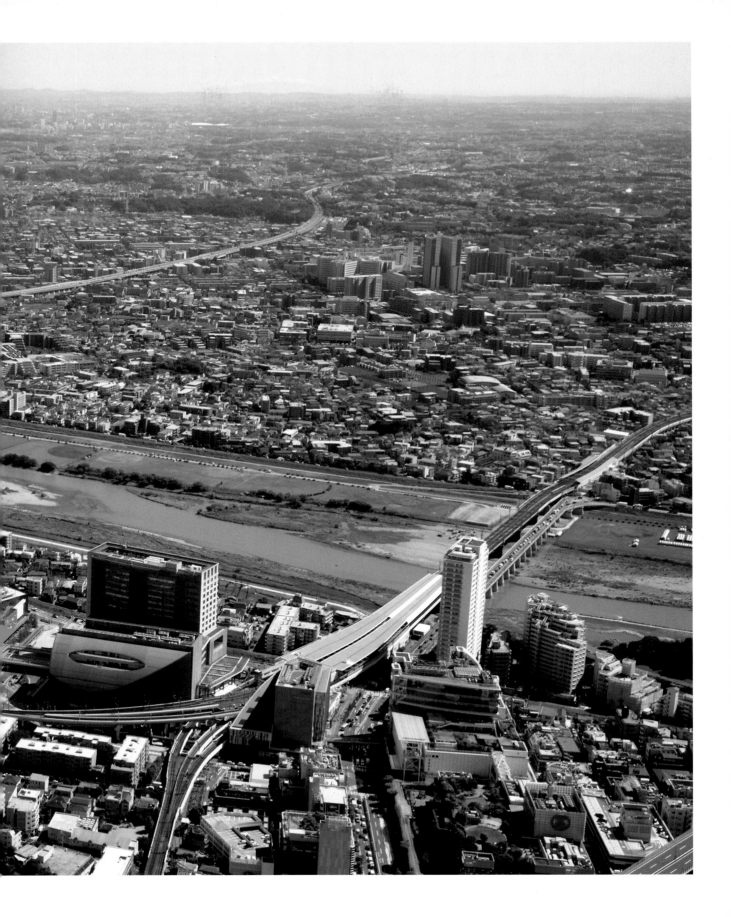

"The 11 years spent developing the Futako Tamagawa project have been fascinating and build further upon our experience of working in Japan."

PREVIOUS PAGE
This breathtaking aerial shot demonstrates the sheer scale of our master plan for the 400,000 sq m (22 hectare) mixed-use Futako Tamagawa development in Tokyo. It is a beautiful piece of architectural storytelling, where the feel is more solid and vibrant around the railway station to the right of the picture, becoming more transparent and finer in detail to the left. The landscaped city park on the far left represents the final part of the journey from the city to nature.

OPPOSITE & ABOVE LEFT
I love the cheerful balconies, which add a flash of colour and vibrancy to the cavernous shopping galleria. The colours were informed by the rising sun.

BELOW LEFT
The development includes four new high-rise blocks – a trio of residential towers, ranging from 28 to 40 storeys, and a 30-storey office building, topped by a three-storey hotel.

ABOVE RIGHT
The central promenade connects various buildings set on a unifying stone plateau. As the buildings progress east out of the city, they become lighter, reflecting the less urban environment.

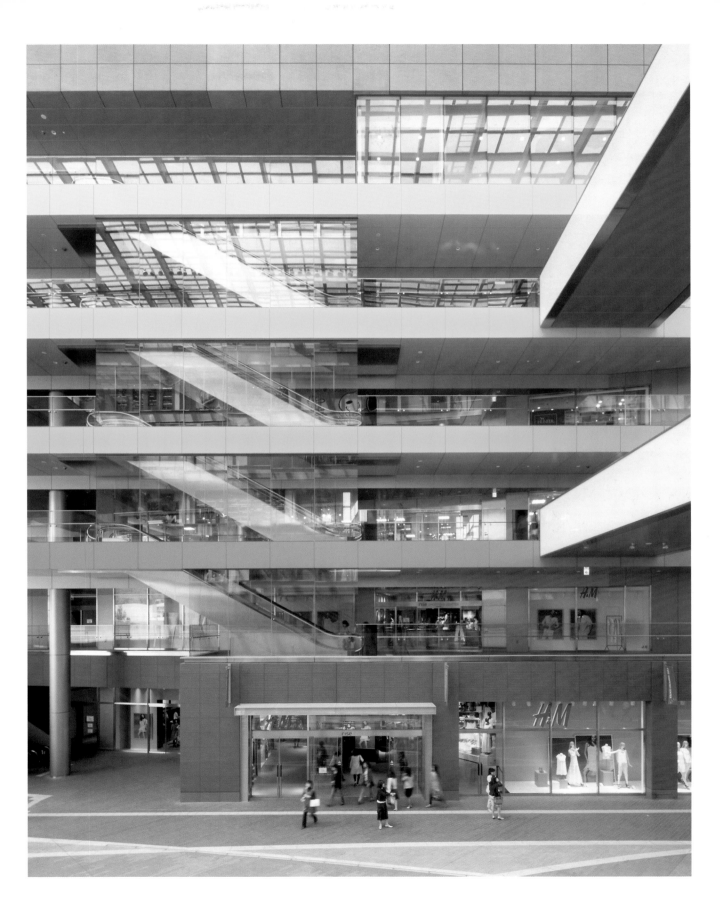

PREVIOUS PAGE

Led by developer Knight Dragon, The Greenwich Peninsula master plan is one of Europe's largest regeneration schemes, to create London's "ultimate village". Conran and Partners were commissioned to design interiors for The Lighterman and The Waterman residential towers. Pictured is The Waterman private lobby space, featuring a huge sculptural chandelier; our design team, led by Tina Norden, worked in collaboration with the lighting studio Jona Hoad to develop this stunning piece.

LEFT

A Conran and Partners residential interior in Blake Tower, an iconic Grade II-listed building in one of London's most architecturally significant areas: the Barbican estate. Our architects were appointed by housing developer Redrow London in 2015 to revive this iconic 1960s brutalist building, transforming it from a youth hostel into 74 apartments.

BELOW

A Conran and Partners interior in The Guesthouse, a beautiful new boutique hotel in the heart of Vienna, with interiors inspired by the classic Viennese approach to architectural modernism. There is a very domestic feel to the interiors, which I like very much – they feel more like relaxed living spaces than hotel rooms.

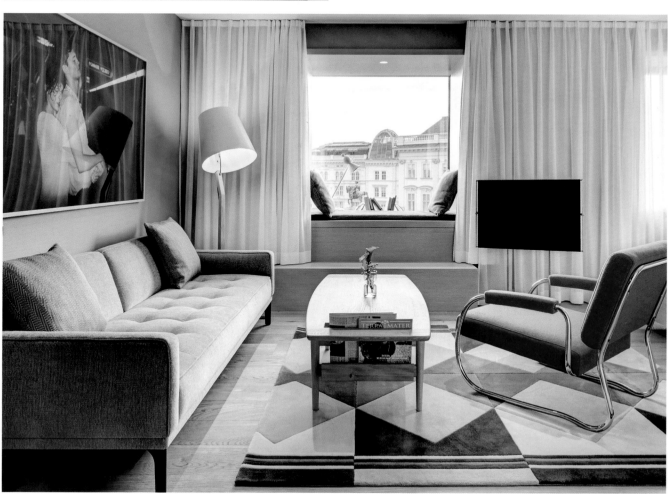

RIGHT
Designed by Conran and Partners, this is The Lighterman penthouse apartment within the Greenwich Peninsula residential development.

BELOW
This Conran and Partners residence is part of an innovative project in Istanbul for the developer Yenigün Insaat. Called The House Hotel and Residence Bomonti, it comprises 51 hotel rooms and 155 residences. I like the concept, and the design reflects the local area's craft and manufacturing history. I think it will become a design classic.

OPPOSITE & THIS PAGE

I am not particularly flamboyant but I do enjoy the architectural majesty of a grand staircase. Conran and Partners were asked to transform 81 Avenue Victor Hugo, a 19th-century palace townhouse in Paris, into 40 modern residences. We balanced the existing architecture with contemporary design, keeping many original features, such as the spiral stairwell (below). With the architect Peter Lorenz, we transformed the Das Triest hotel in Vienna. We preserved parts of the original structure, including the central staircase (right), combining elements of imperial elegance with sober lines. For the Great Eastern Hotel in London, we installed a dramatic new central atrium (opposite). A beautiful piece of architecture, it was perfect for our vision of a modern hotel set in Victorian splendour.

ABOVE

Conran and Partners are working with Catalyst Housing Limited to bring more than 300 high-quality new homes to the Portobello Road area of London. It is part of the community-focused £200 million regeneration master plan, designed to improve and retain all that is great about the vibrant neighbourhood, while enhancing it with contemporary design.

LEFT

Our architects have converted the former printworks of Brighton's local paper, the *Evening Argus*, into apartments, shops, offices, restaurants and a theatre space – a vibrant blend of uses reflecting the historic building's location in Brighton's thriving North Laines.

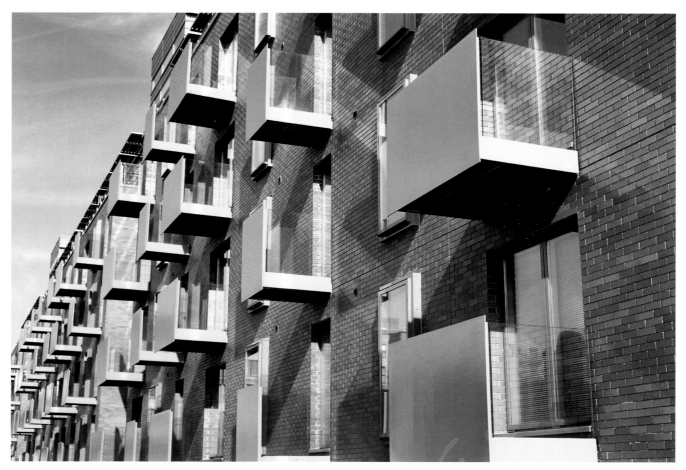

ABOVE
Vantage Quay site is part of the Manchester Waterfront master plan, commissioned by Town Centre Securities to regenerate the Piccadilly Basin area of Manchester. The scheme comprises 117 studio, one- and two- bedroom apartments.

RIGHT
Lennard Road is a mixed tenure redevelopment in Croydon for London-based housing provider Family Mosaic. It will see existing buildings demolished and the creation of 26 new one-, two- and three-bedroom quality homes. Conran and Partners' are working on a design that includes a four- and five-storey block of apartments, with balconies and terraces, as well as three-storey townhouses and a number of two-storey mews houses and a shared garden.

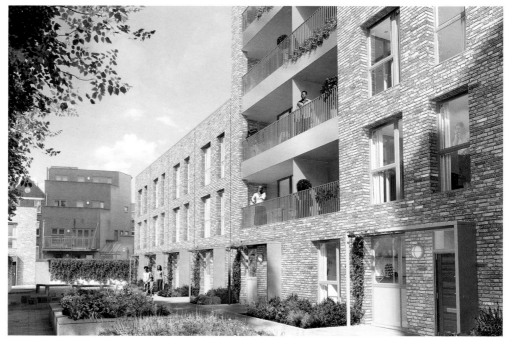

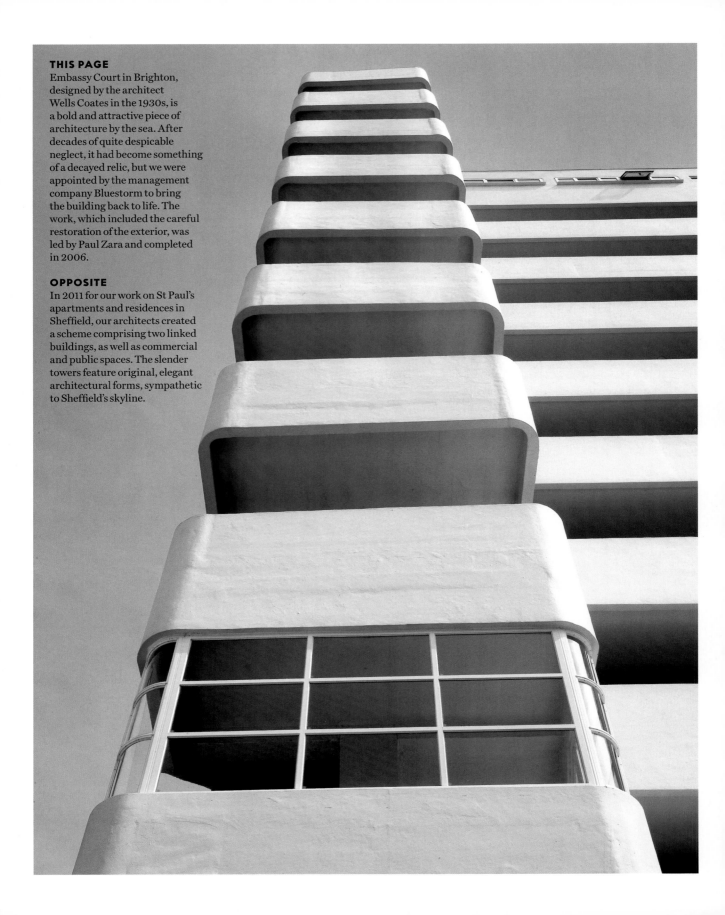

THIS PAGE

Embassy Court in Brighton, designed by the architect Wells Coates in the 1930s, is a bold and attractive piece of architecture by the sea. After decades of quite despicable neglect, it had become something of a decayed relic, but we were appointed by the management company Bluestorm to bring the building back to life. The work, which included the careful restoration of the exterior, was led by Paul Zara and completed in 2006.

OPPOSITE

In 2011 for our work on St Paul's apartments and residences in Sheffield, our architects created a scheme comprising two linked buildings, as well as commercial and public spaces. The slender towers feature original, elegant architectural forms, sympathetic to Sheffield's skyline.

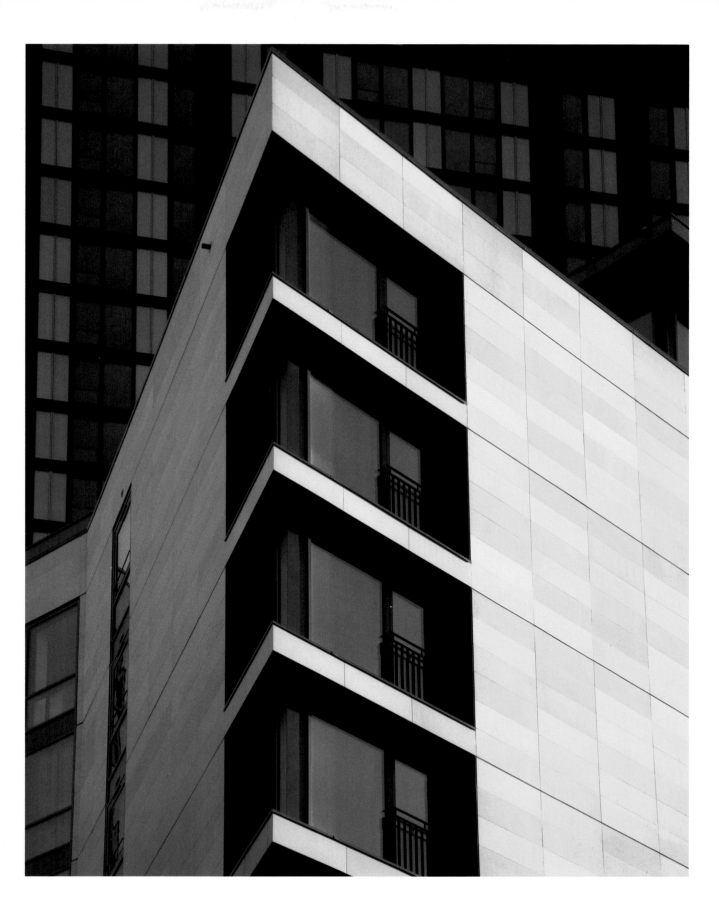

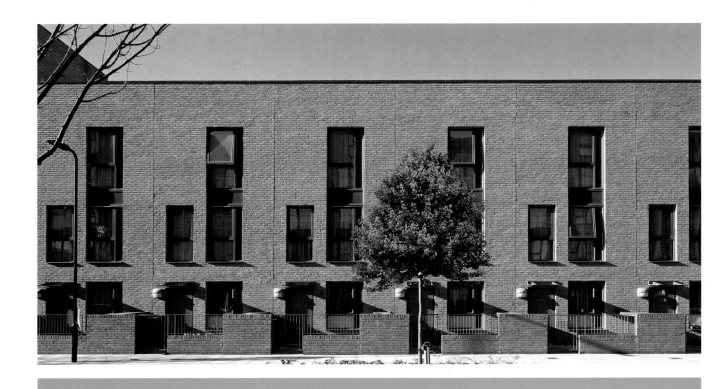

"The regeneration of the Green Man Lane estate is an outstanding example of how good design can improve the quality of life for whole communities."

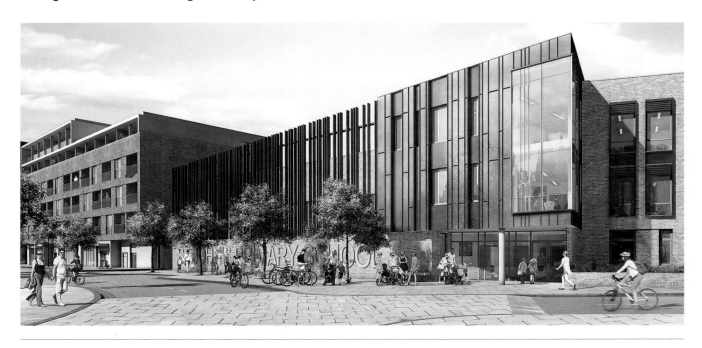

RIGHT

We are master planners and architects for the redevelopment of the Green Man Lane estate in Ealing for A2 Dominion and Rydon. Our work is providing more than 780 homes and facilities, including a gym, cafés and community parks. Lee Davies, Paul Zara and the team from the Brighton office have led the project, one of the largest and most significant ever undertaken by any of my design groups.

OPPOSITE ABOVE

Planned around a traditional street layout with rows of terraced (row) family houses, public and private gardens and play areas, the Green Man Lane estate is a far cry from the dreary, brutalist council estates of the 1960s. I believe our work on this project could be a new dawn for social housing. There is no reason why well-thought-out social housing cannot be designed and built using quality materials in a carefully planned space, which encourages residents to play an active role first in the design and then in their community.

OPPOSITE BELOW

As part of the continuing transformation of the former estate, we are designing a new primary school to replace the existing St John's Primary. The design team has worked closely with the school and Ealing's education chiefs to create classrooms fit for 21st-century learning, with double the amount of spaces for pupils.

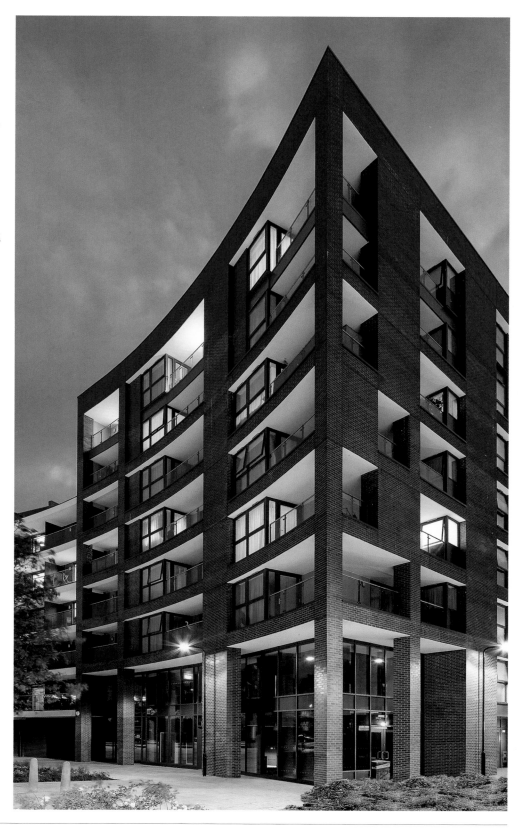

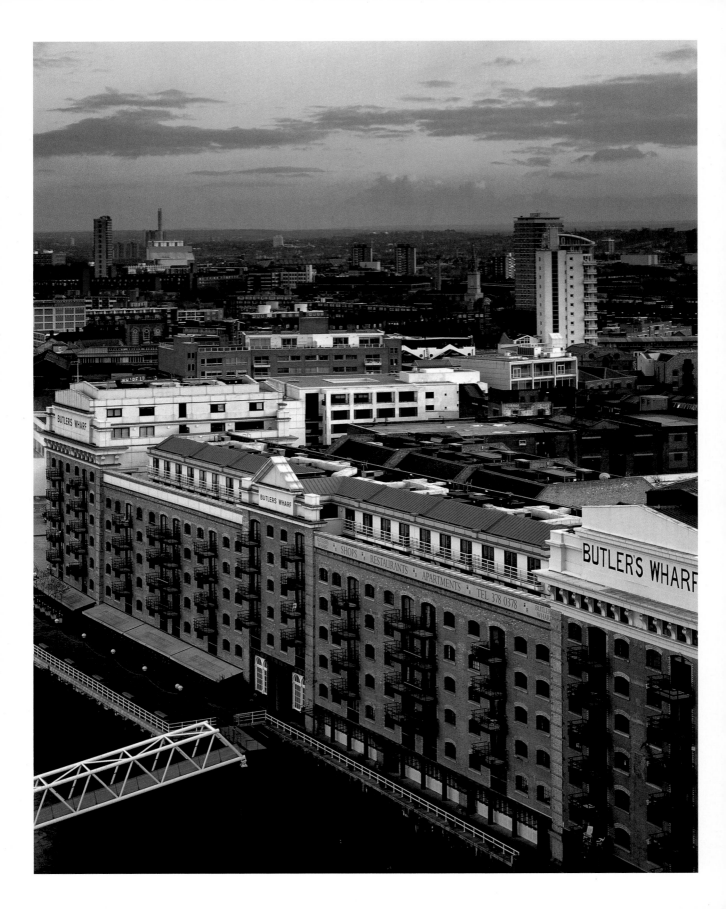

Regeneration

Throughout my career, one of the things that has given me the greatest thrill is working with old, abandoned buildings and bringing them back into new and exciting use. The contrast between modern design and existing, beautiful architecture creates a great deal of synergy, and we have done some important work in this area.

OPPOSITE
Our work on the regeneration of Butler's Wharf, close to Tower Bridge, was a vast project that saw a derelict area of redundant Victorian warehousing transformed into a thriving community of restaurants, bars, shops, galleries, apartments and offices. We drew up the original master plan for the site in 1983, and although property agents thought we had lost our minds attempting such a mammoth project south of the Thames, the area is now recognized as one of the UK's most significant urban regeneration projects and has put the borough of Southwark well and truly on the map.

I suppose I have been easily seduced by quirky, eccentric spaces – they might be off the beaten track or have been rejected by others as being too difficult to develop. But for me, perhaps the most inspiring thing of all is that the renovation of such places often proves to be the catalyst for the regeneration of run-down parts of towns and cities. Saving an old building, bringing it back into use and then seeing the surrounding area thrive gives everybody involved a degree of pleasure that an entirely new project may not inspire.

Some of the early Habitat stores were located in beautiful disused spaces: a church in Tunbridge Wells, a 1920s cinema on King's Road, Chelsea and even a Spitfire factory in Chester. I remember that the landlord of the first Habitat threw in the basement for free, as he didn't think anybody would have a use for it. Well, we certainly did.

Over the years, we put the Bluebird restaurant in an empty garage at "the wrong end" of King's Road and converted old horse stables in Marylebone into a Conran Shop and the Orrery restaurant. We took the derelict and abandoned Marquee Club in Soho and created Mezzo, one of the biggest restaurants in London in the 1990s. Quaglino's was a vast black hole when we first saw it, flooded and rat-infested, and we turned it into one of the most popular restaurants in London, with table reservations at one point trading on the stock exchange.

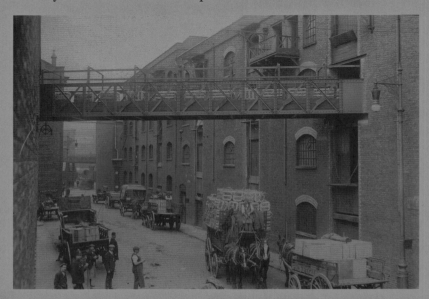

Perhaps the bravest thing of all was going to New York and putting a huge restaurant called Guastavino's in the abandoned arches underneath the Queensboro Bridge on 59th Street. One hundred years ago the arcade had housed New York's main marketplace, but when we first visited in the late 1990s, we had to cut through barbed wire to get on site, and there were tramps sleeping under blankets. Most recently, we transformed a gigantic, abandoned printworks in Shoreditch and turned it into Boundary – a small hotel, restaurant, rooftop bar and grill, the Albion café and a shop.

Out of all the old buildings we have worked with, I think I can say that it is our work restoring the Michelin building in Chelsea that has given me more pleasure than any other. The site of the first Habitat store was just across the road from it and I fell in love with its delightfully quirky architecture and dreamed of turning it into a wonderful shop with a first-class restaurant on the first floor. I had written countless letters to the head of Michelin over the years, as I watched the building deteriorate and fall into an incredible state of disrepair. I could not believe it when I heard they were finally putting it up for sale and that I might be able to have a crack at it.

Astonishingly, the building had not been designed by an architect but by the Michelin engineers at their factory in Clermont-Ferrand, France, in 1910. It was a flamboyant advertisement of the achievements and aspirations of an inspirational company. A building like this would simply not be allowed to be built in modern times – just imagine what the planners would say if it were proposed today – but that didn't mean that its beauty couldn't be preserved.

I went to see the head of Michelin UK and told him that I would repair the building so that it would always remain an excellent advertisement for his company. I also said that I would match the highest offer that he got, plus £1. My enthusiasm won the day and the company agreed to sell the building to Paul Hamlyn and me for conversion into a huge Conran Shop, a restaurant and oyster bar, which would become Bibendum, and offices for Paul's publishing company. Our architects and designers worked together on the fascinating and complex conversion of a very visible London landmark, which became fully reoccupied once the work was finished and also helped to publicize the Conran name as architects.

Without doubt, though, the biggest urban regeneration project we ever took on was Butler's Wharf in Southwark, on the south bank of the Thames by Tower Bridge. Curiously enough, my first view of the site was from the river itself. It would have been 1981 and I had taken our office staff, architects and designers on a boat trip down the Thames for a summer party. We had all had a few drinks too many and were in a very happy frame of mind when we sailed under Tower Bridge, and the boat, for some reason, turned around twice. I was leaning against the side at the time, drink in hand, when I noticed this wonderful collection of apparently abandoned Victorian warehouses.

As chance would have it, I had just formed an architecture practice, Conran Roche, with Fred Roche. He was perhaps the best-connected chap in the business – he knew all the people running the LDDC (London Docklands Development Corporation) at the time, and Butler's Wharf came under their jurisdiction. Fred found out that Butler's Wharf belonged to P&O, and that the LDDC had turned down their plans to demolish the site and build dreary housing three times. We felt they might be persuaded to sell.

Both Fred and I were utterly smitten with the rough, robust industrial architecture – amazingly, some of the warehouses were still in use grinding spices, so the air was richly fragrant with their aromas. We agreed it would be a wonderful project for our architects to work on – if only we could afford it. But Fred was a terrific negotiator and we managed to buy Butler's Wharf for £3 million, which we felt was a very fair price.

We set the Conran Roche architects the task of producing a bold and ambitious scheme for the site. It turned out that our plans and the wishes of the LDDC were in perfect harmony: to combine new buildings with the sensitive restoration of the old ones and, in doing so, create homes, shops, restaurants, workshops, offices and, eventually, a space for a Design Museum.

The estate agents didn't share our enthusiasm, though. When we told them our idea was to put restaurants in the Butler's Wharf buildings, with views out over the river, they laughed and said, "Nobody will cross Tower Bridge to have lunch, so you will find it difficult to find customers for your restaurants."

The project wasn't without its problems. Based on the strength of our scheme, Midland Bank lent us the money for the development and we were so confident of success that we invested heavily in the infrastructure, putting in roads, complex drainage systems and a new riverfront walkway. The first thing to go wrong was the unpleasant realization that the main Butler's Wharf building only had proper foundations at one end. We just had ourselves to blame, but the presence of foundations at one end had obviously led to the expensive assumption that there would be foundations at the other end, too. Lesson learned, we had no choice but to absorb the huge cost of adding new foundations but, perhaps more significantly, this delayed the project considerably.

By the time the apartments were completed and ready to be sold, Britain was in the grip of one of its deepest and grimmest recessions, with interest rates running at 16 per cent. We couldn't afford to continue, and Midland Bank called for the repayment of their loan. I suggested to the chairman that they took shares in the project, that its long-term viability was economically sound and that we just had to see the recession through. But nobody then was buying property in this area or, indeed, anywhere in London, so we were forced to put Butler's Wharf into receivership. When you look at what apartments there are selling for now… well, perhaps it is better for me not to dwell on what might have been, had we been able to repay the bank loan or persuade the bank to take shares in the project.

Some 30 years later, the project long since completed, there is no doubt that Butler's Wharf is a serious example of urban regeneration, admired greatly by other planners and architects, even though it might not be completely true to our early vision. I think we helped to persuade people to venture across the Thames and make that stretch of its south bank popular. The regeneration has spread to other parts of the area and helped put Southwark on the map as a destination for Londoners, tourists and businesses.

On a more personal note, Butler's Wharf was a happy home for me for nearly three decades. I bought David Mellor's handsome building in Shad Thames, converted the top two floors into my apartment, and moved the architects and designers from Conran & Partners, and the buyers and office team from The Conran Shop into the floors below.

We installed the Design Museum nearby, in the wonderful white building that was once a banana warehouse, overlooking the Thames. And, of course, we have had four successful riverside restaurants in Butler's Wharf: Le Pont de la Tour, Cantina del Ponte, The Butlers Wharf Chophouse and Blueprint Café. Very early in the project, I showed the restaurateurs Chris Corbin and Jeremy King the ground-floor warehouse space where I was planning to create Le Pont de la Tour. Apparently, they spent the taxi ride home having a good belly laugh and saying, "Dear old Terence Conran has lost it." To a certain extent, they were right – at the time, if you had asked a taxi driver to take you to Butler's Wharf, chances are they wouldn't have heard of it. But 30 years later, and having hosted dinner at Le Pont de la Tour for the likes of Bill Clinton and Tony Blair, I think I can allow myself a satisfied smile, if not share their guffaws.

On a warm summer's evening, taking a stroll along the south bank of the Thames, with the restaurants and bars spilling out onto the terraces and the buzz of happy chatter filling the air, you realize this is a magical place. To think that when I first clapped eyes on Butler's Wharf, there wasn't a single sign of life. I don't think you could call it anything less than a success story that, to some degree, has changed London.

As a British designer, I certainly try to fly the flag for my country whenever I can. London has such a rich and glorious heritage that I feel proud of the role we have played in renovating and rejuvenating some of the key elements from its glorious past. And I'm not sure there are many more things that give me greater pleasure than using our architectural and design skills to help regenerate entire inner city areas.

BELOW
It is amazing to think that this rather depressing old banana warehouse was soon to become our shiny new Design Museum, comprising two floors of galleries, a café and a shop, along with the Blueprint Café on the first floor. Our architects stripped back the brickwork and used the steel structure to create a simple, white building that was the Design Museum's happy home for more than 25 years.

OPPOSITE
A detailed metal printing plate of our plans for the whole Butler's Wharf complex, which I designed and called "A Tale of Two Cities". We used it for a double-page advertisement in *The Times*, to capture people's attention as we struggled against the recession. One proposal that didn't materialize is Spice Quay, at the bottom of the plate, Stuart Moscrop's design for a "glass cobweb" building that would have been the headquarters for the technology firm Logica.

THE DESIGN MUSEUM.
Already established as a world centre for people enthused by design.

THE BLUEPRINT CAFE AND BAR.
Open this November for lunch, coffee, tea and, in the Spring, dinner. A fine modern café with a terraced view and balcony.

THE BUTLERS WHARF HOTEL.
We are looking for a joint development partner for what we hope will be one of the

...finest small hotels in London. There will be over a hundred bedrooms and space for restaurants, bars, a health club and conference facilities with a vast waterfront terrace and stunning views of Tower Bridge.

CINNAMON WHARF.
A finely converted 59's warehouse made into 68 excellent apartments.

THE DAVID MELLOR BUILDING.
The famous master cutler is building a studio, a workshop and a shop for his own use. Designed by Michael...

VANILLA AND SESAME WHARF.
52,000ft² for sale uncompleted or for tenants to tenant's requirements.

BUTLERS WHARF BUSINESS CENTRE.
Fully Let.

NUTMEG HOUSE.
Offices from 1,200ft² suites at £25 per ft² Available now, Grocery Store 1,100ft² to let for immediate occupation.

LSE HALLS OF RESIDENCE.
To be occupied this October by 599 s...

Steps down to Butlers Wharf Sales Centre

BUTLERS WHARF

BLUEPRINT CAFE AND BAR.
A modern café with seating for 80. Opens November.

SPICE QUAY.
46,000ft² of offices undergoing a let to a company of excellent and highly intelligent people. Completion 1992.

BUTLERS WHARF

David Birt designed the brochure that we produced to explain the concept behind, and the opportunities for, the Butler's Wharf development. The brochure outlined the history and character of the area, the residential proposals, and the possibilities for retailing, employment, culture and leisure, and firmly emphasized our plans to put this run-down area on the map. Our regeneration work was recognized in 2016, when I was awarded the Freedom of the Borough of Southwark.

OPPOSITE

The cobbled street of Shad Thames is one of my favourite parts of London. I have always loved the original features, such as the iron bridges and overhead goods gantries that connect the warehouses together, and was determined to keep them as part of any refurbishment. The robustly engineered warehouses and factories, which truly reflect the energy and entrepreneurialism of the Victorian age, were beautifully converted into apartments that were perfect for modern living.

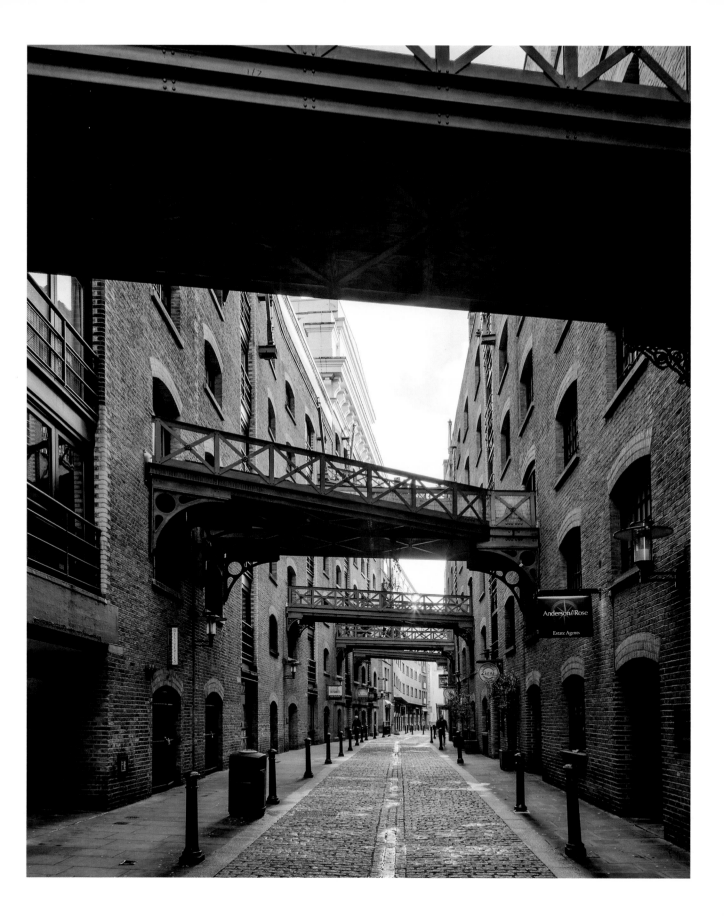

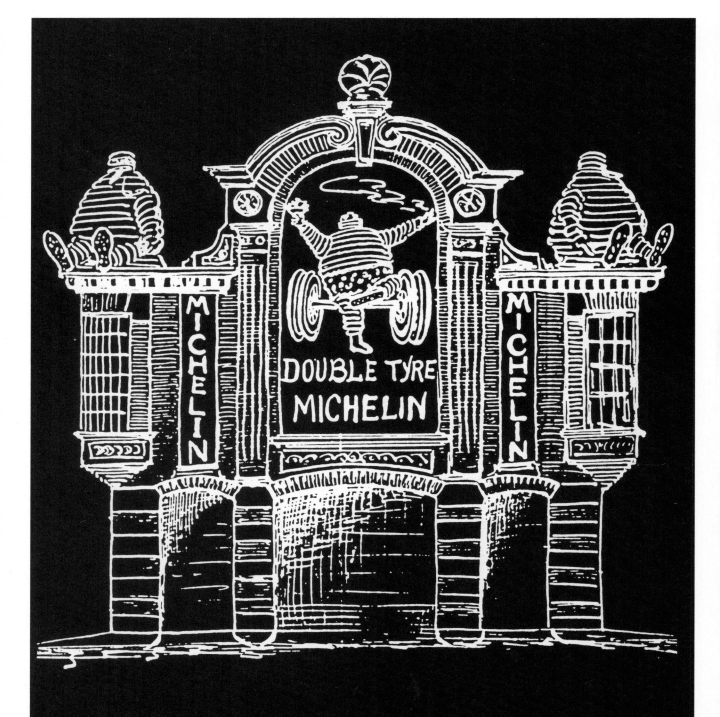

ELEVATION ON FULHAM ROAD

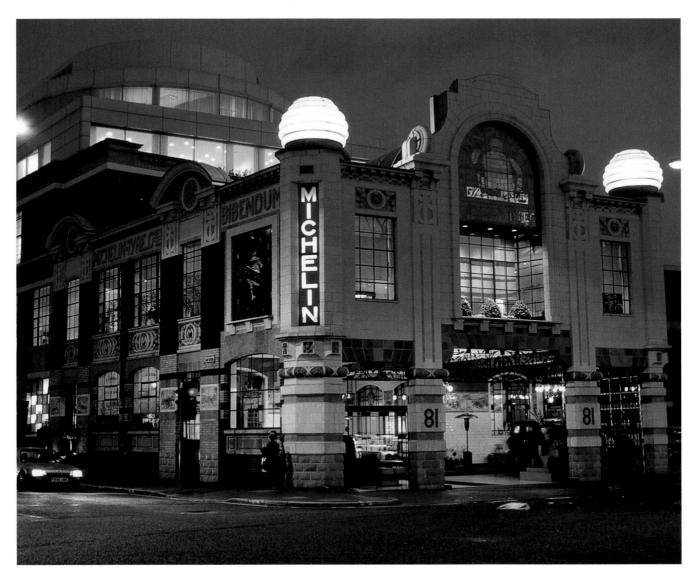

OPPOSITE

An early drawing by Michelin of how their beautiful building in Fulham Road might look. Astonishingly, it was not designed by an architect but by François Espinasse, an engineer from the Michelin factory in Clermont-Ferrand, France. It was a flamboyant advertisement for the achievements and aspirations of this cathedral of a company, which helped to develop the future of motoring and a whole lot more besides.

ABOVE & RIGHT

This remarkable building was designed in 1910 as a tyre warehouse, with a bay at the front for weighing cars and fitting tyres. It was the first reinforced-concrete building in the UK. With our change of use in 1985, major structural alterations had to be made and two new floors added to make it suitable for its new role as a restaurant, shop and offices for Paul Hamlyn's publishing group – all without changing its appearance.

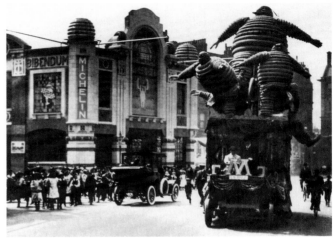

"I promised Michelin that I would preserve and enhance its building with great care and sympathy and that its name would always be featured prominently on the ceramic facade."

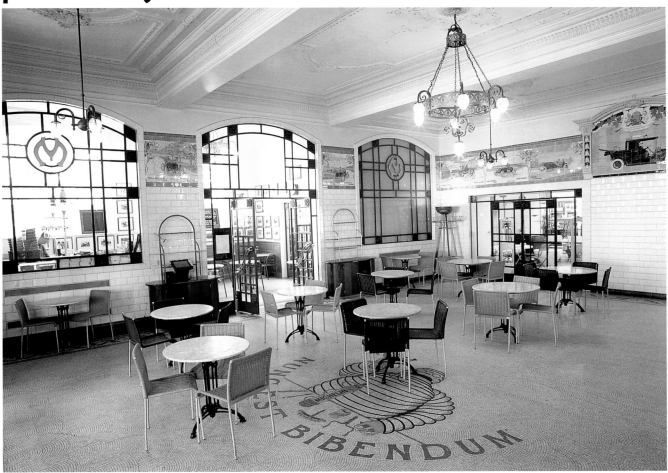

OPPOSITE
The building itself is a tribute to Monsieur Bibendum, or the Michelin Man. Before the Second World War, the stained-glass windows were removed and taken to Stoke-on-Trent, the Michelin headquarters in the UK, for safekeeping but they were never seen again. Our architects had to painstakingly re-create them using only old posters as reference for the colours. I was delighted when Michelin told us we had got the glass spot on. The light that streams through the windows really is part of the enjoyment of this unique space.

ABOVE & RIGHT
The ceramic plaques surrounding the ground-floor lobby of the Oyster Bar depict motor rallies organized by Michelin, and they preserve much of the atmosphere of the original building.

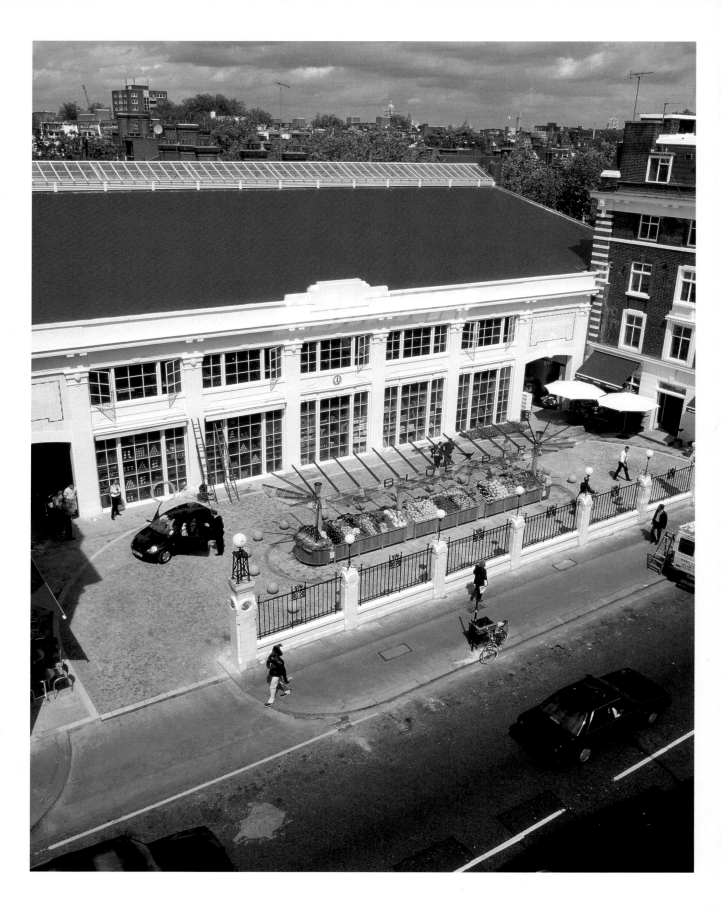

"I am easily seduced by quirky, eccentric spaces. Saving an old building and giving it a new lease of life provides a degree of pleasure that an entirely new project may not always inspire."

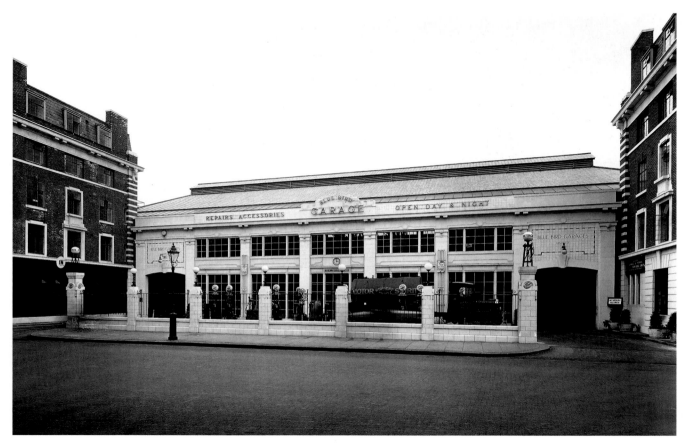

OPPOSITE & ABOVE
Bluebird had been a beautiful garage in the 1920s, with connections to that glamorous king of speed Malcolm Campbell. He was said to have assembled his world-speed-record cars – the Bluebird series – there. The garage was just over the road from my original Orrery restaurant, and I loved the place, but I felt sad as it deteriorated and eventually became a rather sleazy market. In 1994 we took on the vast site and decided to create a giant gastrodome that would encompass a food market, restaurant, café, bar and club, together with an outdoor plant and flower market. Paul Zara led the design team on this thrilling project. We decided to retain the Bluebird name and emphasize the connections with Campbell, particularly in the design of the logo.

THIS PAGE

The far end of the restaurant was dominated by a rather magnificent crustacean bar, with the metal bar in front reminiscent of the exhaust pipes of a racing car. Matthew Wood's sketch of a cross section of the deceptively complex project demonstrated how we might configure all the planned activities and bring this wonderful site back to full use.

OPPOSITE

Our original design for the restaurant retained the industrial feel of the garage, and we also kept its old, riveted steel roof. I commissioned Richard Smith to create a series of sculptural painted kites that floated in the light well above the dining area.

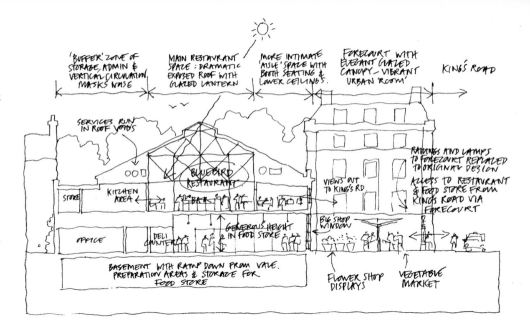

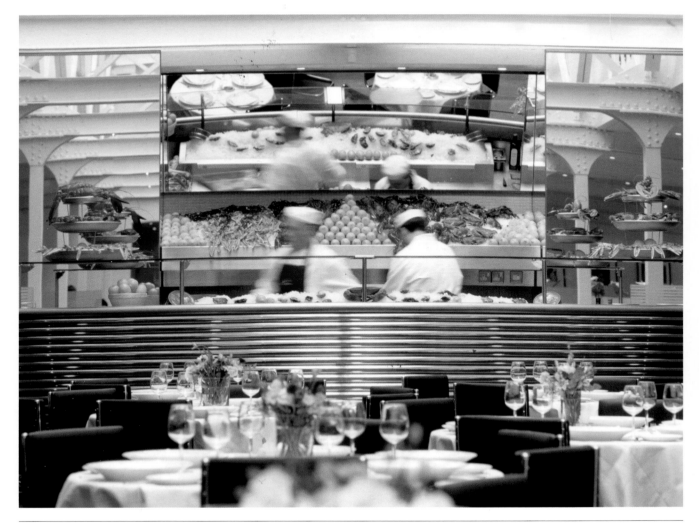

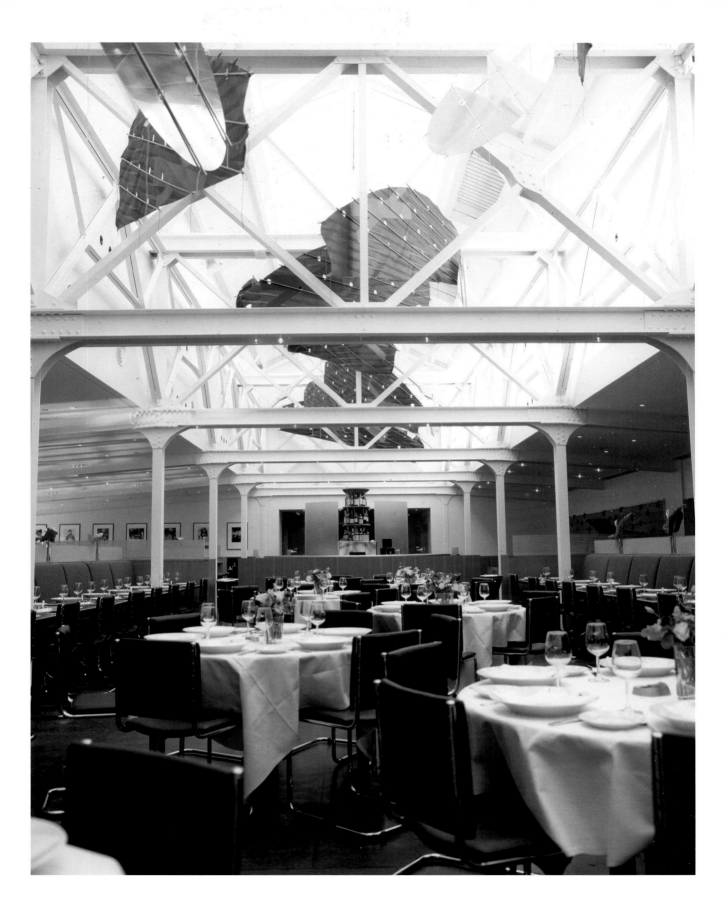

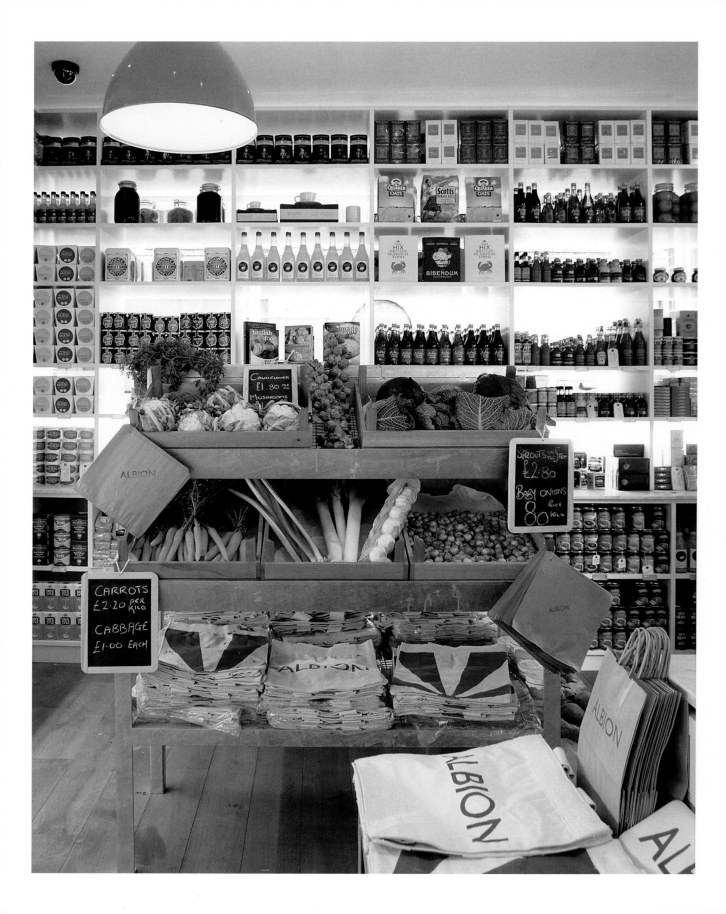

OPPOSITE

The Albion shop at Boundary has proved incredibly popular, with the shelves absolutely chock-full of great British food and drink.

RIGHT

I vividly remember Peter Prescott saying in 2004 that he had found a wonderful Victorian building in Shoreditch that might be available to buy and there was the potential to do something truly special with it. I fell in love with this robust former printworks, which had been unoccupied for many years. The original configuration from 1893 had barely changed, and many of the original features were still intact. We managed to restore and keep some of these features, and they give the overall design of Boundary much of its charm. Tim Bowder-Ridger was lead architect on this project.

BELOW

The rooftop bar and grill at Boundary is one of my favourite outdoor spaces in London, with its views out over the crooked and twisted rooftops of East London.

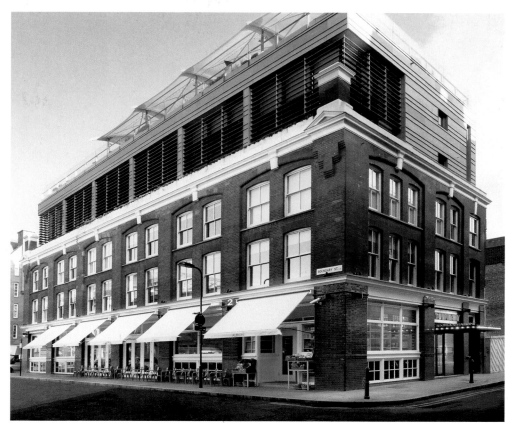

LEFT
Each of the Boundary rooms and suites are different, inspired by a legendary designer or design movement. This room is a nod to the Austrian designer Josef Hoffmann, who made a major contribution to the Wiener Werkstätte design movement in the 1920s. His work is elegantly modernist and quite domestic, so ideal for a hotel room.

BELOW
The British room features a sideboard by Stuart Westwell and a colourful, patchwork headboard by Lisa Whatmough of Squint, who built her business in Shoreditch.

OPPOSITE
I enjoyed being able to create from scratch the sort of space that I would like to stay in. The Terence Conran suite features a driftwood branch, covered with pretty, coloured, paper butterflies.

Catalogues & Books

Books and catalogues have always been an important accompaniment to my work and an enjoyable extension of my design philosophy. They are a simple and effective way to get ideas and products across to a far wider audience, helping customers to make their own choices.

OPPOSITE
The spine of a book requires as much thought put into it as a front cover, as they spend much of their time on the shelves, hopefully making a pleasant display. I like this collection of "Conran Spines" from some of my favourite books I have written over the years, and these book spines all illustrate the importance of good typography.

I suppose that these days companies have their websites, online shopping and social media channels for communicating with their customers but, for me, creating books and catalogues is a much more personal and satisfying way of doing so. I love the feel

of a well-produced book that has been printed beautifully on quality paper, with the type set in such a way that reading it is an absolute pleasure. I also love the process of putting a book together, sifting through thousands of images and choosing those that best suit my vision.

The first book I ever produced, when I was ten years old, was a pressed-flower book. I was always encouraged by my wonderful Aunt Doff to indulge my passion for flowers and gardens. She was a friend of the Dalai Lama, believe it or not, and used to visit Tibet, hunting for wonderful plants to bring back home. I called my creation *The Wild Flower* and painted a fly-catching monster on the front cover (see page 24).

I was over the moon when my drawings of the school boathouse, which I had helped to build,

LEFT
Printed Textile Design – the first-ever book I had published under my own name, in 1957. My wife Shirley, who was pregnant with our son Sebastian at the time, was a very important contributor to the book.

BELOW
This little A5 booklet, produced for The Electricity Council, had sections on The Plan, The Services, The Look, The Big Buys, Quick Assembly and The Time Savers. In my introduction I said that although we may long for the nostalgia of the kitchens of the past, "electricity has obligingly done away with drudgery, and helped to make the whole cooking process a joy".

appeared in the school magazine, the *Bryanston Saga*, and just before I left school, I was invited to design the front cover of the magazine. As an "old boy", in 1997, I was very proud to do so again.

From the *Rayon and Design* magazine, which I art directed early on in my career, and the first book published in my own name, *Printed Textile Design*, to the Habitat catalogues and the scores of books I have written since, these projects have given me immense pleasure, while helping to drive my various businesses forward.

An early commercial venture into printed material landed me in scalding hot water, mind you. In the mid-1950s, I was a member of the Society of Industrial Artists, which had strict rules that members should not compete with one another. I employed six or seven designers at that stage and I needed to find work, so I started to think about how we could market our services. I decided to produce a simple newsletter, which we would print ourselves and send to potential clients, telling them about the work we had done and suggesting how our services might benefit them.

I received an irate phone call from the secretary of the Society, who had received a complaint about our newsletter from another member. So off I went to see the secretary, who wagged my "offensive newsletter" at me across his desk and said: "It is against the rules of the Society to solicit work in this way. You've been advertising to a company where one of our members already works and that's not allowed." I explained that we were a young, impoverished company and that I had to find work to pay my staff. His suggestion was that I join a

in Pall Mall, get talking to some chaps there and buy them a drink, in the hope that they might pass some work my way. I believe that the architect Basil Spence proposed me to The Travellers Club, although I certainly couldn't afford the membership fees back then; to this day, I think I am still an unpaid member there.

At any rate, I was appalled by the Secretary's suggestion and continued to produce my newsletters, which were proving to be very effective. Of course, I was thrown out of the Society. Some years later, though, I was asked to rejoin, as those in charge eventually embraced the idea that actively promoting your business and expanding your influence was not actually a bad thing. Can you imagine a company today not being allowed to promote itself commercially in the marketplace? It would be out of business before it had even begun.

The 1962 Habitat brochure for the flat-pack Summa range of furniture was our first commercially successful "catalogue", as it were, and a breakthrough in the way we marketed our products and furniture. It was a very well-designed brochure and the first time that we used room-set photography, rather than sterile product shots, which were common at the time.

I expanded on the idea when creating the Habitat catalogue in later years, which became an enormously influential part of our business. I felt that the catalogue was a great opportunity to give potential customers a peek at the sort of products we had in store – we put a vast amount of effort and creativity into the shop window to showcase our products and I felt that we could do even more to promote them.

The catalogue began as a fairly modest, hand-drawn leaflet of a few sheets bound in one corner. Put together in-house, it featured simple but very charming illustrations by Juliet Glynn Smith and David Wrenn. Habitat wasn't just about selling things, though – we were also selling a style of life that people could aspire to and easily achieve. If they couldn't imagine how our products and furniture might look in a domestic setting, we were able to show them before they committed to buying anything.

The team enjoyed creating the catalogue, and the immediate response from our customers was enthusiastic, so the project grew and grew. The catalogue became much more sophisticated and was produced annually. We introduced photography and colour, and added editorial features, such as recipes.

Stafford Cliff took over the design of the catalogue in 1971 and introduced the idea of using actual homes for room sets, rather than studios. We did quite a lot of the photography in my houses to begin with, and then started using properties in France, which fitted in perfectly with our philosophy. Stafford developed the idea of placing Habitat products alongside antique furniture and accessories to show how everything could work in the context of people's own homes and give a much higher degree of reality.

ABOVE
In 1984 Weidenfeld & Nicolson published the first Conran Habitat biography, written by Barty Phillips, a journalist at the *Observer*, whom I had known for years. She interviewed all the main players of the time and managed to create a fairly accurate record of the Habitat story. The cover was designed in-house by Guy Fortescue, an associate director of the graphics studio and, for many years, our man in charge of the production of the Habitat catalogues.

These days, there are scores of magazines and television programmes educating the consumer but back in the 1960s they were few and far between. Our catalogue was a rather jolly and very effective way to sell our vision of the world as we tried to impart the spirit of Habitat through its pages. We wanted to inspire people and make them think, "We could live like that." The Habitat catalogue was our very own book of ideas.

My first major book grew out of my work with Habitat and actually started life as an in-house training manual for our staff. I worked on it with Stafford and it just grew and grew as a project. Eventually, we realized we had an absolute smash hit on our hands. *The House Book* was published by Mitchell Beazley in 1974. Drawing on my own personal experience of converting houses , it was full of practical advice about how to do things around the home, as well as providing decorating inspiration and ideas. Stafford was an absolutely brilliant designer to work with, and *The House Book* was very much ahead of its time. It wasn't an overnight success, mind you. I think we sold 75,000 copies in the first year, but it went on to become an international bestseller. At the last count, it had sold more than two and a half million copies – not bad for an idea with such modest beginnings.

Paul Hamlyn and I established Conran Octopus Publishing in 1985, with a vision to produce inspiring, educational books on subjects we were passionate about. In my long life, I have written more than 60 books, all connected in some way to my work as a designer: about every room in the home, as well as the garden; about food, cooking and restaurants. We have done DIY manuals and explored the world of design itself. I have also enjoyed many successful collaborations with people I have loved and admired, such as Dan Pearson, Diarmuid Gavin, Peter Prescott, Stephen Bayley, Stafford Cliff and my wife Vicki.

Writing books has allowed me to indulge my passions and enjoy a temporary escape from the pressures of running several international design, retail and restaurant businesses. If pushed to pick a favourite, I would say *Terence Conran's France*. In many respects, it was written as my personal love letter to the country that has always been the greatest inspiration to me. Working with the editor and designer on this book was an absolute dream, and in the end we had to reluctantly pick just 500 pictures, even though I could have chosen 500 more, had the number of pages allowed it. It really was the most enjoyable book to put together and I hope we managed to capture the spirit and qualities of France that have captivated me so much since I was a young man.

In producing a variety of interesting and informative publications, I have had the pleasure of working with countless talented editors, graphic designers, art directors, picture researchers and photographers. Whether it is a book, catalogue, company brochure or magazine, I don't think there is a better way of getting your products out to a vast audience, or a simpler or more effective method of putting your ideas and beliefs in front of people, to give them a pleasurable opportunity to make their own choices. It is certainly far more powerful and satisfying than joining a gentlemen's club in Pall Mall!

BELOW
Terence Conran's France was the book that gave me the most pleasure to put together. A feast for the eye, it looked at life in the country that has utterly seduced me. I love the simplicity of the cover, with its photograph of a meadow by Michael Busselle.

A HISTORY OF HEAL'S

ABOVE

In 1984, following the purchase of Heal's, we designed a 138-page paperback book subtitled, "At the sign of the four poster". Written by Susanna Gooden, it told the story of Heal's from its foundation in 1810 to the present day. Drawing on the incredible Heal's archive, kept by the wonderful in-house archivist Robin Hartley, and the memories of Anthony Heal, the book finished with pictures of the newly designed shop interiors, and a few memories from me. I recalled having been brought there as a child, to revel in the toy department at Christmas time, and, later, doing the rounds with my fabrics portfolio, trying to get them to give me a job. The cover illustration was by David Penney.

"I think that with Mothercare we managed to demonstrate to the British retail world how important design could be on the high street."

SPRING 1987

mothercare

30p

OPPOSITE

This cover for the Spring 1987
Mothercare catalogue is still
one of my favourites.

THIS PAGE

With the Mothercare catalogues,
we were trying to show that even
"difficult" products could be
designed and presented in a
stylish, modern way. As with
all regular catalogue work, the
process was almost continuous,
beginning with casting sessions
for new babies and toddlers each
spring. Ken Lumsdale led our
tireless design team, and most
of the photography took place in
our studio complex in Brewery
Road, north London. These
pages show some of the dozens
of products that we were
simultaneously designing,
including young fashion
collections, carrycots (bassinets)
and pushchairs (strollers),
babycare product packaging and
toddlers' unbreakable tableware.

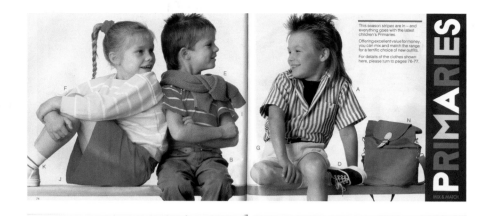

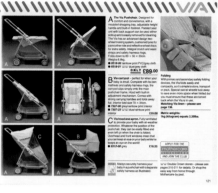

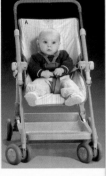

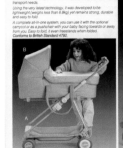

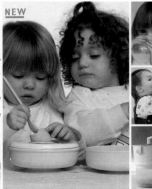

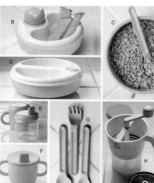

UPHOLSTERED FURNITURE RANGES FROM THE CONRAN SHOP, 77 FULHAM ROAD LONDON SW3, 01.589 7401

ABOVE

The front cover of a modest
16-page, black-and-white leaflet
to promote the furniture ranges
at The Conran Shop in the mid-
1980s. The pattern was also used
on tissue paper for wrapping
purchases at the cash desk.
It is a terrific piece of design
by Stafford Cliff.

OPPOSITE

Designed by James Pyott and
photographed by Henry Bourne,
this 1995 catalogue cover for
The Conran Shop was based
on the idea of revealing new
products. The bondage concept
seemed to convey a fresh and
risqué, burlesque approach,
which was unique for a furniture

catalogue. Inside, the theme was
progressed with equal irreverence,
by juxtaposing furniture into
groups and leaving unrelated
objects, such as lunch and
cleaning products, at the edge of
the crop frame. This began a new
trend for more progressive art
direction and remains a fresh
approach some 20 years later.

£2·50

THE
CONRAN
SHOP

FURNITURE CATALOGUE

MOVING IN

£2.95

THE
CONRAN
SHOP

LONDON PARIS TOKYO HAMBURG FUKUOKA

OPPOSITE & THIS PAGE
In 1996, with Conran Shops in London, Paris, Hamburg, Tokyo, and Fukuoka, Robin Route and the team produced an incredible product catalogue to illustrate some of our range of more than 13,000 products for the home, including furniture, bedding, china, glass and giftware. These pictures show the front cover and the opening spread, with photographs by James Merrell and styling by Anita Buston.

"Following on from Habitat, we wanted to create a new brand image for The Conran Shop. The design we came up with was more sophisticated and the look more seductive."

The first edition of *The House Book*, designed by Stafford Cliff and published by Mitchell Beazley in 1974, came in a cardboard slipcase, with a cut-out window that revealed one of a series of eight differently shaped windows that looked into different rooms of the house. The 448-page book was a ground-breakingly ambitious attempt to guide the reader through every stage of buying and furnishing a home, from "simple" structural improvements, such as converting an attic, to finishing touches, such as choosing taps (faucets), arranging pictures and deciding on the right style of house number for the front door. Under the brilliant editorship of Beverley Hilton and Maria Kroll, 28 experts were commissioned to offer their expert advice on various topics. For the book's launch, Oliver Gregory and I bought a run-down house in Islington, north London, and renovated it, to illustrate the various aspects of the book. It remained open to the public for a few months afterwards.

THIS PAGE

As styles for interiors change rapidly, there was the opportunity to produce many additional house books including the *New House Book* designed by Douglas Wilson; *The Essential House Book* art directed by Helen Lewis; *The Ultimate House Book*, art directed by Alan McDougall & Broadbase and *The Eco House Book* art directed by Jonathan Christie. I believe that after all these years there is still room to do one more.

"*The House Book* was full of practical advice, as well as providing decorating inspiration and ideas. It was very much ahead of its time."

OPPOSITE & THIS PAGE

The great pleasure I get from writing books is that they are all in some way connected to my life in design. They reflect my lifelong interest in food and restaurants, the home and gardening, as well as cities that excite me and places and objects that inspire me. I suppose they all add up to what I call a "style of life".

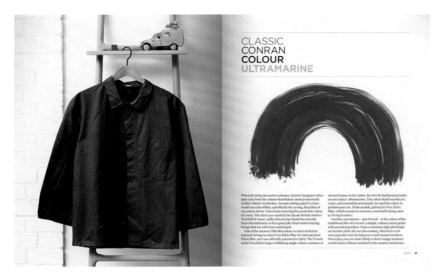

THIS PAGE
A selection of pages from my books that I hope have given people ideas, inspiration or enjoyment over the years.
Above: Tips for using my signature colour, "Conran Blue", or ultramarine, in *Conran on Colour* (2015) art directed by Jonathan Christie.
Middle: Ideas for displaying objects or artwork on walls and shelving in *The House Book* (1974) art directed by Stafford Cliff.
Below: A mouthwatering recipe for roast mallard from *The Bibendum Cookbook* (2008) photographed by Lisa Linder and art directed by Jonathan Christie.

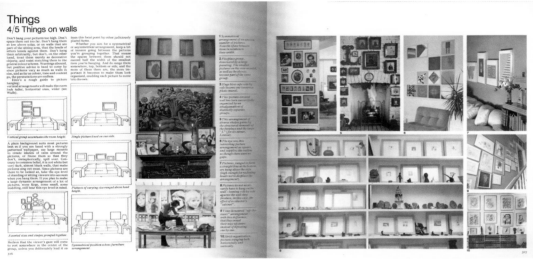

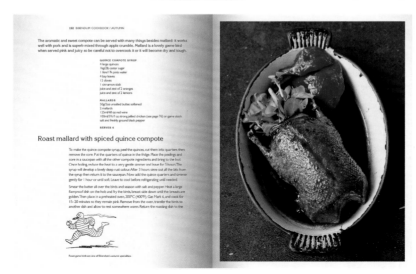

OPPOSITE
I particularly enjoyed working on this book *Design: Intelligence Made Visible* (2007) art directed by Jonathan Christie. My co-author, Stephen Bayley, was the first – and very enthusiastic – director of the Design Museum. The famous Le Corbusier quote that design is "intelligence made visible" was our title; I must say, Stephen taught me more than a few things about design history that I didn't know before.

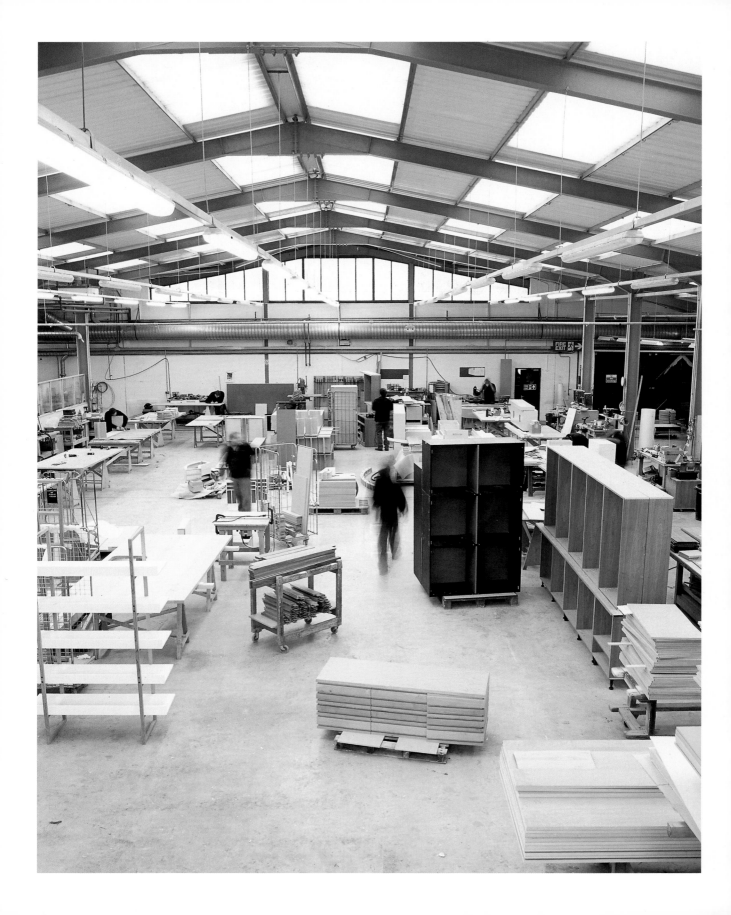

Furniture

In my heart, I have always considered myself a furniture maker. When I was around ten years old, I grew frustrated making a bookcase and hurled it down the stairs, where it completely disintegrated, sending my mother into a fury. "Pick up all the pieces and go back upstairs and don't come down until it's finished."

And that is exactly what I did. The joy of actually finishing the bloody bookcase made me feel ecstatic, which was the start of me as a furniture maker. Soon after, my mother set me up with a new set of tools in a proper workshop in the outbuildings of the old farmhouse where we lived. I was on my way.

My early furniture making was pretty rough-and-ready. When I was a student, Scandinavian craftsmanship was always very important to me, but even more important was the Bauhaus, which was all about mechanization and being able to make metal-framed furniture, tube bending and the like. That is what interested me.

Around 1947, I had a small room in Warwick Gardens, Kensington, but I absolutely

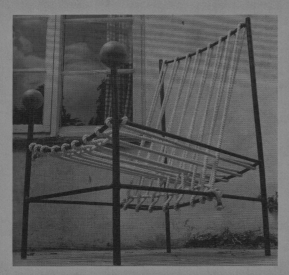

detested the furniture in it and wanted to make my own. The only problem was I didn't have much of a clue as to how to go about it. My great friend and mentor Eduardo Paolozzi suggested we share a workshop. We rented a small space in Roman Road, Bethnal Green, acquired some simple tools and basic welding equipment, and set about making things. Materials and equipment were scarce in those frugal, post-war years, so we scrounged old bits of metal from building sites and textiles from stalls on Petticoat Lane.

I used welded-reinforcing rods to make the frames for chairs or the base of a bed, and pine flooring boards for shelving units. My wobbly trestle table had an old door as its top. I used coloured felt for cushions and printed curtains in a very Paolozzi-like pattern.

I began to appreciate that designers have to get their hands dirty making things. They have to understand materials and processes, learn how to use their tools and, later, understand the way machines work.

Commercially, I had some notable early successes, and I remember being very proud when the great American architect Philip Johnson bought one of my chairs. More impressively, a friend of mine from Bryanston, Toby Jellinek, had a girlfriend who lived in the south of France and was Pablo Picasso's current model. Toby bought her one of my chairs – a rope seat with large, wooden balls – and Picasso liked it so much he ordered two of them for his studio. I once met his daughter, Paloma, and she remembered sitting in them as a child, so it was a great thrill to know they had been used.

I moved to a new workshop in Notting Hill Gate, in the basement beneath Ballet Rambert. Nobody else would take the space because of the pounding of ballerinas practising above, but it was perfect for a noisy furniture maker and cost me £1.10s a week. I made tables with black-and-white tiled tops, cabinets with black-and-white sliding doors, and chairs with cane woven onto metal frames. I made terracotta cones in all shapes and sizes that I suspended in metal tripods for use as planters, which were very popular – they even sold in John Lewis on Oxford Street. Looking back, I am rather proud of my early furniture, which today still seems relatively fresh.

The next few years were a very important time in my life because I took on staff and had responsibility for finding work to keep them busy and paying wages and tax. I had to define my objectives and target the sort of customers I was aiming to sell my furniture to, which meant creating the type of furniture they might buy.

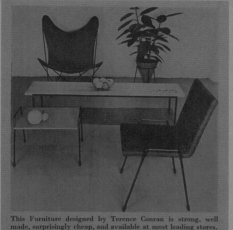

This Furniture designed by Terence Conran is strong, well made, surprisingly cheap, and available at most leading stores. Catalogues will be sent upon application.
Sole manufacturers and distributors of conical plant pots and holders.
Approximate retail prices of furniture shown in the above photograph : Conical plant pot and holder (P.3) £1.8.6. Canvas and metal Tripolina chair in red, orange, green, etc., £6.16.0. 5' long coffee table, ash top (T.6) £8.9.6. Stacking table with beech top (T.4) £1.15.0. Dunlopillo upholstered dining chair, various colours (C.4) £6.16.0.

CONRAN FURNITURE
22 Piccadilly Arcade, S.W.1 HYDe Park 9210

Outside of Heal's, John Lewis and Elders of Glasgow, there were no decent outlets for the furniture I wanted to make, so I focused on selling contract furniture to architects – hospitals, offices, universities, schools and libraries were being rebuilt after the Second World War and there was plenty of work. As the business expanded, I moved the workshop to Donne Place, Chelsea, where we spread over three floors, and established a tiny showroom underneath a flower shop in Piccadilly Arcade. We now had a name – Conran Furniture – and employed ten people. After gradually adding more sophisticated equipment, we moved our showroom to former stables in Cadogan Lane, Belgravia, which gave us a larger, elegant space to display our growing collection of furniture.

Our next move was to a large, completely derelict building on North End Road, Fulham, in 1956 where we invested in our first proper woodworking machinery, including circular saws, a belt sander, a spindle moulder and a router. As we were based near Earls Court Exhibition Centre, we began taking on shopfitting and exhibition-stand work. We moved the furniture-making part of our business to Cock Yard in Camberwell, which had a proper woodworking mill. We also moved our design offices to Hanway Place in 1959, just behind the corner of Oxford Street and Tottenham Court Road, which reflected our status as a maturing company.

For the first time, we felt properly professional and able to take on the likes of furniture manufacturers Herman Miller and Knoll, which were starting to establish themselves in London. Although our furniture work was still primarily contract work for architects, our enormous and luxurious showroom encouraged a growing demand for private commissions for people's homes and I really wanted to take my business into the domestic furniture market.

By the beginning of 1960, though, it was clear we couldn't carry on with these rather ramshackle, oversized workshops at North End Road and Cock Yard. I had heard about a scheme being promoted by London County Council to move manufacturing out of the capital and to provide factories and housing for companies that wanted to do so. This seemed like a dream to me: a purpose-built factory equipped with new machinery, where we could plan the flow of our manufacturing.

Conran domestic furniture

We settled on the town Thetford in Norfolk. In the end, around 80 workers and their families agreed to leave London, and we moved in the summer of 1962. We celebrated with a party, and Paul Reilly, then head of the Design Council, agreed to perform the opening ceremony. We wanted to do something a little bit different that acknowledged our heritage as furniture makers, so we placed a plank of wood across the entrance, which Paul planned to cut with a circular saw. But the saw jammed and he almost cut his leg off! My factory at Thetford and our furniture became entwined with Habitat, which is a story told elsewhere (see page 44). As Habitat expanded, I didn't really make anything but prototypes for something like 15 years. I designed hundreds of pieces of furniture and thousands of products that other people made in factories around the world, but I missed the fundamental, sleeves-rolled-up pleasure of using my creativity to make furniture.

One day in 1983 I received a call from Sean Sutcliffe, who had just graduated from Parnham College in Dorset. He had heard that I might have some spare workshop space at Barton Court, and he was right. His timing couldn't have been better, especially as my restless soul was pining to return to its furniture-making roots. Sean was a devotee of woodworking and we hit it off immediately. Our dream was to create a craft-based workshop and produce high-quality, beautifully designed furniture on a fairly big scale. I offered to back Sean in a new company, with him as managing director. We agreed that there was no chance of making a living from furniture without machinery, so from the start this was a serious business, rather than a romantic ideal. We converted and rebuilt the derelict farm buildings attached to Barton Court, and Benchmark was born.

Not many things over the last 30 years have given me as much pleasure as having a design-led, furniture-making factory right on my doorstep. It is quite unusual to have a saw mill filled with rough logs at one end of a site and an elegant showroom at the other selling the finished furniture. They may be only 180m (200 yards) apart, but it is everything in the middle – the process through the factory – that really excites me.

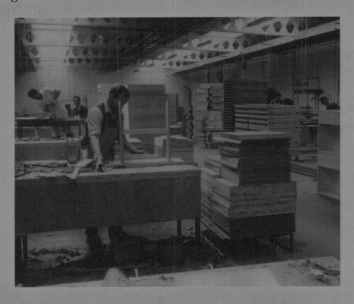

We've expanded Benchmark slowly, bit by bit, enlarging our space, putting in a timber shed and mill, adding the latest, most sophisticated machinery and increasing our workforce to around 65. At the heart of its growth has been a scheme replicating traditional apprenticeships in cabinet making. Since taking on our first apprentice in 1987, well over 50 young people from the local area have qualified in cabinet-making and woodworking, with more than half remaining with the company, including some of our most senior directors, which fills me with pride. This shared love of making furniture unites the whole team.

We approach everything at Benchmark in a sustainable way, from our choice of materials and our use of energy, to our designs and their longevity, and we are committed to making furniture that will last a lifetime. We are very proud to have twice been awarded the Queen's Award for Sustainable Development.

Not only do we make domestic furniture, but we have also taken on a huge amount of contract work in the past 30 years, completing more than 1,000 jobs around the world for luxury fashion stores, theatres, offices, schools, museums, restaurants, hotels and bars, and a cathedral. We have even produced a custom-made replica of the front door at 10 Downing Street as part of an art installation that will tour the world promoting British business. Clients, particularly architects, come to us with huge, fascinating and complex projects because they know how well we understand wood, its properties and its potential. We have also added metalworking skills to our repertoire, such as wrapping zinc, brass, copper and pewter around wood forms.

I think we have created a pretty special business at Benchmark, achieving the early dreams that Sean and I shared, while adding quite a few ambitions along the way. What's more, we are looking to expand Benchmark even further, perhaps with a bigger showroom, more technology and new workshops. I love having people with whom I can discuss design details, materials, construction methods and finishes so close to me – fellow craftsmen who share my love of making furniture.

BELOW
Our factory in Thetford, probably in 1962, where, for the first time, we were able to make in quantity. Inspired by the German manufacturer Thonet and my knowledge that boatloads of Thonet parts were moved across the world and then assembled at their destination, we adopted the idea of flat-pack furniture. It was quite a challenge, though, because the pieces had to be made with such precision.

OPPOSITE
The "Ashworth" table and chair, part of the Conran range of furniture at M&S. I like the clean lines, gently tapered legs and subtle detailing, which create a very modern look. The "Ashworth" range also features a glass-topped dining table.

The top floor of my home at 11 Regent's Park Terrace, London, which I shared with Shirley in 1955. I designed and made most of the furniture in these two pictures myself – even then I had pretty clear ideas about how I wanted to live. It was here where I first experimented with open-plan living, converting three small rooms into one large space, which ran from the front to the back of the house, flooding the space with natural light from the large windows at the front. The overall effect prefigured Habitat in many ways. In the picture below, you can see my favourite textile print, "Leaf", on the wall.

OPPOSITE
Early Conran furniture from the 1950s on display in the Design Museum in 2011. I hadn't seen any of these pieces for more than 50 years, so it was very emotional for me to touch and feel them, to actually run my fingers over the metalwork I had welded by hand more than half a century before. I allowed myself a smile at how good they still looked, slightly rough-and-ready, but considering they were designed and built in the 1950s, I was pleased that they still looked fairly relevant to contemporary design.

"I used welded, reinforcing rods to make the frames for chairs or the base of a bed, and pine flooring boards were made into shelving units . My wobbly trestle table had an old door as its top. Looking back, I am rather proud of my early furniture and it still seems relatively fresh today."

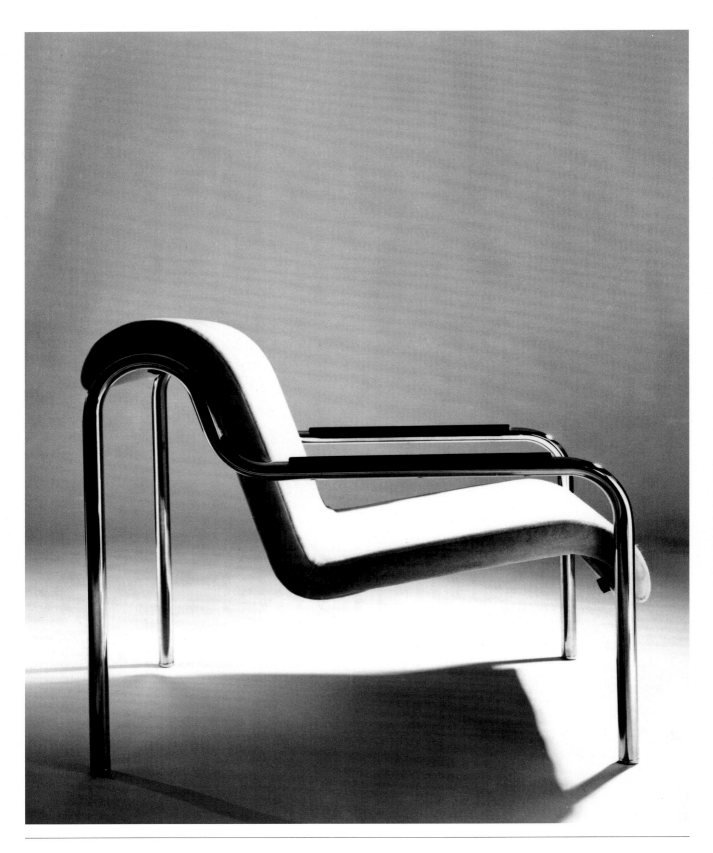

Part of a range of furniture commissioned by BAA (British Airports Authority) for Terminal 1 at Heathrow in 1968, designed by me and refined by Peter Crutch to "create movement, warmth and colour, and to meet the functional essentials of durability, easy maintenance and flexibility". The pieces were made by Alan Zoeftig and looked very modern at the time. It was important for the chair to be comfortable but not so that people would fall asleep in it.

LEFT

The "Pliable Man's Chair", designed in 2010 and made by Benchmark in laminated birch with a lacquer finish. I have always been interested in laminated wood but I haven't achieved anywhere near as much with it as someone such as Charles Eames. This is a very comfy chair to sit in and smoke a cigar, and the useful lip allows you to keep a glass of something decent on hand.

BELOW

This Benchmark club chair, which I designed in 2009, was made for the Lutyens Cellar Rooms, the private members club and bar in London's Fleet Street. It is exceptionally comfortable to sit in and perfect for relaxing in the art deco-inspired interior.

"More than any other piece of design, the chair reveals most about the principles, philosophy and style of a designer. I sometimes think you are unlikely to be perceived as a successful designer until you have designed a classic or iconic chair."

LES MEUBLES PRISUNIC

ABOVE

I first sold my furniture in France in 1968. I was approached by a young home-furnishings buyer, Francis Bruguière, for Prisunic, and asked to design some furniture. Prisunic's stores weren't suitable for displaying and selling contemporary furniture, so Francis's solution was to produce a catalogue, and he wanted to feature an important modern designer in each issue. His style director, Denise Fayolle, kindly suggested he approach me, as she had heard the buzz around Habitat. The range was mostly "modern-classic", with a light wood feel, and made in France by LaFargue. The prices were *modique* and the range sold well. I very much enjoyed working with Francis and Denise, and they were highly influential a few years later when we decided to open Habitat in France. We became lifelong friends.

OPPOSITE

The "Brimstone" side table that I designed for Benchmark in 2010. The turned-oak pedestal pokes through the classic Carrara marble top, making a rather pleasing contrast. It is a robust piece of furniture that still brings a very light, airy feel to a room.

Bibendum was the first restaurant that Benchmark furnished. It made practically every piece of furniture in it, marking the start of a long involvement with restaurants and bars, which now total more than 200. The magnificent, silver-plated waiter station has always been a grand focal point of Bibendum – a hard-working altar in the very centre of the space. I couldn't be prouder that the restaurant has required only one minor refurbishment during all its years – it looks as beautiful as it did when it first opened. I don't think most people realize just how much use and abuse the furniture in restaurants receives, so this is quite remarkable.

RIGHT

The "Clifton" range for Benchmark was one of my favourite-ever designs. As well as these shelves, the collection included a table, bench and console, all made from solid ash grown in Britain. I took the design's name from the Clifton Suspension Bridge in Bristol, as it features stainless-steel tension wires. Its sleek structure also belies the actual strength of the unit – it really can hold a terrific amount of weight if needed.

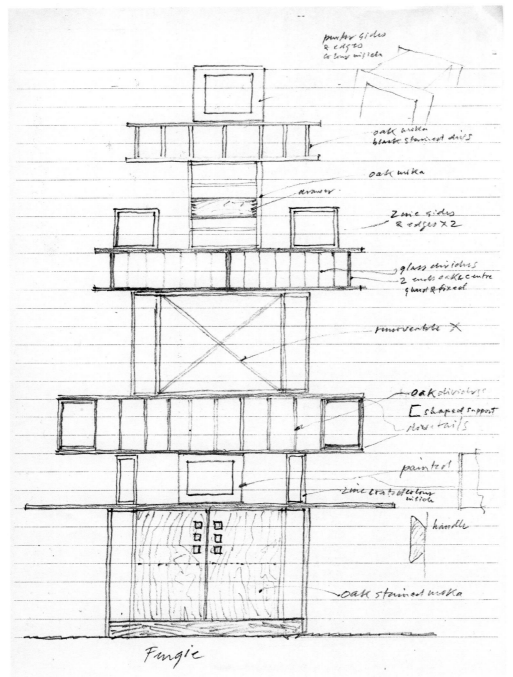

The handwritten annotations on the sketch read:

pewter sides & edges to lens inside

oak inlka black stained divs

oak inlka

drawer

zinc sides & edges x 2

glass dividers 2 ends oak & centre glass & fixed

removable X

oak dividers

L shaped support

dovetails

painted

zinc crate colour inside

handle

oak stained inlka

Fungie

A fairly elaborate sketch of an idea that I had for a shelving unit. It was inspired by a stack of rather precarious-looking antique boxes at Barton Court that hold my collection of butterflies and hawk moths. I don't think the technical team at Benchmark would have thanked me much had I pursued the idea.

OPPOSITE

The "Balance" shelving unit is, thankfully, a much simpler and more elegant piece of design and has been a key feature of the "Content by Terence Conran" range ever since we launched it in 2003. The unit is sold in John Lewis and independent retailers up and down the UK and is great for storing books or displaying objects and collections. We have been able to adapt "Balance" very well – the range now includes a coffee table, console table and side table. We have also added flashes of colour, as in this "Mondrian" special edition (below).

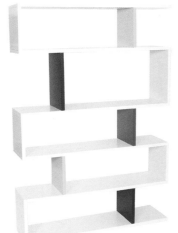

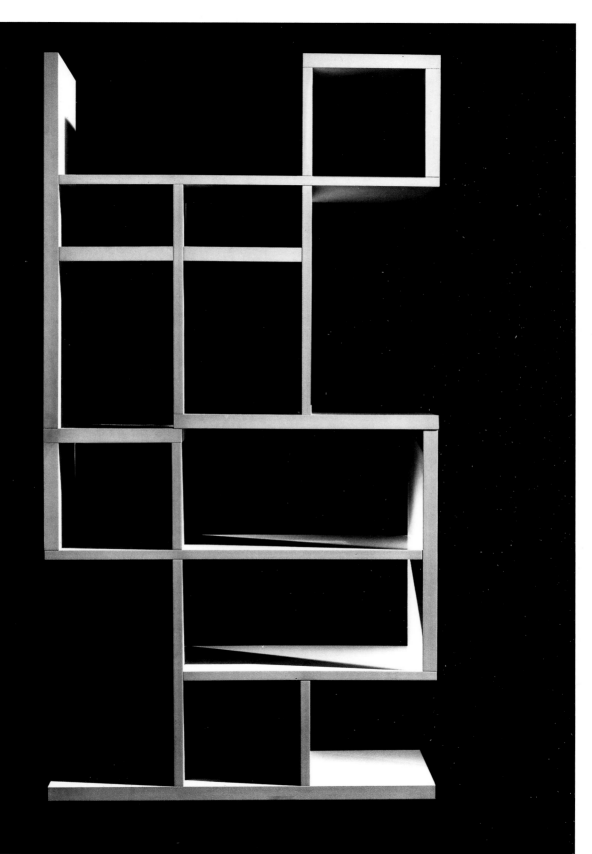

"The marriage of fine craftsmanship with considered design and detail is the secret ingredient that makes pieces by Benchmark so special."

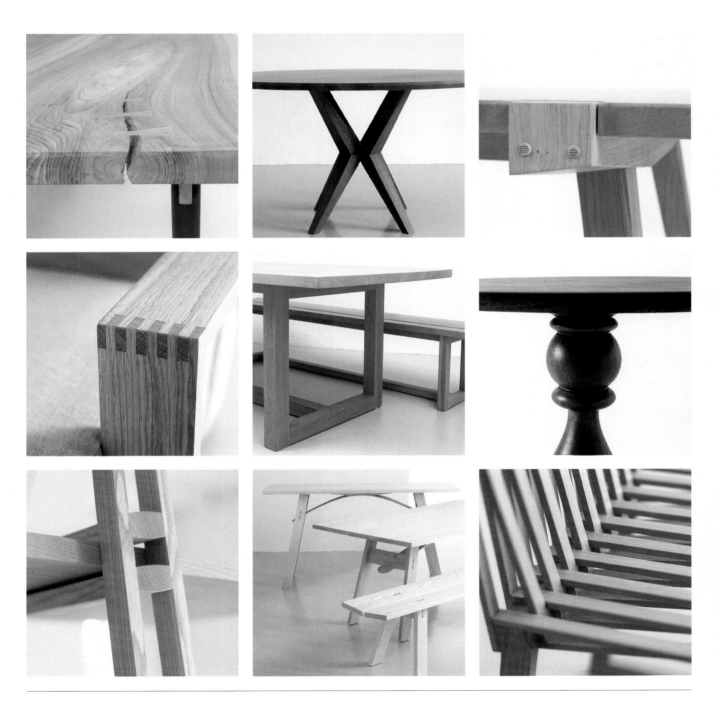

OPPOSITE & THIS PAGE
I think these images of Benchmark furniture are perhaps my favourite pages in the book. They capture the brilliance and fundamental philosophy of a very special company with a very talented design team: exceptional craftsmanship, immaculate detailing and the use of natural, sustainable materials.

Opposite, row 1: detail of the "Darby" dining table by Steve Owens; "Jack" dining table by Steve Owens; detail of the "Mason" dining table by Steve Owens. Row 2: detail of the comb joint of "Alvis" sofa by Terence Conran; Peter Lowe's 8 seat "Bailey" table; detail of the "Barnabas" table by Hannah Stowell. Row 3: detail of the "Clifton" unit by Terence Conran; "Clifton" table and bench by Terence Conran; detail of the "Comb" chair by Shin and Tomoko Azumi. Below, row 1: detail of the "Clifton" bench by Terence Conran; "Maiden" dining table and stool by Russell Pinch; detail of the "Stiletto" side table by Sean Sutcliffe. Row 2: "Cristo" chair by Terence Conran; detail of the "Mrs B" bench by Russell Pinch; "Darcey" dining table by Steuart Padwick. Row 3: detail of the "Planks" console trunk by Max Lamb; "Plank" table or stool by Thomas Heatherwick; detail of the "Honor" chest of drawers by Terence Conran.

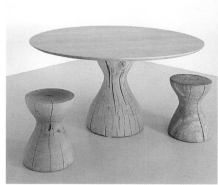

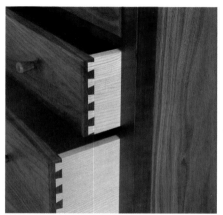

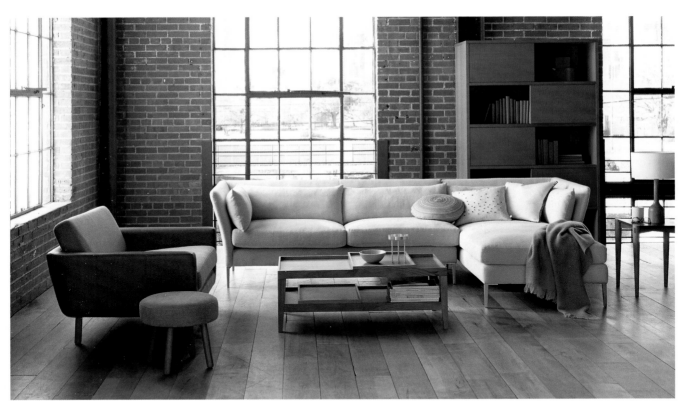

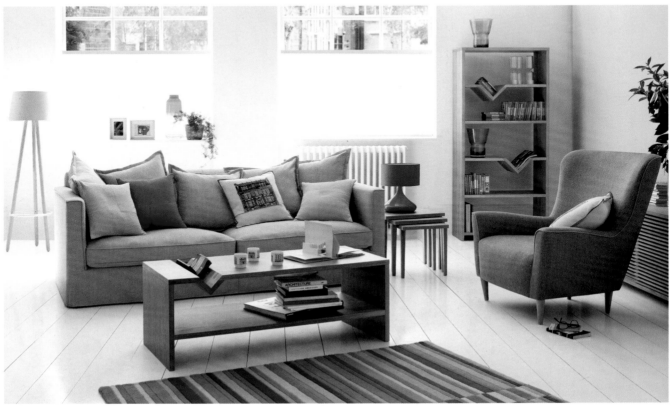

OPPOSITE ABOVE

I have been using room-set photography to demonstrate how my furniture might look in people's homes since the 1950s, but I particularly like these rooms, styled by Jill Webb, for our collection for JCPenney in America. In 2013, we were asked to design a vast collection of modern furniture and homewares for the retailer, which wanted to use intelligent design to refresh and renew their stores. Although the collection is no longer sold in America, it was much praised by consumers and the media alike, and I am very proud of the work we did for them. It was bright, fresh and interesting, and I think it certainly has a place on today's high street somewhere, but perhaps not in America!

OPPOSITE BELOW

A room-set for our Marks & Spencer collection featuring furniture and products from the latest range. Again it was styled by Jill Webb and feels like a light, airy space where you could live quite happily.

ABOVE RIGHT

This picture from the early 1960s shows our "Abacus" range of modular unit seating. It was very popular at the time, particularly with universities, but I really wanted to see it in people's homes, hence this room set. Also in the picture is the SK4 record player designed by Dieter Rams and Hans Gugelot for Braun. If you look very, very closely, you can see the House of Cards toy by Charles Eames on the table.

BELOW RIGHT

This chair and day bed from the early 1960s were from our "Summa" range, made in our factory in Thetford, Norfolk. We had acquired an old maltings building there, where we began to produce our own upholstery. This definitely helped to give our furniture the domestic feel we were aiming for.

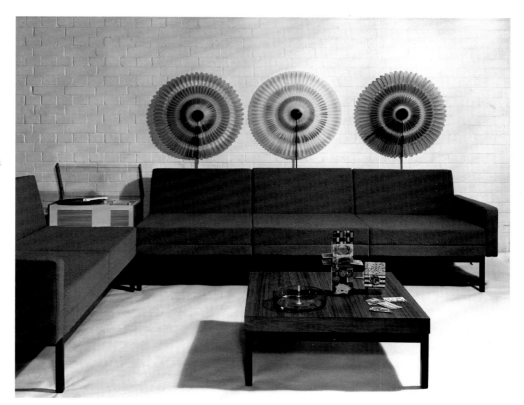

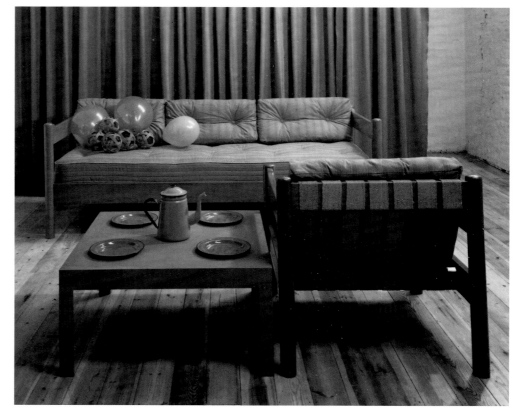

Products

A popular Shaker mantra that has always seemed relevant to my design work is: "That which has in itself the highest use possesses the greatest beauty." Simple, well-designed products have always been at the heart of my life and work, whether as a designer, retailer or just as a collector of beautiful objects. They really are the key to a comfortable and easy way of life.

OPPOSITE
My son Sebastian and his design team created this elegant collection of tableware called iCon in 2013 for the Germany-based manufacturer Leonardo. There were 50 pieces in the collection, inspired by natural forms and Zen food culture and made from a combination of porcelain, glass and bamboo.

I have always believed that good design should be democratic and available to as many people as possible, and that the role of a designer is to provide contemporary solutions to modern life. Accordingly, I have tried to design products for the home that make life easier and strip it of complications and strife – well-made things that grow old gracefully and slip seamlessly into people's lives and give them years of pleasure.

These principles have been at the heart of my design philosophy for as long as I can remember, and I suppose my passion for products started when I was a schoolboy at Bryanston. I was absolutely devoted to pottery under the guidance of my tutor Don Potter, who was very much my inspiration from the beginning. He had been taught to sculpt and carve by Eric Gill and was heavily influenced by Bernard Leach. I learned that the shape, texture and colour of things mattered, and that was probably when I started to think like a designer. Bryanston definitely developed my confidence in my practical abilities and allowed my creativity to flourish. It shaped the way I saw the world and appreciated things.

I remember Don helping me and others to set up a wood-fired kiln in the cellar and we were allowed to sit up with a keg of beer at night, keeping the kiln burning – I spent many a long evening down in the pottery. In school holidays, I worked at Wrecclesham Pottery near Farnham, in Surrey, making terracotta pots, and I also built my own kiln at home so I could "potter" to my heart's content. Priscilla, my sister, used to tease me that Old Shepherd's Farm, where we lived, had become a craft centre.

The work that my fellow students and I produced at Bryanston must have been to a good standard, as we put on an exhibition in Heal's, where I think an early Conran pot sold for 10s. *The Times Educational Supplement* covered the exhibition and I am still very proud of the comment: "The slipware has a definite personality and the forms are simple, natural and strong."

We also went on school trips to visit stately homes, such as Montacute House in Somerset. I was astounded, although not necessarily impressed, by their magnificence – the opulence, grandeur, sumptuous decoration, gilt, velvet and Chippendale furniture – and spectacular gardens.

I was attracted to the working parts of the houses, "below stairs" – the wonderful kitchens, where everything worked and had a purpose, the dairy, the pantry, the robust gardener's sheds and the fantastic wine cellars. I was drawn to the products that the servants used because they were all practical and fit for the job in hand. This was an approach to life, with very Shaker-like principles that I could immediately identify with. I began to understand that plain, simple and useful things can also display a high degree of craft and finesse. These pieces of furniture, products and tools were basic and functional, absolutely stripped back to the bare essentials.

I knew I wouldn't be able to make the ornamental furniture and objects that featured in the upstairs world of those stately homes but I understood the purpose and construction of everything that featured downstairs in the servants' quarters and knew that I could reproduce it myself. I think both the moral and aesthetic lessons from those visits have remained with me ever since and they are what inspired me to become a designer of plain, simple and useful products.

An early design pioneer who had quite an influence on me was a chap called Roy Midwinter, who was the sales and design director of his family's company, Midwinter, a very small and traditional pottery in Stoke-on-Trent. Founded by his father in 1910, it churned out fairly dated ceramics with mimsy floral patterns. However, Roy had been to America on a sales trip and witnessed a design revolution taking place on the West Coast – the likes of Eva Zeisel's wonderful ceramics, and products by the prolific industrial designer Raymond Loewy.

Returning to extremely traditional Stoke-on-Trent, Roy was absolutely fired up with the idea that design could turn the family pottery into something terrific, and he managed to persuade his father that there was a market for modern, innovative products. I remember going to dinner with Roy around this time, and his passion for design was extraordinary. I shared his enthusiasm and was delighted when he asked me to work for them and fan the fire he had lit. I designed a showroom at his factory to complement his new products, and throughout the 1950s did simple line illustrations for his ceramics. The first one was called "Nature Study", which played on my childhood obsession with collecting butterflies and moths. I also did others of early steam trains, vintage cars and a couple of abstract works called "Melody" and "Chequers" (see page 35).

Looking back, I can't say that this work is something I am particularly proud of, but the important thing was that Roy's passion for using innovation and intelligent design revolutionized his company. It bridged the gap between the constipated conservatism of the early fifties and a more beautiful, optimistic future because he realized the true value of design.

As a designer, passion must be involved in everything you do, and if you ensure that intelligence is used in the design of your products, this will make a tremendous difference to your work. Roy recognized this, carried it through, got his products recognized all over the world and revolutionized his company.

The secret of our own success with Habitat was selling iconic but affordable products alongside our furniture. This approach gave the store vitality, surprise and delight. One of the big inspirations for this were the wonderful *quincailleries* (ironmongers) you would find in every small market town in France. They were filled to the gunwales with those simple, practical and useful things you need at home and in the garden. Everything at Habitat was intelligently designed because it had a job to do, with perhaps a slightly naïve but charming decoration added – certainly nothing flamboyant or pretentious.

The Habitat idea that buying a few products could completely refresh your home caught on very quickly. To make it onto the shelves, these products had to be simple and well designed. The key was always the price – you could have the most useful, beautiful product imaginable, but there would be no point to it whatsoever if it remained unaffordable and out of the customer's reach.

ABOVE
In 1988 we designed a range of home utilities housewares for Britain's leading plastic goods manufacturer Addis, that we called Via. The products, designed and drawn in this – one of a series of presentation sketches by Sebastian Conran – had a new "soft look" visual language, with clip-on components that could be produced in different colours.

I experienced a tremendous amount of joy during the early merchandizing meetings in the months leading up to the opening of Habitat, when the products we were thinking of stocking started to arrive. Occasionally, the team had no idea how some of the stuff worked, scalding themselves on coffee pots or trapping their fingers in the snap of the metal top on a Kilner jar. I think we derived the same element of discovery that our customers would later enjoy in the shop. As the buyers presented the products they had sourced, we would argue furiously about their respective merits: aesthetic, practical and economic. The team shared my philosophy and fervent belief that intelligently designed products would help people to enjoy a better life. It was a collective effort – the team really did believe just as passionately as I did in the products we were selling.

Introducing these new products to Britain wasn't all plain sailing, though. I remember how a shopper came into the Manchester branch with a bag of broken glass, plumped it down on the counter and said, "This pasta jar is no good." We asked, "Not good in what way?" "It broke when I put it on the gas," she explained. So, we asked, "Why did you do that?" The lady responded, "Well, it was too big to put in the oven."

I suppose our Habitat adventure was so exciting not just because of the new products we introduced but also because we changed the way they were sold, which was very different from the normal retailer. We stacked up our stock on the shelves, so the store was full of merchandise, creating a sense of fullness and generosity. I wanted people to touch the products, too, so they could enjoy the natural materials in the texture of things such as terracotta bowls and copper pans. There is definitely an emotive value in handling a product, and I think our approach made people really love being in our shop; it created a feeling of, "Oh, this is a marketplace" – very much like those *quincailleries* I first encountered in rural France.

Later, The Conran Shop initially grew out of our frustration at having to reject products because they were too unusual or too expensive for Habitat customers. We opened the first one in 1973 with Maggie Heaney as our first buyer. Sometime later, my sister Priscilla moved back from France and headed up the buying team. Moving The Conran Shop into Michelin House in 1987 gave us three times the space, and in many ways it became my dream store. Priscilla and her team did a terrific job, sourcing the very finest products from around the world, and with incredible consistency.

A single eye and a consistency of style are absolutely vital in retailing and selecting products. I remember being in India buying rugs for The Conran Shop. There was a huge pile of them, about 3m (10ft) high. I went through them one by one and out of hundreds I chose 27. The pile was reassembled and Priscilla went through the rugs and picked out the exact same 27 as I had. It was an extraordinary moment but demonstrates how important the Conran "eagle eye" was. We now have Conran Shops across the world and that same passion for products and consistency remains.

Looking back, I practically gasp at how many products we have designed or introduced to the marketplace over the past 60 years. It really must be tens of thousands of pieces, from homewares, kitchenware, pushchairs (strollers), cameras, audio equipment and car interiors to ceramics and textiles. They are designs that I believe have in some small way shaped how we live and made everyday life more in tune with what we really enjoy. I hope that Conran design – and the Conran "eye" – have endured the test of time and shown that useful can be beautiful, and that beautiful can be affordable.

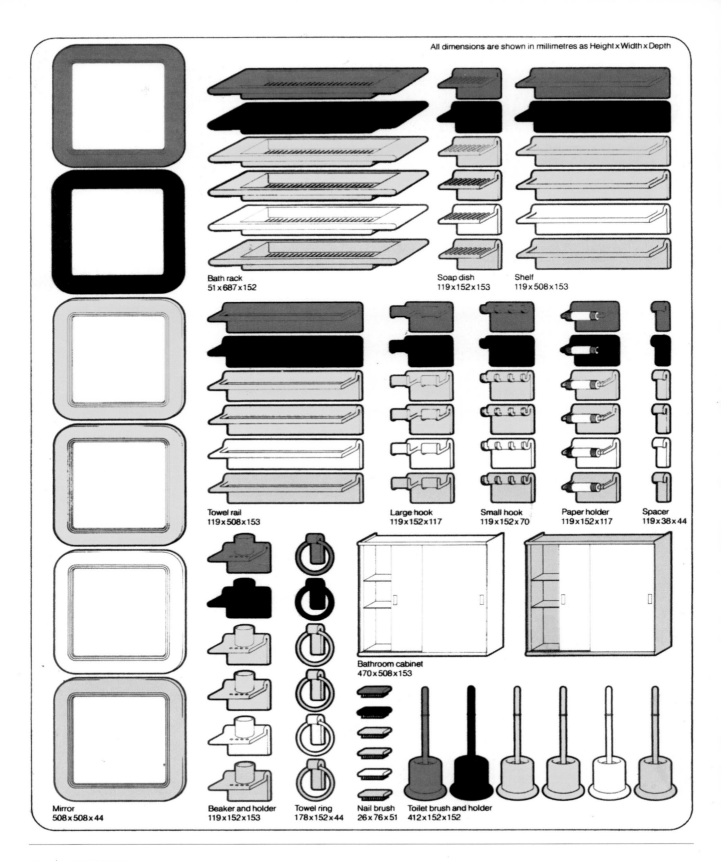

All dimensions are shown in millimetres as Height x Width x Depth

Bath rack
51 x 687 x 152

Soap dish
119 x 152 x 153

Shelf
119 x 508 x 153

Towel rail
119 x 508 x 153

Large hook
119 x 152 x 117

Small hook
119 x 152 x 70

Paper holder
119 x 152 x 117

Spacer
119 x 38 x 44

Bathroom cabinet
470 x 508 x 153

Mirror
508 x 508 x 44

Beaker and holder
119 x 152 x 153

Towel ring
178 x 152 x 44

Nail brush
26 x 76 x 51

Toilet brush and holder
412 x 152 x 152

"Such was the success of the Crayonne brand in changing people's attitudes towards long-lasting plastic products that the range we developed was selected for display by the Museum of Modern Art."

ABOVE

In 1973 Airfix Plastics wanted to produce household products in a more distinctive style than their usual buckets and bowls. Martin Roberts and our team began working with the company on product development, starting with the now iconic "Input" range of household containers, marketed under the Crayonne brand. The range, which won the Design Council Award, confounded sceptics, who said that virtually taperless products could not be moulded commercially in ABS plastic. The multimillion pound

Crayonne business came about because an entrepreneurial managing director of Airfix, David Singalia, recognized what designers could do for his company, and he slotted them accurately into his management team. We introduced a standard of manufacturing quality that became the hallmark of Airfix.

OPPOSITE

We then started to focus on specific rooms in the house. This was the extensive range of Crayonne bathroom items, for which we also designed launch brochures and packaging.

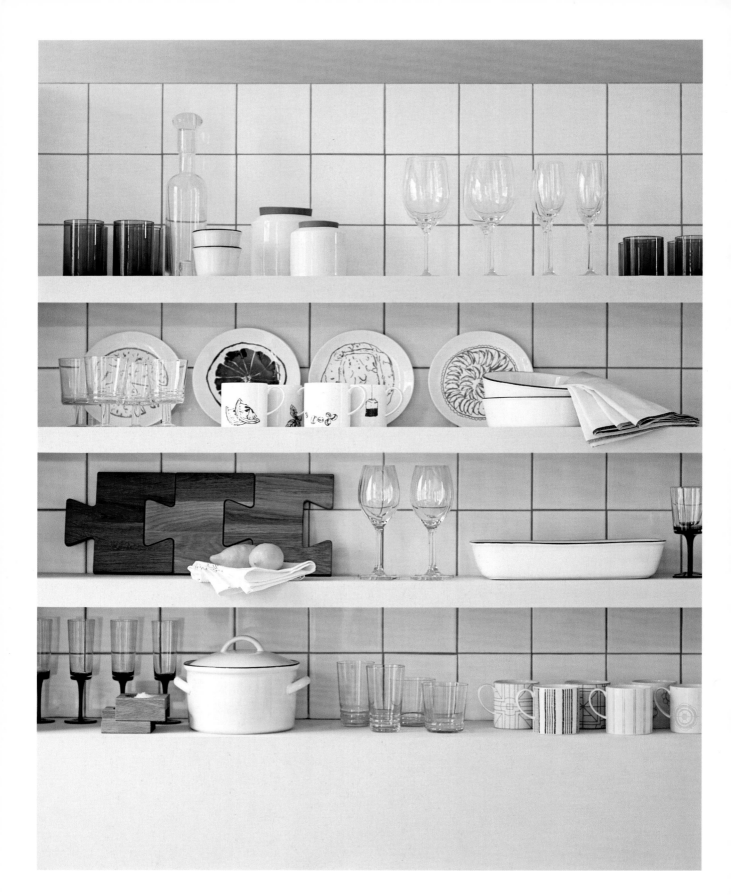

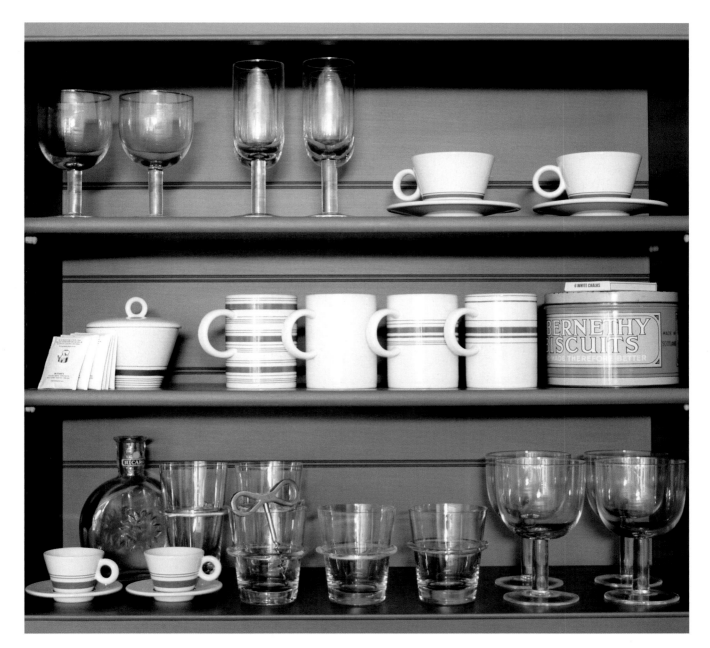

OPPOSITE

In 2010, Marc Bolland, the chief executive of M&S, approached us to design a collection of furniture and homewares. Marc is an inspirational retailer, who truly recognizes the value of good design. He wanted to use our Conran design signature to help grow their Home business. For me, it was the opportunity of a lifetime, the dream job to get Conran design back on the high street and fill a rather sad, Habitat-shaped hole in the marketplace. The first products were launched a year later in 2011, with Jill Webb leading the design team. This selection of products came from the later 2013 Spring/ Summer collection, which was bright, cheerful and very charming. It felt like it had been designed in the sunshine.

ABOVE

In 2006 I designed a collection of contemporary kitchenware and tableware for one of the world's best-known ceramics manufacturers, Royal Doulton, a fine British company founded in 1815. It was a very traditional, robust collection inspired by my nostalgia for the traditional working kitchen.

A selection of some of our
products designed for M&S.
Working with Jill Webb and
her design team on this dream
project was one of the happiest
and most creatively stimulating
times of my life. It was the
opportunity to produce a truly
democratic and British collection
of exceptional quality that would
be available to everybody. It was
everything that William Morris
and the Bauhaus, both great
inspirations to me, also hoped
to achieve.

ABOVE LEFT

The "Maclamp", probably one of the most iconic products I designed for Habitat in the 1960s. It had an adjustable beech arm, and the aluminium shades came in a variety of bright, cheerful colours. The lamps now seem to be highly collectable. I see them from time to time when I am rummaging around at flea markets. They often need rewiring and some TLC but they still look great.

LEFT

The "Beep" light really was the flagship product from our 2006 "Light by Conran" collection. My son Sebastian led the design team and he was absolutely in his element creating this product. Its simple, elegant form masks an innovative balanced construction of counterweights and hidden cables. Sebastian always had a passion for lighting design, seeing it as domestic sculpture.

ABOVE RIGHT

The "Leading Light" floor lamp, which I designed for Benchmark in 2015, features a solid, oiled walnut or oak shelf on patinated-steel legs. It goes very nicely next to an armchair or sofa, to create a perfect reading spot, and it has a handy place for a drink.

ABOVE LEFT
The "Nimbus" table lamp, which was designed in 2006 as part of the "Light by Conran" collection, has a unique pebbly shape.

LEFT
I designed the "Hector Bibendum" collection in 2011, to celebrate the 21st anniversary of British lighting manufacturer BTC and the centenary of Michelin House. I adapted BTC's original bone-china model of the "Hector" light to give it the curvy form of Monsieur Bibendum. We had it made at the same Stoke-on-Trent factory that had been used to make the original.

ABOVE RIGHT
This was one of a series of three modular chrome light fittings for contract and domestic use that we designed in 1971 for the German company ERCO Leuchten KG.

"As a designer, don't look upon yourself as a disciple. Look upon yourself as a good servant who is going to help people around you to enjoy their lives more."

OPPOSITE
When Sainsbury's launched their Home Store in 2003, they asked Conran to create an exclusive, high-quality cook-shop collection. The resulting "bY" range of 120-items included tableware, cook's knives, cookware, kitchen electricals and even a barbecue. All the items were sophisticated as well as robust. Our collection was based on informal cooking, eating and entertaining at home with simple, uncomplicated shapes like this collection of cutlery (flatware).

ABOVE LEFT
In 1999, Conran and Partners teamed up with Bliss Home to create "Equilibrium by Sebastian Conran", an award-winning collection of domestic products. It was launched with these iconic kitchen scales and pebble weights, which were plated zinc alloy castings, inspired by the shape of sea-worn pebbles.

ABOVE RIGHT
We launched the "Pente" collection of homewares in 2002, an innovative take on everyday domestic objects. It was a satisfying and solid range, and the cook's knives proved very popular with professional chefs, which was testament to their quality and durability.

BELOW
I was honoured when Alessi asked me to work with them for the first time in 2011 to celebrate my 80th birthday. I designed a stainless steel bowl with a Bibendum-ish, inverted beehive-shape that featured a distinctive double walled construction. As you would expect from a product in the "Alessi Officina" collection, it was beautifully crafted by highly skilled Italian artisans.

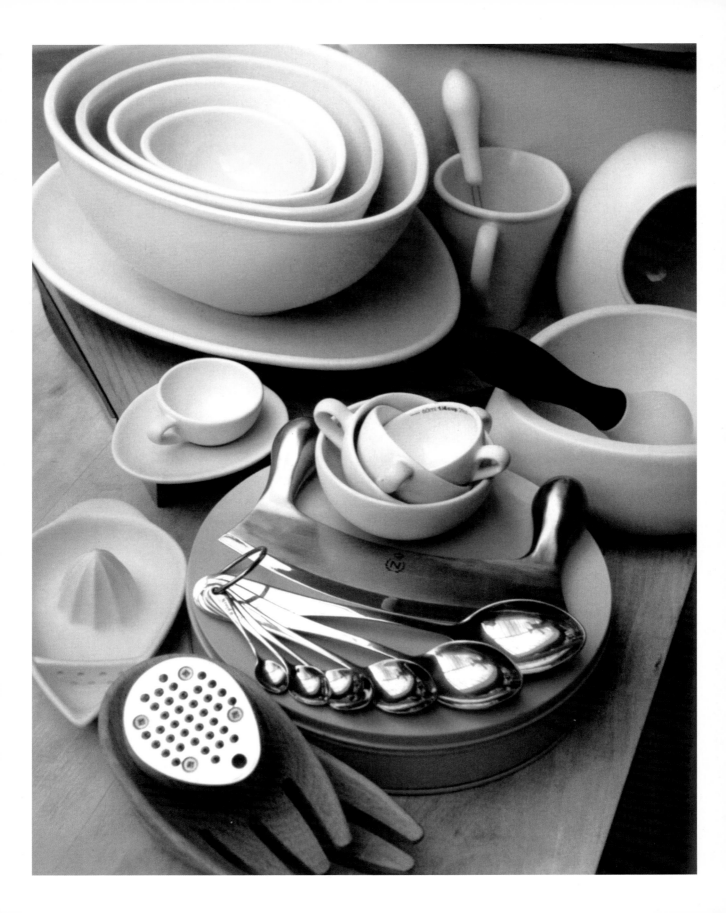

The Living Kitchen range was designed by the cook Nigella Lawson in 2003, in close collaboration with Conran and Partners, and with Sebastian leading the design team. It is one of the most successful ranges of kitchenware we have ever been involved with, and it still sells very well today, nearly 15 years after its launch. The extensive collection includes mixing bowls, stacking measuring cups, a charming modern take on the salt pig, a bread bin and storage jars, a pestle and mortar, parmesan grater, a mezzaluna and some rather nice pitchers. The collection was made with beautiful natural materials, in seductive, organic shapes and a delicious organic colour palette of clotted cream and duck-egg blue – just beautiful. One of the most significant things that Sebastian and Nigella did was resolve many practical difficulties in the kitchen, while losing nothing in terms of aesthetics. It really was good, clever design at its very best. All of the products were expertly made to high, exacting standards – the quality of the craftsmanship and durability of the products were standout features of the range.

"Kitchen equipment must be reliable but there must be pleasure beyond the functional." – Nigella Lawson

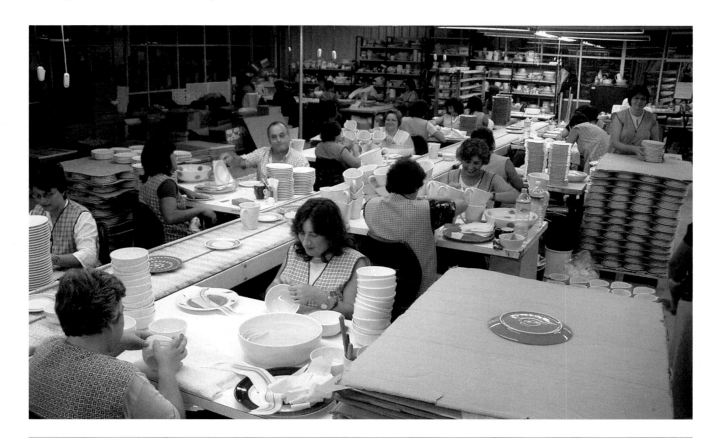

In 1995 we created the "Conran Collection", a core range of unique and timeless products, exclusively for The Conran Shop. As creative director, Alex Willcock hired a design team to develop, design, source and buy more than 1,300 new products that reflected the ethos of our brand. A young Russell Pinch was the first team member hired. This would become one of the most creative and productive design teams in Britain. The collection included everything from furniture, lighting, rugs, china and glass, office stationery and even food. We were trying to use good design to turn everyday objects, such as bowls (below) and book ends (opposite), into something special and express a spirit of confidence – modern living made simple, as we said at the time. The "Conran Collection" was quietly on trend, beautifully made and reflected the way we thought people would like to live. We worked with some of the best manufacturers and suppliers in the world to ensure the products were affordable, looked good and worked well.

The Design Museum

Perhaps the most important moment in my long career in design so far is the creation of the new Design Museum in Kensington. In this world-class space, with the size and scope for the serious promotion and celebration of design and architecture in Britain, all my dreams and ambitions for an exhibition venue devoted to design have come true.

OPPOSITE
Our beautiful Design Museum on Shad Thames, with a warm, ambient glow in the south London twilight. Converted from a derelict banana warehouse, this wonderful building really could have been part of the Bauhaus. It was the museum's happy home for more than 25 years.

Over the years, my foundation – the Conran Foundation – has given £74 million to help fund the Design Museum, and about £20 million of that is invested in the new building. It is true to say that I feel enormously close to this project.

At the beginning of my career, the word "design" hadn't really entered the English language, and people lazily assumed it was just another word for drawing. But when Habitat became a public company, I found myself, for the first time in my life, with rather a lot of money and thought I would like to do something serious with it. I had always been

involved in selling design to the public and to industry, but I had a strong conviction that we could use design in some way to change and improve Britain as a whole.

It seemed to me that design education was not at all understood by the government, and that good design wasn't recognized as being crucial to the quality of our lives, as well as to the economy, both now and in the future. So I spoke with Paul Reilly, a wonderful man who headed up the Design Council and who was to some extent, my mentor. We agreed that a museum of industrial design exhibiting products from all over the world could be an amazing and influential project.

When I was a student, I spent a lot of time in museums, particularly the V&A in South Kensington. It seemed to me that while we celebrated the history of the decorative arts, there was nothing particularly contemporary being exhibited, apart from at the Design Centre in Lower Regent Street. I felt that, as a country, we were all too keen to celebrate our glorious past, but I was fixated on the present and the future.

I had been hugely affected by the Triennale di Milano, which held absolutely brilliant design exhibitions. Stimulating and influential, they enabled both students and manufacturers to see the best contemporary designed products in the world. Paul and I believed we could create our own modest version.

Around the early 1980s, Paul said he would like to introduce me to a young man he had met from Liverpool University, who "seems just as passionate as you are". He wasn't wrong. The young man was Stephen Bayley and he would go on to become the Design Museum's first director. Stephen was full of energy and ideas, bursting with imagination and ambition – just the sort of person I have always been attracted to. So I set up the Conran Foundation and put in a huge chunk of money with the intention to create a permanent home for the display of modern design.

We spoke to the director of the V&A, Roy Strong, to see if he could provide the space, rather cockily pointing out that his museum hadn't focused on contemporary design in the way that perhaps, it should have done. Roy came back and offered us a dark, dingy space of about 37sq m (400sq ft) in the basement. It used to be the museum's boiler room but there were no stairs leading to it. Roy said that if we were prepared to put our hands in our pocket to convert it, the space was ours. That was the start of the Boilerhouse Project.

We converted the space into a simple, white box that would become our home for the next five years. We liked the name because a boilerhouse creates energy and lets out a puff of steam now and again, which felt very appropriate. Stafford Cliff created a brilliant poster for the opening exhibition and off we went.

Over the next five years, we put on around 25 exhibitions. It was the first time there had been design exhibitions in the UK – we were vibrant and questioning, looking at subjects from a different angle. The Boilerhouse was a real success story and became very popular very quickly, which was actually what brought us down in the end. There was the perception that we were too commercial, heaven forbid, and our final exhibition was: "Coca-Cola: the making of a brand." It was an important exhibition and not at all frivolous but Roy's curators were lining up outside his office to get the cocky young upstarts out of there.

The Boilerhouse had been a success, though, and we had certainly learned a lot about how to create a really serious museum. We just needed to find a new home. This was around the time we were developing Butler's Wharf and it seemed obvious that we should take it there with us. I knew we would have support from Southwark Council, which was desperate to bring more culture to the area.

Stephen was also enthusiastic about building a new Design Museum, and we identified an old banana warehouse alongside the Thames that would become our home for the next 25 years. Our architects, headed by Richard Doone, devised a scheme that stripped back the brickwork and used the steel structure to create a simple, suitably Bauhausian building, which I thought was a perfect look. Through the Conran Foundation, we found the money and we built it – it was quite possibly the happiest bit of money I have spent in my entire life.

We thought a great deal about who might open the Design Museum and initially approached Prince Charles. He was very charming but it was obvious he didn't like the modern building we were creating. Lord McAlpine, who was on our board of trustees, suggested the Prime Minister, Margaret Thatcher. She agreed and became a terrific champion of the Design Museum over the years. On the opening night in 1989, there was a rather hilarious moment. We were in the lift and it juddered and shook, eventually coming to rest about a foot above the floor. "What do we do now?" she asked, and I said, "Jump." To our amazement, she did.

One thing Mrs Thatcher did get quite cross about was that there were a great number of foreign products in the museum – she thought it was going to be filled with British products and examples of British design. I explained that it was a museum to celebrate design from all over the world, which we hoped the British public and our industries might learn from. With that, she became quite jolly and made a very good speech. I think having such high-profile government support was very important in the way the public perceived us and what we were doing.

Stephen was absolutely terrific at creating a buzz around the project and getting people to come to Butler's Wharf, which was still off the beaten track in those days. The Design Museum blossomed into something very beautiful and very important.

During its time, the Design Museum has produced consistently excellent exhibitions about every aspect of design you could possibly imagine. We have featured the very

biggest names in the world of design, as well as supporting and promoting the brightest young design talent. The education and learning programme has connected with schools across the country, and we have become, in my opinion, the most important museum of design in the world.

And that is why we have relocated to a bigger home, choosing the former Commonwealth Institute building in Kensington. Designed by Sir Robert Matthew in the 1960s, this outstanding piece of architecture and listed building has an extraordinary geometric roof. When I visited the site, the cathedral-like scale made me gasp. In reconfiguring the space, the design team, led by the architect John Pawson, has paid homage to the building as a piece of sculpture, making it fit for a 21st-century design museum.

A bold and exciting new chapter now begins for the Design Museum, under the excellent directorship of Deyan Sudjic and his team. The move gives us three times more space in which to show a wider range of exhibitions and a dedicated area to showcase our world-class collection. We have also created a library and a lecture theatre, which has significantly extended our learning programme.

So this is our big moment. Britain is one of the most creative nations in the world, and design is implicated in practically everything that is made here. We need to put design at the heart of that creativity, by educating and enthusing young people. If we can show them that something that is thoughtfully and intelligently designed will improve the quality of their lives, then we have done an important job.

I am convinced that the very size of our new Design Museum and the enormous amount of space that we are giving over to education will play a vital role in the future of design in Britain. I hope that the museum will be embraced by industry and manufacturing in this country, and that successive governments will see it as something of a national museum and encourage foreign visitors because they are proud to show off British design. It will, I hope, demonstrate the ambition and creativity of British designers and how important our policy on design education is to our nation's children and students. The new Design Museum can become the definitive voice of contemporary design, reinforcing Britain's place as one of the world's leading creative economies.

LEFT
This four-page colour brochure, designed to coincide with the move of the Design Museum to Butler's Wharf in 1989, explained the aims of the foundation and the idea behind the museum.

BELOW
Eduardo Paolozzi's bronze sculpture, *Head of Invention*, 1989, which sat outside the Design Museum on the riverfront. On the base is a quote by Leonardo da Vinci that captures the heart of my own design philosophy: "Though human genius in its various inventions with various instruments may answer the same end, it will never find an invention more beautiful or more simple or direct than nature, because in her inventions nothing is lacking and nothing is superfluous."

OPPOSITE
The poster, designed by Stafford Cliff for the inaugural exhibition at the Boilerhouse, was a dramatic evocation of the steps down to our basement space in the V&A. Each step was marked by the name of one of the designers in the show.

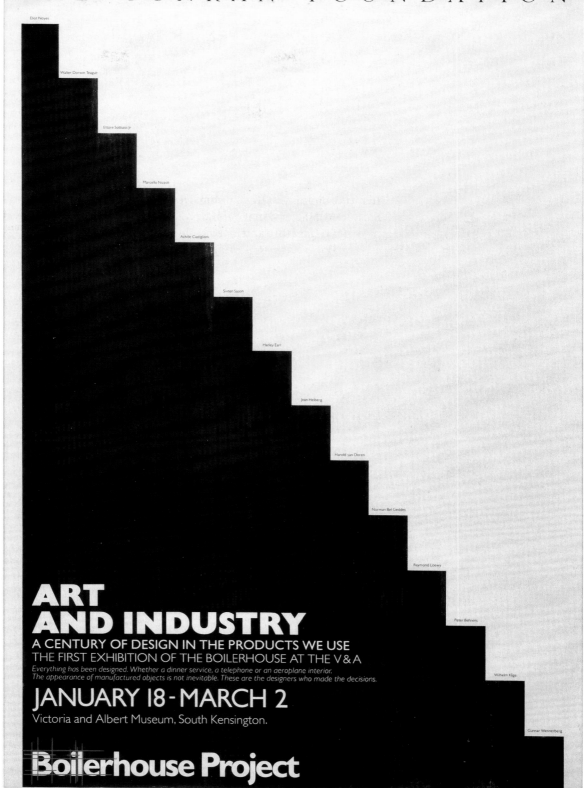

THIS PAGE

Art and Industry was the first of a series of exhibitions about the history, theory and practice of design, in 1982. It looked at influential designers of the 20th century and their relationship with successful manufacturers. We were asking people to consider industry as one vast studio – some of the most inventive and original artists at the time had worked at major companies, such as IBM, Saab and Ericsson, and had used the production line as their canvas. The Mobil petrol pump (below) was designed for Mobil in 1968 by Eliot Noyes. It was a dominant feature of the exhibition and remains an important part of the Design Museum's permanent collection.

OPPOSITE

The tagline for the exhibition was "A Century of Design in the Objects We Use". It featured objects placed on white display stands, such as the Olivetti typewriter, a Toledo shop weighing scale and even a Gestetner duplicating machine. The Olivetti typewriter is particularly interesting and relevant today. Designed in the 1960s by Ettore Sottsass, it is a design classic and, in many people's eyes, the precursor of the iMac.

"Our ambitious plan was to make a truly modern museum, a resource of ideas and images, to turn the world of manufacturing into a classroom, where products can be read like books."

"The *Car Programme* exhibition was thoroughly informative, looking at how every detail in the Ford Sierra's design was tested and accepted or rejected."

THIS PAGE & OPPOSITE
The *Car Programme* was a brilliant Boilerhouse Project exhibition from 1982 that traced the planning and design of the Ford Sierra, from inception to completion, 52 months later. Here I am admiring the detail of the car with John Stephenson (above). We were absolutely desperate to get two of the cars into our basement space at the V&A and had to winch them in through the roof (right) – poor Roy Strong must have had a heart attack! Pie in the sky, blue-sky thinking and clouded judgement were just some of the thoughts behind the design of the exhibition poster (opposite). The 52 months in the exhibition's title were subtly marked down the sides of the poster, like time passing.

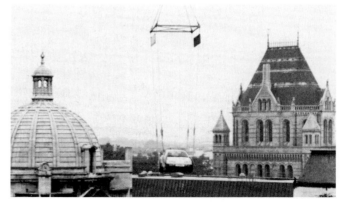

THE CAR PROGRAMME

52 MONTHS TO JOB ONE or HOW THEY DESIGNED THE FORD SIERRA

An exhibition of product planning and design in the motor industry

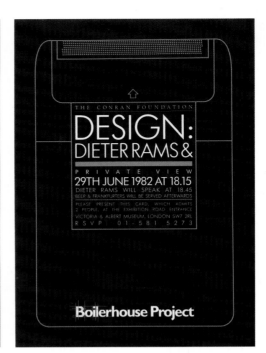

LEFT
Each Boilerhouse Project exhibition had its own poster – we needed to promote ourselves and tell people, particularly the design and business community, what we were up to. This led to some terrific design work and a series of iconic, individual posters that really sold the mood of each exhibition. One of my favourite shows was *Hand Tools*, 1983 (below right). Another was all about shopping bags.

OPPOSITE
The *Issey Miyake* exhibition, 1985, was another surprise – the immaculate, white-tiled gallery was pumped full of black foam rubber, out of which bald, glossy black mannequins rose and floated.

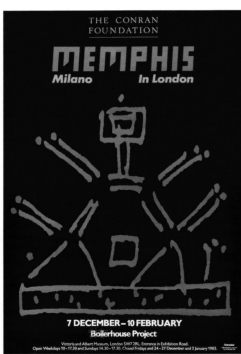

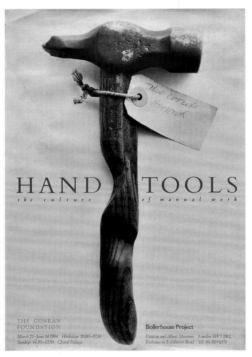

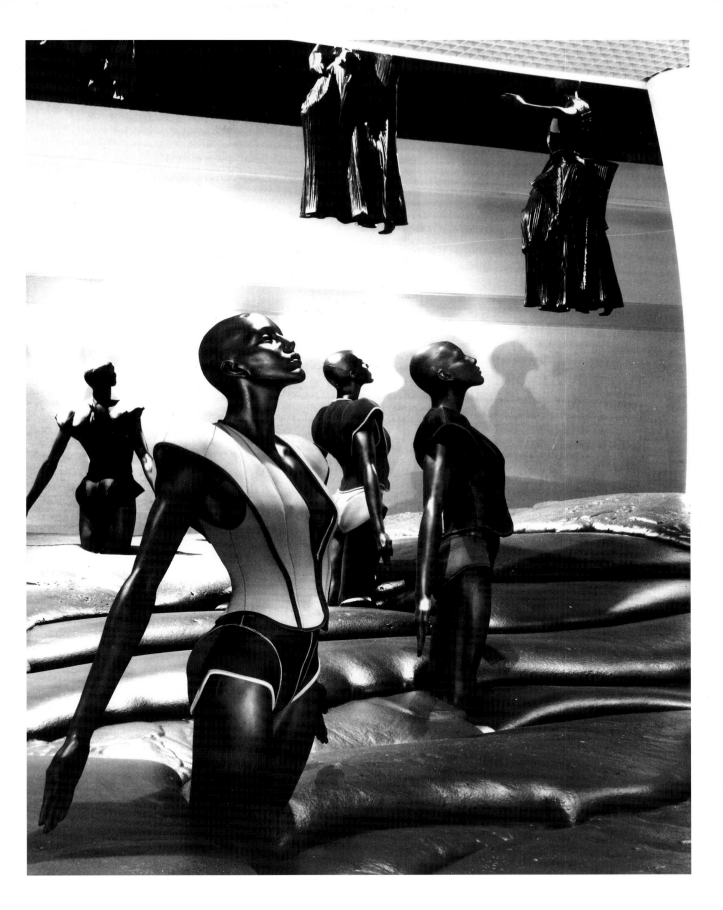

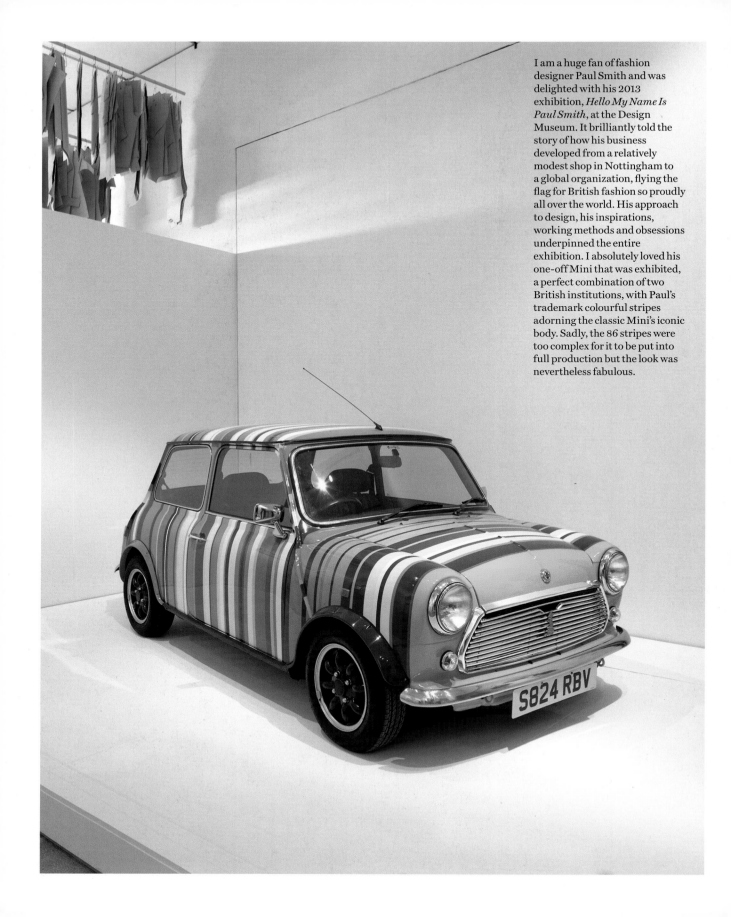

I am a huge fan of fashion designer Paul Smith and was delighted with his 2013 exhibition, *Hello My Name Is Paul Smith*, at the Design Museum. It brilliantly told the story of how his business developed from a relatively modest shop in Nottingham to a global organization, flying the flag for British fashion so proudly all over the world. His approach to design, his inspirations, working methods and obsessions underpinned the entire exhibition. I absolutely loved his one-off Mini that was exhibited, a perfect combination of two British institutions, with Paul's trademark colourful stripes adorning the classic Mini's iconic body. Sadly, the 86 stripes were too complex for it to be put into full production but the look was nevertheless fabulous.

RIGHT

The 2012 *Christian Louboutin* exhibition was an absolute smash hit, the most visited in the history of the Design Museum. Curated perfectly by Donna Loveday, it captured all the rich glamour and seductiveness of the shoe designer's work, but also gave a fascinating insight into how he designs.

BELOW

In 2011, to celebrate my 80th birthday, The Design Museum hosted the first exhibition of my work that I can remember. These giant pencils greeted visitors at the entrance, a none-too subtle reminder that all of my design work still starts with a pencil and sketchbook.

ABOVE RIGHT

A full scale model of a De Stijl motorbike, as imagined by Werner Graeff who was a German painter, sculptor, photographer and inventor, and a great student at the Bauhaus. The model was commissioned by Stephen Bayley when we opened the museum in Shad Thames in 1989.

RIGHT

Kenneth Grange is such a prolific, talented industrial designer, and his work has literally touched the lives of millions of ordinary Britons. His 2013 retrospective *Making Britain Modern* was a terrific exhibition – and one that was long overdue.

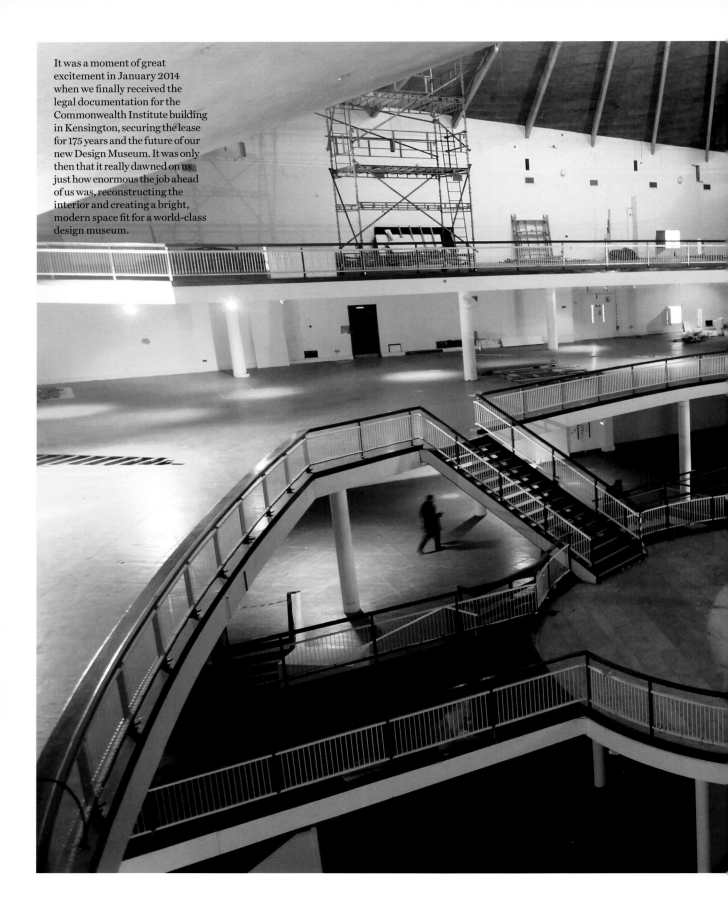

It was a moment of great excitement in January 2014 when we finally received the legal documentation for the Commonwealth Institute building in Kensington, securing the lease for 175 years and the future of our new Design Museum. It was only then that it really dawned on us just how enormous the job ahead of us was, reconstructing the interior and creating a bright, modern space fit for a world-class design museum.

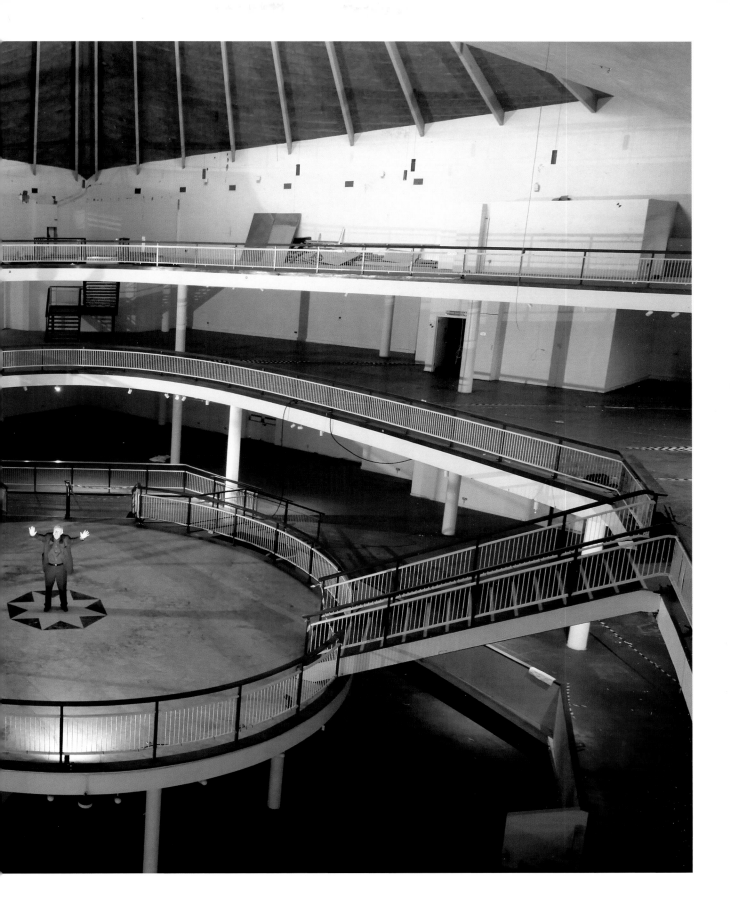

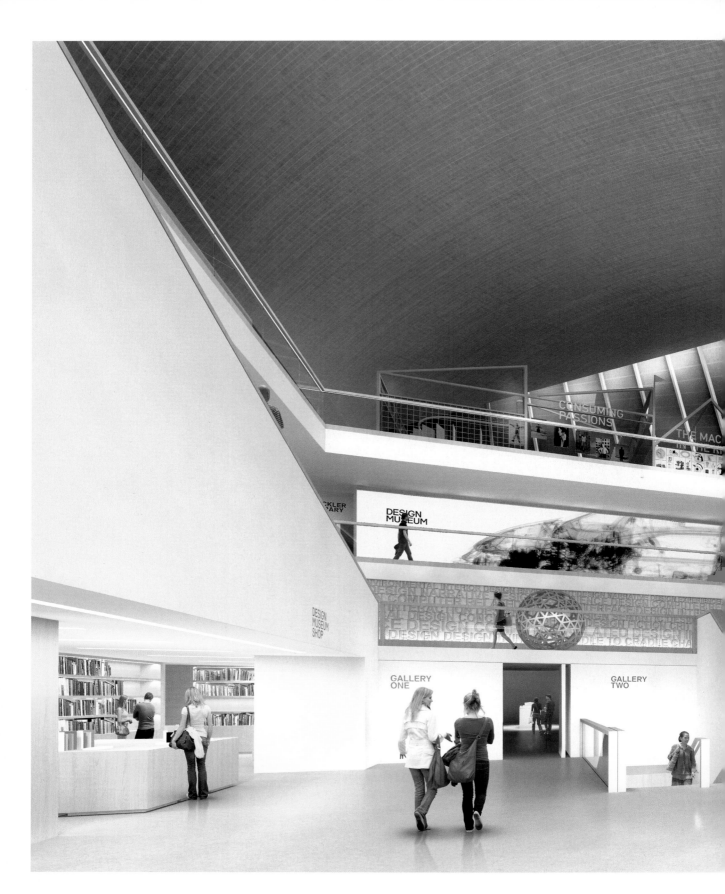

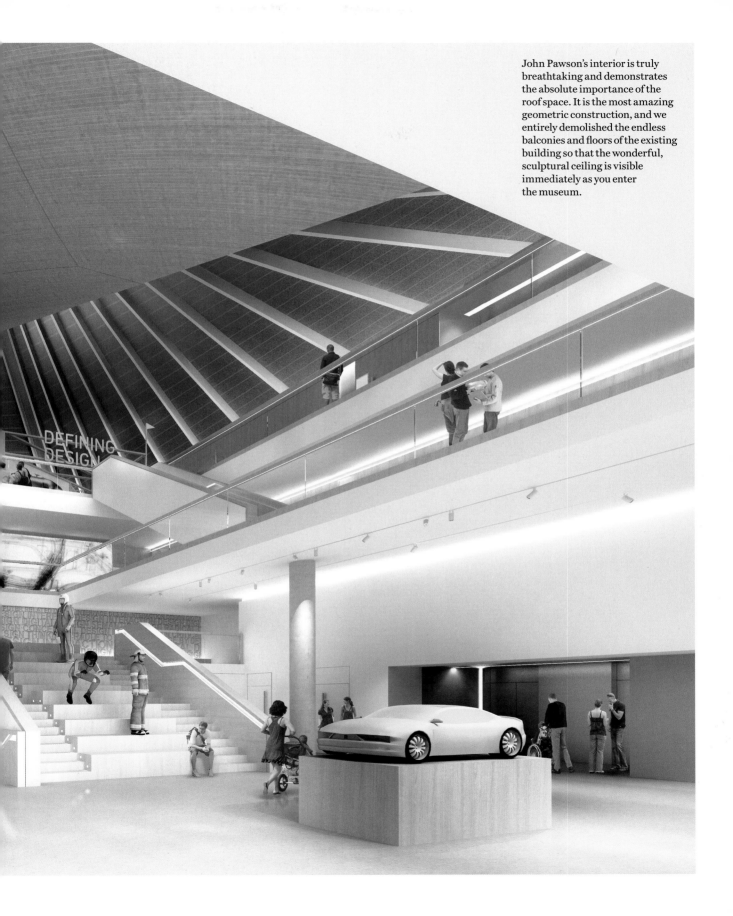

John Pawson's interior is truly breathtaking and demonstrates the absolute importance of the roof space. It is the most amazing geometric construction, and we entirely demolished the endless balconies and floors of the existing building so that the wonderful, sculptural ceiling is visible immediately as you enter the museum.

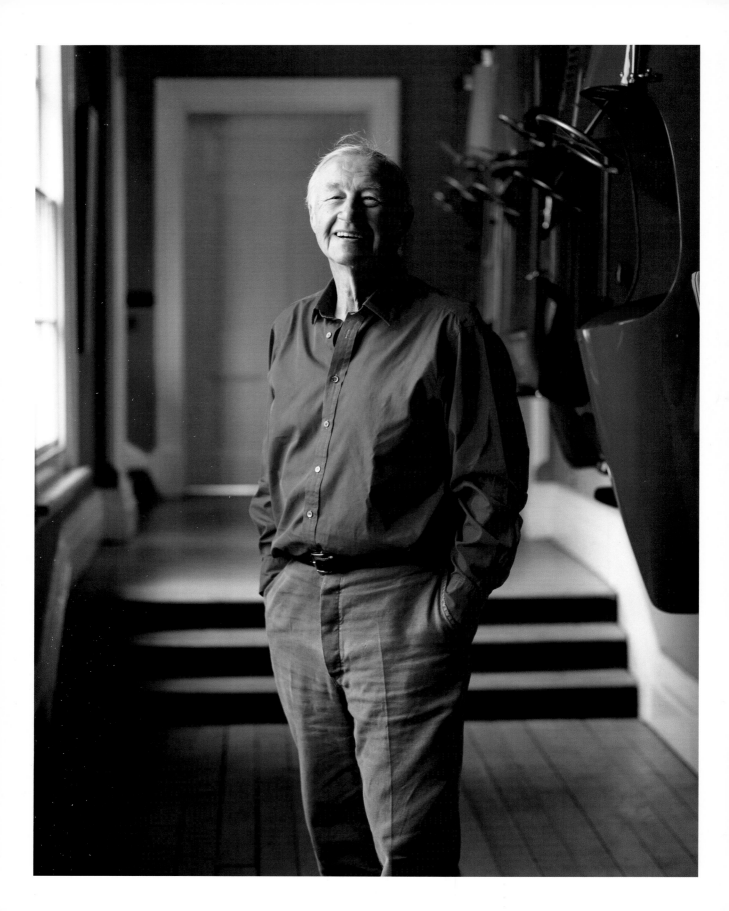

Thank you

And finally, thank you to the many brilliant designers and architects with whom I have worked over the past 65 years – what a time it has been. I think we have gradually improved the quality of life for the many customers of our products and managed to influence a great number of manufacturers and retailers to understand the importance of design in all aspects of their businesses. There is still a long way to go, so the good fight must continue.

How important it is that British Government is finally understanding how significant a role design plays in improving the quality of life for our country's citizens, just as the Scandinavian countries realized many years ago. It is, I believe, a political opportunity. We are frequently told that Britain is the most creative nation in the world, so we have every opportunity to demonstrate that we are.

Terence Conran

PS. Some of the managers of my various design businesses and senior designers who worked in them are:

John Stephenson, Rodney Fitch, Oliver Gregory, Malcolm Riddell, Maurice Libby, Stafford Cliff, Guy Fortescue, Ron Baker, George Montague, David Wrenn, Peter Crutch, John Bampton, Don Goodwin, Ron Baker, Bernard Dooling, Alan McDougall, David White, Ken Lumsdale, John Brockliss, David Birt, Graeme Lusted, Rob Pickering, Tony Rowe, John Steadman, Keith Appleby, David Davies, David Vickary, Fran Lane, Martin Roberts, Flo Bayley, Fred Roche, Stuart Moscrop, Richard Doone, Paul Zara, Matthew Wood, Tim Bowder-Ridger, David Chaloner, Jenny Jones, Tina Ellis, Tina Norden, James Soane, Sebastian Conran, Russell Pinch, Linzi Coppick, James Pyott, Alex Willcock, Priscilla Carluccio, Jeff Heading, Giuseppe di Stefano, Betsy Smith, Jill Webb, Sean Sutcliffe, Steven Huzzey, Steve Owens, Steve Cooper, Peter Prescott, Isabelle Chatel de Brancion.

Created in the mid-1960s, the
brief for this exhibition stand
for UKAEA (the UK Atomic
Energy Authority) was to
incorporate a number of pieces
of technical equipment into a
cohesive display. We devised
the simple structural form as
a "container" for the exhibit,
to create in the visitor's mind
a feeling of involvement with
science in progress. An area
was included within the stand
for scientific experiments, which
could be watched on closed-
circuit television.

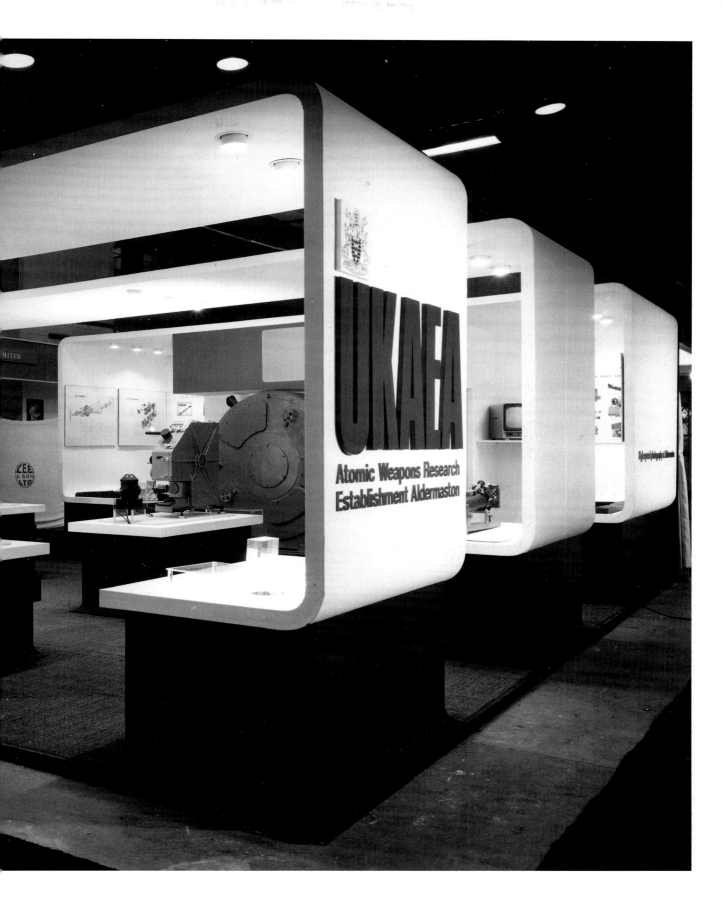

Index

PICTURE CREDITS

The images used in this book have been mainly provided courtesy of Stafford Cliff, Conran and Partners and Prescott & Conran. Additional credits are included below:

Angus Thomas Photography 212ar; David Brittain 149a, 170, 171; Dominick Blackmore 168; Edmund Sumner 120; Ernest Simons 210r; F10 Studios 154b; Guy Montagu Pollock 111; Janne Peters/Conny Welz 216; Jim Stephenson 150b; [J Z A] Photography 155; Liam Clarke Photography 130a; Luke Hayes 248; Matt Livey 154a; Miller Hare Ltd 144–5; Nacasa and Partners 130b; Paul Raeside 81 all, 117–118al, 174–5, 207; Prisclla Carluccio 202; Roy Attfield 16.

The publishers would also like to acknowledge and thank the following:

Image courtesy of The Advertising Archives 14; Alamy Jeremy Pembrey 240b, Morley von Sternberg/Arcaid Images 152, Pictorial Press 70a; David Constantine 6; David Garcia 10-11; Design Council Archives, University of Brighton Design Archives

Architecture and Building, March 1955 84, 86, Tim Street-Porter 95; from the Design Council Slide Collection at Manchester Metropolitan University Special Collection 61r; © the Design Museum 160, 203, 242, 247, Alex Morris Visualisation 17, 252-3; Getty Images Dan Kitwood 250-51, John and Tina Reid 163, Paul Popper 22-3; courtesy Habitat 27; Julian Broad 254; Miller's Guides auctioned by Gary Grant 35a & bl; Octopus Publishing Group 35br; REX Shutterstock Ann Ward/ Associated Newspapers 49; RIBA Collections 243, John Maltby 46b, 61l, 66, 68, 98-9, 103, 105l, 123a, 126, 200, 204, 215a & b, 256-7; courtesy The Conran Shop 80b; The David Steen Archive 2; TopFoto 70b; Trunk Archive Terence Donovan 50a; Victoria & Albert Museum, London 20a, 24, 29, 30, 34, 36, 38-9, 40b; View Pictures Peter Cook 236.

All reasonable efforts have been made to correctly acknowledge images used in this book, but the publishers would welcome any clarifications that may be forthcoming.

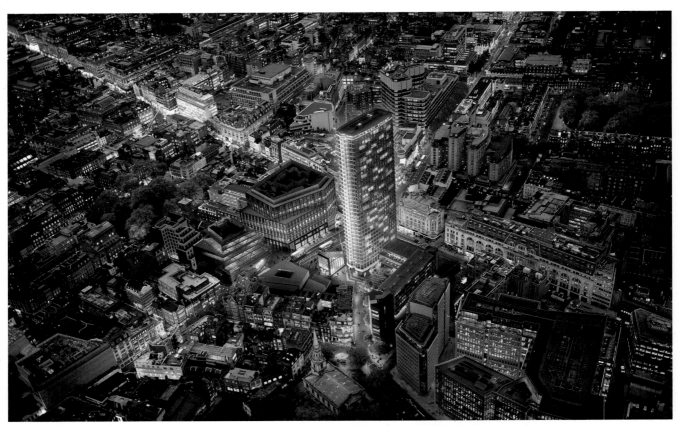

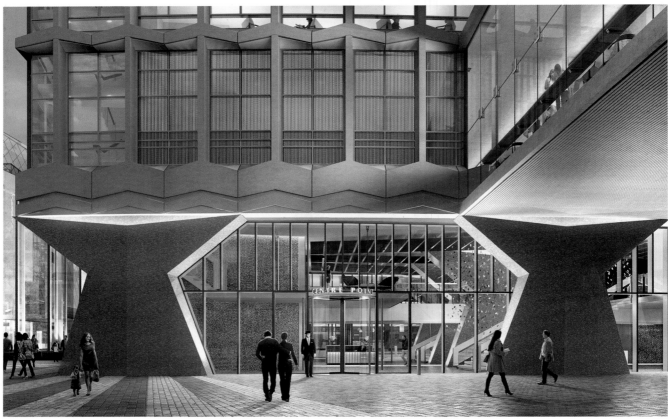

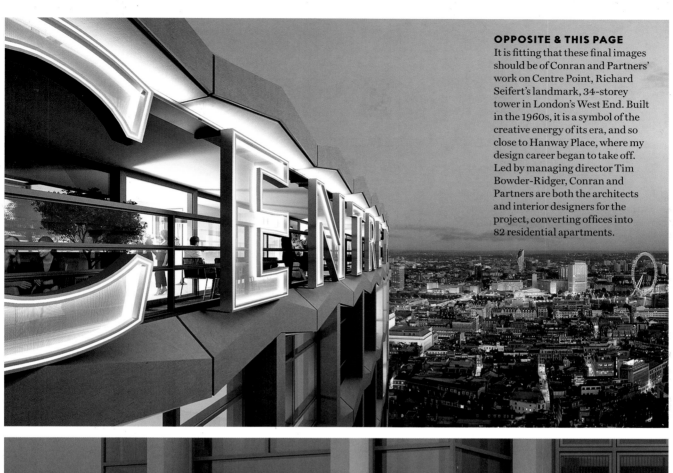

OPPOSITE & THIS PAGE
It is fitting that these final images should be of Conran and Partners' work on Centre Point, Richard Seifert's landmark, 34-storey tower in London's West End. Built in the 1960s, it is a symbol of the creative energy of its era, and so close to Hanway Place, where my design career began to take off. Led by managing director Tim Bowder-Ridger, Conran and Partners are both the architects and interior designers for the project, converting offices into 82 residential apartments.

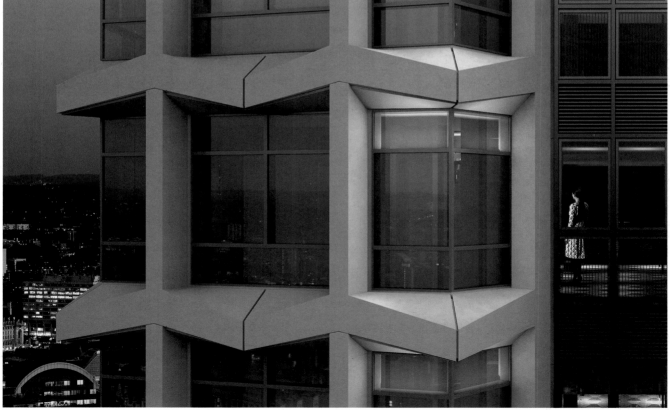

Dedication

I would like to dedicate this book to my four wives, all of whom have influenced my design career.

Brenda, an architect, who gave me an insight into architectural designs; Shirley, who worked with me on textile design and was a director of our Conran Fabrics company; Caroline, who has a great eye and taught me a lot about food and its preparation; and my current wife, Vicki, who has a very sharp eye for intelligent design and has contributed to building the Conran brand.

The feminine influence is vital in the design process and there have always been talented female designers and architects in our various design businesses since the very beginning.
—*Terence Conran*

Acknowledgements

Stafford Cliff would like to thank: Constance Zaremba, Steven Owens, David Wrenn, James Pyott, Tony Rowe, David Birt, Helen Senior, Dominick Blackmore, David Brittain, Sebastian Conran, Sean Sutcliffe, Cara Steeden, Fiona Coyne, Maurice Libby, Graeme Lusted.

Matthew Riches would like to thank: Nu-Nu Yee Hoggarth, Sue Owen, Flora Pope, Paul Zara, Jennifer Hunt, Richard Doone, Josephine Chanter, Jenny Stewart, Nell Reid, Cecil Hastings, Jesse Connuck.

An Hachette UK Company
www.hachette.co.uk

First published in Great Britain in 2016 by
Conran Octopus Ltd, a division of
Octopus Publishing Group Ltd
Carmelite House
50 Victoria Embankment
London EC4Y 0DZ
www.octopusbooks.co.uk

Copyright © Conran Octopus Ltd 2016

Distributed in the US by Hachette Book Group
1290 Avenue of the Americas
4th and 5th Floors
New York, NY 10020

Distributed in Canada by Canadian Manda Group
664 Annette St.
Toronto, Ontario,
Canada M6S 2C8

ISBN 978 1 84091 720 8

A CIP catalogue record for this book is available from the British Library.

Printed and bound in China

10 9 8 7 6 5 4 3 2 1

Creative Consultant: Stafford Cliff
Contributing Editor: Matthew Riches

Publisher: Alison Starling
Creative Director: Jonathan Christie
Managing Editor: Sybella Stephens
Copy Editor: Helen Ridge
Picture Research Manager: Giulia Hetherington
Senior Production Manager: Katherine Hockley